The
Artist's Soul

❖ ❖ ❖

The
Artist's Soul

❖ ❖ ❖

Daily Nourishment to Support Creative Growth

LINDA COONS

JEREMY P. TARCHER/PUTNAM
a member of
PENGUIN PUTNAM INC.
NEW YORK

Most Tarcher/Putnam books are available at special quantity discounts for bulk
purchase for sales promotions, premiums, fund-raising, and educational needs.
Special books or book excerpts also can be created to fit specific needs.
For details, write Putnam Special Markets,
375 Hudson Street, New York, NY 10014.

Jeremy P. Tarcher/Putnam
a member of
Penguin Putnam Inc.
375 Hudson Street
New York, NY 10014
www.penguinputnam.com

Library of Congress Cataloging-in-Publication Data

Coons, Linda
The artist's soul: Daily nourishment to support
creative growth / Linda Coons.
p. cm.
ISBN 1-58542-016-6
1. Artists—Psychology. 2. Creation (Literary, artistic, etc.) I. Title
NX165.C66 2000 99-37588 CIP
701'.15—dc21

Printed in the United States of America

1 3 5 7 9 10 8 6 4 2

This book is printed on acid-free paper. ∞

Book design by Linda Maxwell

❖ ❖ ❖

Dedication

This book is dedicated with soul-felt gratitude to my Higher Power, whom I often refer to as the Great Creator. I am deeply grateful for having been gifted with the inspiration to put these words together to share with others who may be seeking them, as I once was.

❖ ❖ ❖

Julia Cameron has been an inspiration for me and my search for creative outlets and expressions. The words in her books *The Artist's Way* and *The Vein of Gold* have served as a healing balm to my spirit. In experiencing the activities she describes so beautifully in her books, I felt as if she extended her hand to me personally, uplifted me, and invited me to explore the world on new creative and spiritual terms. It is with appreciative acknowledgment that I recognize the contribution she has made to my life and my recovery efforts.

Thank you, Julia, for being who you are. The gift of your sharing has strengthened me and moved me forward on my creative/spiritual journey.

❖ ❖ ❖

Intention

My intent for writing this book is to share my experience, strength, and hope with other artists. My purpose is to encourage the development of the healthful creative spirit that is an intrinsic part of each of us. I have written this book from information and lessons I have gathered from the many sources of my own eclectic artistic development. Rather than considering my words as advice on any specific issue, I suggest that professional help be sought in instances where necessary.

❖ ❖ ❖

Suggestion

This book is designed to be used in two ways: First, as a daily companion for artistic recovery, it can provide ideas for us to contemplate and consider for personal and creative growth. Second, if we struggle with an issue, perhaps we can scan the monthly indexes to pinpoint ideas and descriptions of feelings concerning the topic. By turning to that date, we can read about the issue and gain more awareness of possibilities for growth. This book may serve as a springboard for further reflection or discussion, opening lines of communication on specific areas of concern.

Introduction

Some of us may have preconceived and limiting concepts of what art is, or who artists are, and what we do. Art may involve more than many of us envision. When I refer to myself as an artist, for example, I generally get a response that implies that I do paintings or murals.

In one sense I do paintings and murals. I often use flowers or words as the creative choice from my personal palette, however. Sometimes I use antiques, music, furniture, fabric, homemaking endeavors, or other things to portray my expression of myself and my choices in the moment. From my perspective, my palette is my creative gifts, and the choices I make to use my gifts are my colors. My canvas is my life.

My husband sometimes uses lumber, screws, sweat, and imagination to accomplish his art. He also uses facts, figures, instincts, and educated guesses in making his choices. And his accomplishments are as beautiful as anything the recognized master artists ever created.

I believe we are all artists when we express who we honestly are by our healthful creative choices. I do not believe art is limited to traditional stature or recognition attainable by only a few whom we may have learned to believe were endowed with mystical or magical talent while others are given little or none. I believe there is no need to compare any one artistic expression with any other.

My philosophy is that art emerges from the soul when we learn to become honest and open to receiving, developing, and using the gifts each of us is uniquely given by the Great Creator. Art is, for me, the use of one's creative gifts for healthful self-expression and to provide pleasure to the soul.

Introduction

Art can be as simple as a momentary creative thought, or as complex as one chooses to express oneself.

I invite you to join me in exploring what art means in your life. I have endeavored to refer to art in as nonlimiting terms as possible so that each reader can interpret art on a personal choice basis. My hope is that you will connect with that most healthful creative part of your soul and become who God intended you to be—an artist as you define your art.

The
Artist's Soul

❖ ❖ ❖

Days of Special Remembrance

Days of Special Remembrance

JANUARY

New Year—New Chances

As we greet the new year, rather than make resolutions, many artists learn to do some soul searching. We learn to assess the previous year for our creative growth and accomplishments, no matter how large or small they seem to us. We learn to do it with increasing gentleness.

We may or may not choose to make lists. We merely reflect on what the year has brought to our lives. We might ask ourselves: Have I done some of the things I hoped I would? If not, this year offers a new chance. Have I made a conscious effort toward an artistic goal or dream? If not, this year offers a new chance. Have I worked toward improving relationships with those around me, significant and stranger? Have I invested in my relationship with myself as a creative child of my Higher Power? If not, this year offers a new chance.

Some artists find that this attitude of gentle, honest searching encourages us to accept ourselves as we are. It promotes a positive atmosphere for healthful changes as well. We find that we can look forward to the new year with faith that our lives and our art are evolving according to the gentle will of a loving and creative Higher Power.

❖ ❖ ❖

God, please guide me to the lessons that will teach me to accept myself exactly as I am. Help me to believe that your plan of goodness for my life and my art is already in effect, even if I may not be aware of it.

Being Strong

Some artists may have learned that being strong requires that we not feel our emotions: especially pain, anger, sorrow, and grief. When we suppress our emotions, however, we deny that a part of our human spirit exists. We become less than a whole and unique person.

This denial may eventually lead us to feeling powerless in our lives and our art. We may become overwhelmed by trying to keep our feelings under control. In the same feeling-control process, we may also have learned to control our happiness, joy, and spontaneous creativity—thus limiting our creative options.

Being strong, in recovery, may mean we find the strength inside ourselves to get honest with all our feelings. It may mean accepting our pain, sorrow, grief, and anger by expressing, rather than denying, them. Some of us may discover strength in crying out and working through our pain. We may find that our sorrow emerges in our art. It is possible that our resolved anger will reveal previously discouraged areas of our artistic expression. We may spontaneously express our joy in our creative endeavors, as well.

Strength does not involve a show of power. We do not need to prove our strength by bullying, controlling, or manipulating people, places, and things. Sometimes our strength is manifest in quietly accepting who we are by simply being who we are, with all our range of feelings.

Being strong also means that we do not give away our God-given power to others who want to use us for their own purposes that do not meet our personal needs. We learn strategies that guide us to respect our boundaries from within

so that our personal, creative, and spiritual strength is not drained by others.

❖ ❖ ❖

Today, I will consider my attitude about being strong. There is no need for me to hide my honest feelings behind a tough exterior, or to give away my true power to be who I am. I can learn strategies that will encourage me to express my healthful feelings and guide me to being my creative self.

Fine-Tuning Our Instincts

Some artists learn to become aware of the ways in which our own instincts can guide our paths toward our gifts and talents. We learn to listen to our feelings about ourselves and our art.

We might question: What would I enjoy investing my time to learn and to do? We surround ourselves with it if it's healthful. We seek it out. We allow our imagination to have free rein with possibilities.

We may ask: What in my life do I dislike and feel enslaved doing? Is it possible to free myself of it? Can I find creative ways to at least reduce the time spent doing it so I have more time to do more of the things I enjoy? Can I delegate the responsibility for at least some of these things to others?

Some of us may question: In my relationships, have I learned to spend more time with people who support my creative endeavors? Have I learned to invest less of my time and energy, or detach from those who abuse me or my artistic efforts?

❖ ❖ ❖

I can become willing to ask questions of myself that will help me to fine-tune my instincts. My honest answers to these questions can serve to guide me to become the creative person my Higher Power intends me to be.

Recognizing Gifts from God

Some artists believe that there is an art form in learning to recognize gifts from God. Because they don't arrive in our lives neatly wrapped in a gift box with a pretty bow and a tag which says, "To _____ from God," we often do not recognize them as gifts. We may lack the faith to believe that they come from a source greater than ourselves, or perhaps doubt that we deserve the goodness some creative gifts and talents might bring to our lives.

Most often gifts require willingness and hard work on our part. We can consider them spiritual gifts just the same. Usually they require that we recognize and accept them, including the footwork involved in the process.

Sometimes gifts from God arrive when and how we least expect them. That a Higher Power is a mysterious force for good, many of us learn through experience. We can consider opportunities as gifts. Sometimes the opportunity to say "no" or "I choose not to be a victim" is a gift. The opportunity to say "yes" to something we do want is also a gift.

We can learn in our prayers and meditations to thank our Higher Power for all our gifts, no matter how small or large. Some of us happily discover that our gratitude seems to create a pathway for even more gifts to appear in our lives and our art . . . even if they're not wrapped in a gift box.

❖ ❖ ❖

Today, I will pray and meditate about whether there are gifts from God available to me that I am not recognizing. I will express my gratitude for all my gifts, no matter how small or large they seem to me.

Changes Will Happen

Change is an inevitable part of life, whether we like it or not. We may like things to remain the same because they are comfortable and familiar. We know what to expect.

Change is necessary for us to grow. We can grow into new, more healthful expectations and different levels of comfort and familiarity. We can expand our horizons, opening our artistic awareness of who we are and what is possible to do, create, and to be. We can experiment with new opportunities for growth.

Sometimes we feel ready for change and adapt easily. Other times we resist. We may kick and scream that we want things to stay as they are. But changes happen anyway. We can learn to work through changes with acceptance as our goal. Eventually we may come to see that the changes were necessary for our growth. We reach acceptance of the new reality.

We can grow in our awareness by trusting that God has a plan for us. We can come to believe that the plan will work out for the highest good, though we can't always see the outcome when we're in the process of changing. Even if we do not know what the plan is for our lives and our art, many artists learn to trust that the plan is good.

✦ ✦ ✦

God, help me to learn healthful ways to accept changes and to trust that my life and my art are working toward the highest good. Thanks for caring.

Creativity Is a Process

Most artists invest a great deal of effort in developing our creative gifts and talents. We learn to value our talents sufficiently and have faith enough in our capacity to create that our investment in ourselves feels worthy to us.

Perhaps a few of us are given absolute certainty about the possibility of our creative potential. Many of us, however, learn with time and experience to follow our interests, heed our instincts, and trust our creative feelings as we honestly feel guided.

We do not expect that our art will come to us without doing any work. Much of artistic recovery, many artists learn, involves emotional growth. We examine the many issues that discourage our capacity to choose freely from alternatives. We learn and practice skills and strategies for healthful self-care, including creative self-expression. We nurture a personal connection to a power greater than ourselves. And we learn to trust the process that involves our creating our art as we feel it. Eventually we become grateful for the gifts and talents that have been entrusted to us and learn to use them to the highest good.

❖ ❖ ❖

I'll consider, today, my feelings about the process of creativity in my life. I will strive toward accepting that the process of my creative recovery is unfolding exactly as it should, in God's way and in God's time.

Incubation

Sometimes a creative work needs time to develop. Just as an egg needs time for the process of growth until a chick is ready to hatch, so do our creative ideas and efforts need time to grow and develop to maturity.

We may want to force our creative works to completion, rather than waiting for them to unfold as they will. We might want to control the outcome, and may possibly limit ourselves by our controlling behaviors.

By praying for and accepting patience, we can open ourselves and our art to the highest good. Our patience may guide us to new possibilities, unforeseen outcomes, and unexpected insights. Many artists come to know patience ultimately as a valuable gift and a necessary part of the process of creativity.

❖ ❖ ❖

Help me to see, God, that incubation and patience are necessary parts of the creative process. I am grateful for these gifts.

What's Important to Me?

Many artists have learned to put our creative dreams and art aside, as if they are unimportant. Some of us may believe that life lasts forever and that one day we'll get to our art. In artistic recovery, we learn to honestly ask, "What's important to me?"

We learn to reclaim our creative dreams and our art. We learn to give them a priority in our lives; to bring them center stage. We learn to balance our art as a significant part of the total picture of who we are.

By being among others who support, value, and respect us and our art, we learn to give our art the time, effort, supplies, lessons, spirituality, space, and other necessary ingredients to bring it to life. We learn healthful lessons of taking care of ourselves and our art as an integrated spiritual part of recovery.

We discover that as we give our art a place of greater importance in our lives, others come to respect it as important, too. We continue on our journey toward spiritual wellness as we learn to give importance and expression to our art.

❖ ❖ ❖

I can learn to give my art greater importance in my life. I can open myself to the steps I can take to move my art toward the significance my Higher Power wants it to have in my life.

A Journey of Discovery

Many of us come to see that artistic recovery concerns discovering ourselves as only we can be. By listening to our feelings and trusting our instincts; by following where they lead; by making healthful choices that keep the focus on ourselves and our art; we are staking a claim to the wealth of gifts that is ours only if we accept it as ours.

We have each been given a rich supply of gifts, talents, and skills that ask only that we use them to our fullest advantage. However, some of us deny that they exist, ignore them, or waste them by investing in self-defeating or addictive behaviors that are abusive to our God-given gifts. We may lack the strategies to make the best use of our gifts.

By gratefully accepting and using our gifts, we acknowledge that a power greater than ourselves is available to us, and that we are uniquely connected to that power source. The more we discover on our journey, it seems to some of us in recovery, the more there is to discover about ourselves and the possibilities for creative living.

❖ ❖ ❖

O Great Creator, I am grateful that you have connected to me on my journey of life. I am open to the wealth of your unique gifts to me. Guide me, please, to use them as an act of worship to you for entrusting them to me.

Learning to Manage Stress

No meaningful life is stress-free. Problems arise for many artists, however, when we do not learn and use healthful communication skills and strategies to manage the stress we feel in our lives, our relationships, and our art.

In recovery we can learn to talk about our feelings. We can educate ourselves with stress-management skills and strategies, such as setting and maintaining boundaries, setting limits, connecting to and trusting a Higher Power, delegating authority when appropriate, balancing our time to encourage our art, and many others.

It is the creative combination of these skills and strategies in our lives that can encourage a peaceful attitude for creating and living. Many recovering artists find that learning and using stress-management skills is as important as acquiring and practicing the skills of our unique art.

❖ ❖ ❖

I can learn and use the skills and strategies available to me in recovery. I will choose one today and consciously strive to use it throughout my day in an effort to learn healthful stress management.

I Don't Know

It is possible to accept that we can't always know the answers to issues with which we struggle in our lives, our art, and our relationships. Some of us may have adopted attitudes in which we compulsively feel the need to give a response to questions that are posed to us. Some of us might benefit creatively by learning to answer "I don't know" more often.

Rather than forcing an immediate answer, we can patiently claim time to look for options, explore our feelings, and consider choices and possibilities available to us. Some of us might journal, or discuss our feelings with another trusted person. Others might turn to prayer and meditation.

Many artists discover that waiting patiently is an art form in itself and often it achieves better results than does the compulsive pace of needing to know immediately. We open our souls to spiritual channels that speak to us on intuitive levels. Sometimes, we discover, our instincts provide more meaningful answers than when we respond merely for the sake of responding.

❖ ❖ ❖

I can choose the strategy of saying "I don't know" when I feel the need for patience on an issue with which I am dealing. I can trust that my Higher Power will reveal the answers to me when the time is right.

Giving Ourselves Validity

Some of us may have learned to look to others for approval or recognition on many issues—how to dress, how to decorate our homes, what car to drive, what our art should look like or be, etc. We may have learned that what others say about our choices or our creative work is more important than how we feel about them ourselves.

In recovery, we learn to shift the focus of our attention from outside approval and validity to our own inner validation. We learn to put our most honest and diligent effort into our undertakings and then let go of them, turning the outcome over to a power greater than ourselves.

Freed from our need to please others, we open ourselves to expressing our choices and our art as only we uniquely can. We learn to accept and respect our own opinions of our creative work and our choices. We define ourselves in our own and God's terms, not by what others say or believe about us or our art.

❖ ❖ ❖

I can learn to validate myself through my own healthful valuing of my unique artistic expression. I do not need to look to others for approval or outside opinions, unless it is my choice. My feelings about my art are most important to me.

Defiance

We are taught by unspoken rules that govern our society that the way to acceptance is to blend with others, to fit in, to mold ourselves to the pattern of normality. This is necessary to establish stability in a group.

The artist, however, may feel a sense of loss in molding herself or himself to others. Because our uniqueness is our valuable gift from God, we may feel lost as individuals when we attempt to fit in with prevailing norms. We often need to heed our healthful instincts to defy established rules to maintain our artistic integrity—that sense that we are unique individuals—even in a crowd. We learn to trust our healthful choices, even if they are different from those around us.

Some artists may have been shamed for our artistic attempts by others' perceptions. Our attempts may have been honest acts of creative expression when others perceived them as acts of defiance and shamed us for them. We may have become artistically discouraged in that interaction.

It is hard emotional work to be ourselves when we need to defy conventional rules to be who we honestly are. We learn to rely on our own personal strength and guidance from our Higher Power. Our creative ideas may be battered, abused, or discounted. Eventually some of our ideas may become accepted by the group. We may even get recognition as artists for being the agents of change that we truly are. Or we may not.

In our defiant emotional state, however, we often feel alone, confused, and unsupported for our personal choices. Many artists learn to trust that our Higher Power is our greatest support system.

❖ ❖ ❖

Please stay with me, God, when I need to defy conventional rules to maintain my healthful sense of myself. Help me to trust that I am not alone and that the path you reveal to me will lead me to goodness, eventually, if not immediately.

An Open Invitation to God

One recovering artist shared this inspiring message:

When I journal before going to bed, I review my day. I describe my feelings and express gratitude for my gifts of the day. Sometimes I describe an art project in progress. If there are snags, I write about them. Often during my journaling I uncover creative solutions that had eluded my earlier attempts. Other times I may decide to scrap the idea and try something else.

I am finding it beneficial to share my ideas with God in my journaling. I describe in words, as I would with a trusted friend, what I have perceived. Then I write something like "If you have any better ideas or suggestions, God, I am open to them."

The results of this method of meditation have been gratifying for me. Sometimes, like magic, an idea will coalesce that I hadn't even considered.

By openly inviting God to guide my every endeavor, no matter how small, I am finding that my creations emerge more peacefully. I no longer carry the burden of creativity alone. God is my partner of choice.

❖ ❖ ❖

God, I offer you my invitation to join me in my creative efforts. If you have a better plan than the one I hold, please reveal it to me in your own way and time. Thanks for caring.

Forcing Ourselves and Our Art

At times in any recovery, we may return to unmanageability. We may become overwhelmed with feelings or creative ideas. We may find ourselves returning to using the ineffective behaviors that originally led to unmanageability in our lives and our art. We may return to trying to force outcomes, and manipulating and controlling people, places, and things. It may take several attempts with the same approach before we learn that this forceful pushing of ourselves and our art leaves us feeling ineffective and sometimes powerless.

Rather than pushing ourselves toward impossible or preconceived and limiting outcomes, many artists learn to let go of any attempts at controlling ideas, situations, and people. We turn it over to our Higher Power. We learn, ultimately, to be gentle with ourselves. Many of us discover that when we are gentle and trusting with ourselves and our art, better paths, ideas, or solutions evolve than the ones we try so hard to force. We learn to trust that, in all situations, when we become peaceful and trust God, the outcome is good.

We keep practicing the art of letting go of unmanageable efforts until this response becomes the innate choice for our lives and our art. We learn to live in spontaneity, acceptance, and natural creativity.

JANUARY

❖ ❖ ❖

God, help me to learn to let go of forcing myself and my art. Please guide me toward the path of gentleness with myself and my art and toward spontaneity, acceptance, and natural creativity in my life.

Getting Dirty

Some of us may need to examine our ideas surrounding the behavior of getting dirty and the influence our ideas about it may hold over our art or creativity. Some of us may have learned never to make a mess and always to keep ourselves and our surroundings spotless. We might consider how this attitude discourages us from attempting activities that might bring creative pleasure to our lives.

Perhaps it would feel good to play with clay or experiment with a potter's wheel if we let go of concerns about getting dirt under or breaking our fingernails. We might enjoy the satisfaction of ripping out a wall ourselves to remodel if we weren't more concerned about getting plaster dust in our hair.

Some of us might enjoy a class in reupholstery if we let go of worrying about the possibility of scratching our hands or hitting our fingers with a hammer. Maybe learning to do stained glass, rather than feeling envious of others' art with it, would expand our awareness of ourselves and our capacity to create if we let go of excessively worrying about the possibility of cutting ourselves.

Some artists discover that we feel less frustrated about life if we spend less time investing in compulsive or addictive behaviors, such as our worries and fears about getting dirty. Instead we invest that time and effort in a creative pursuit of which we have long dreamed. We feel more balanced when we take a risk with new and healthful creative behaviors . . . even if they involve our getting dirty.

JANUARY

❖ ❖ ❖

Today, I will examine my attitudes about getting dirty to see if they need to be changed or adjusted to encourage my own creative expression.

Becoming Open to
Artistic Interests

Some of us may have learned lessons in our lives that serve to deny or discourage our honest artistic expression. We might have learned always to serve others' interests and needs in favor of our own. Others of us may have learned to deny our creative feelings or inspirations. Our needs, wants, likes, and dislikes may have become lost in behaviors that focus on our addictions instead.

We can learn skills and strategies that serve to open our minds and souls to our unique artistic interests. As we work on our spirituality and honesty issues, we learn to define and respect our true needs, wants, likes, and dislikes, including our creative expressions. We learn to choose behaviors that guide us toward our creative desires, rather than away from them. We learn to build relationships that respect the uniqueness of each individual involved. We trust that we are guided to the highest good by our Higher Power.

❖ ❖ ❖

Today, I will meditate on my artistic interests. I will consider whether I need to assume responsibilities toward giving more attention to them and less to behaviors that deny or discourage my artistic expression. I will seek healthful strategies for making changes that might benefit my art.

Feeling Peaceful

Many of us may be unable to imagine the peace, joy, and serenity that are available to us when we learn and use the skills and strategies recovery has to offer our lives and our art. We may have come to accept as normal the constant anxiety, fearfulness, self-denial, and criticism of who we are and what our art concerns. We live our lives unaware that the choice exists to let go of self-abusive behaviors and work toward a state of peaceful self-acceptance.

In artistic recovery we can learn to honestly examine our issues and work toward resolving them. We learn to separate our issues of who we are from others' expectations of who we should be. We learn to define ourselves by what we honestly feel is God's will for us. And we become grateful for the personal connection to a loving God who wants us to use our creative gifts to the highest good.

The time we invest in our artistic recovery is a spiritual, loving investment in ourselves and our art. Many of us learn to relish the first moments of peace when we feel them. We continue our recovery work and expand the moments into days, and the days into years. We become grateful for our lives, exactly as they are, an expression of our creative choices.

✦ ✦ ✦

God, please teach me that peace is a choice available in my life. Show me how to let go of the self-abusive habits I have learned. Show me the lessons I need to learn to feel peaceful and to create my art as an act of gratitude. Thanks for caring.

"Eating Crow" and Saying No

The expression "eating crow" may imply that we change our minds about an issue and have the courage to face those involved honestly and openly. Perhaps we felt inspired or competent and committed to do a work. Upon getting involved in it, however, we discover that we choose not to do it for our own personal reasons. Perhaps other issues have changed our plans. Or we simply no longer choose to do what we once committed to doing.

Some artists find that, in learning the lessons that balance us and encourage our art to evolve peacefully, we may need to "eat crow" occasionally. Sometimes it may seem like a steady diet until we learn the lessons we need to take care of ourselves and our art. Sometimes we may need to go back for a "crow snack" to remind ourselves that we need a refresher course.

It is okay to change our minds if what we get involved in doesn't feel acceptable to us. We have a choice about changing our minds. "Eating crow" to say no can be a healthful and respectful strategy for regaining our artistic balance. We can make a graceful exit if that is what honestly feels right.

❖ ❖ ❖

I can learn that it's okay to "eat crow" and say no to something that has my life and my art out of balance. I have the right to change my mind on issues that I face.

Worrying and Obsessing

It is possible for us to get strong enough to let go of worrying and obsessing. We can allow others who are capable to learn to solve their problems. We can say no to things we honestly don't want to do.

Many artists become aware of the things that can get in the way of our creating. If we invest our time, energy, and attention in worrying, obsessing, or giving all our energy to others, we have less energy and time for our art.

We are not helpless victims. We can claim our time and energy and use them toward our creative urges. We can learn to stake a claim to our art by asserting ourselves. Some artists learn to substitute prayer and meditation for worrying and obsessing. We can learn the strategy of letting go of other people and their problems by respecting their boundaries and our own. Then we can put our energy to use for our own creative purposes.

❖ ❖ ❖

God, help me to substitute healthful, creative endeavors for the worrying and obsessing that keep me from them.

The Art of Waiting

We sometimes may feel as if we must do something, create something, be something right now. We want to feel better NOW. The urgency may be based on low self-esteem. There is an art to learning to be patient with our art, our recovery, and our Higher Power. We can learn to allow all of it to express itself when the time is right. The lessons we learn and practice about patience can enhance our self-esteem.

Some of us may need to learn some difficult lessons about timing in our artistic recovery. There is no rule book for these lessons. We learn the lessons about waiting and timing when the time is right, too. Many artists learn to trust our healthful instincts—that inner voice that is uniquely our own.

We learn to put faith in our Higher Power that our lives are evolving exactly as they need to for us. We learn that if we wait patiently, good things happen for us and our art. We are growing. Our spirituality is expanding our capacity to wait until the time is right.

❖ ❖ ❖

Today, I will meditate on the art of waiting. If there are things I don't feel comfortable doing today, I will wait and trust that there may be a better time or way in God's plan for my life and my art.

Boundaries

When we enter recovery, many of us learn for the first time the strategy of recognizing, setting, and maintaining healthful boundaries. Just as each state in the country once had to define the boundaries of the land belonging under its individual domain, so must we learn what honestly belongs in each of our personal domains.

We learn to be accountable for what is honestly ours—our likes and dislikes, our creative dreams and goals, our health, our feelings, our responsibilities, our art. Gradually—sometimes painfully, sometimes joyfully—we learn to allow other people to be responsible for their own boundaries, too.

Some artists use a creative technique when we feel our boundaries being invaded. We envision ourselves with their emotional and spiritual boundaries just as they've seen the state boundaries on a map—as physical space. When we feel ourselves being invaded emotionally, we visualize the person or system who invaded carrying a suitcase and walking on the map crossing the imagined boundary.

With practice we learn that sometimes we need to confront the intruder, in reality, by saying no to situations that feel offensive or invasive. Sometimes we say we need to take care of ourselves or our art by honoring our personal choices. Sometimes we simply meditate and imagine the person walking away, back outside the personal boundaries, with the suitcase full of their emotional offenses in hand, detaching and moving away from the personal boundaries.

Many artists discover that setting and respecting boundaries improves relationships, clears misunderstandings, and allows greater choices for artistic expression.

❖ ❖ ❖

I can learn the strategy of recognizing, setting, and maintaining boundaries that will encourage healthful expression of myself and my art. I can also learn skills that will help me to respect and not invade others' boundaries, so that my time, energy, and interest can be invested in my art.

Other People's Opinions

As artists, we sometimes get caught in the trap of other people's opinions. We may want to please them, at the expense of doing it by our honest choices. If we do our art to other people's specifications, we may need to let go of our own opinions to complete the work as others want it to be for their purposes.

Other times we are free to create exactly as we choose. Then other people's opinions are just that—they belong to the speakers. We can listen to their opinions quietly. But we do not need to accept them as our truths or as personal attacks on ourselves.

When we learn to listen openly, we may hear suggestions we might use, or we may not. We may hear others' envy or jealousy that we have used our creative gifts. We can allow others to have their feelings. We can also allow ourselves to detach from others' opinions if that feels right. We do not need to allow our lives to be controlled by other people's opinions. When we discover where our personal boundaries are, we learn to feel more secure about ourselves and our art. Then we can respect others for their opinions as we respect ourselves for our own opinions of our art.

❖ ❖ ❖

Today, I will examine my boundaries with regard to other people's opinions. I will open myself to emotional work I may need to do in this area and begin it. I will trust that God will guide me to healthful lessons I need to learn to feel peaceful about my art.

The H-O-W of Recovery

Many artists new to recovery are looking for answers to H-O-W we can change our lives for the better. The word HOW is sometimes used as an acronym this way:

H = heart- and soul-felt emotional work. Sometimes difficult emotional/spiritual work is required for us to grow beyond our artistically sabotaging expectations, limitations, and fears. We open ourselves to embrace new levels of awareness.

O = opportunity. We learn to perceive difficulties and obstacles as opportunities to learn ever greater lessons for our growth. Some of us become surprised by how strong we actually become, and the lengths to which our art can take us.

W = willing channels for creative expression. We learn, with time and experience, to become receptive vessels for the mysterious creative process to happen through our souls.

❖ ❖ ❖

Today, God, guide me to lessons for H-O-W. Point my steps, please, toward heartfelt opportunities to be a willing channel for my healthful expression. I am grateful you have brought me safely this far in my recovery of myself as a creative person. Thanks for caring.

How Do I Know If I'm an Artist?

By Linda Coons

How do I know if I'm an artist?
Asking myself is a good place to start. It's
The answer inside that will set my soul free
To be exactly who I'm meant to be.
How do I know if I'm a writer?
Can I put words together that make my soul lighter?
Does writing things out give me the clout
To say, "Hey, I'm a writer. Now there's no doubt."
How do I know if I'm a painter?
Does painting make my life clearer or fainter?
Do the colors emerge from the depth of my soul
And make my life peaceful and whole?
How do I know if I'm a singer?
Can I belt out a tune or hum a soft zinger?
Do the melodies fill my heart with joy
And make me feel like a child with a brand new toy?
How do I know if I'm a freelancer,
Or maybe a florist or a dancer?
By being who I am meant to be
The answers will become clear to me
. . . eventually, if not now.

Replacing Fear with Faith

Some artists in recovery become aware of how fear seems to breed more fear. Our experience teaches us that if we are afraid of what someone else will think of our art, we may become fearful of sharing it. That can lead to a cycle of fear of even trying to express our art, which can escalate into being afraid of thinking of ourselves as artists or creative people.

Many of us learn to break the fear cycle when we recognize it by replacing our fears with faith. We substitute trusting that we will get the right answer, or inspiration, or help as we ask for them in our prayers and meditations. We learn to trust that God's will for our lives and our art is evolving as it needs to.

Many of us learn to have faith in patience with God's timing. Some artists have had enough artistic efforts evolve by faith in strange and mysterious ways with much greater results than we had imagined. So we have our own history of positive experiences based on faith on which to rely.

❖ ❖ ❖

I can learn to let go of my fears about my art. I can grow to trust that my Higher Power is guiding my life and my art.

Calm Seas
Do Not Make Skillful Sailors

Those who know about the art and skills of sailing may understand better than others what this expression implies. Perhaps it could mean that if the winds aren't blowing, we're not going (or growing).

Using our imaginations, we might apply this motto to artists as well. If we find ourselves in the midst of storms of emotions, could this be a creative method of urging us to batten down the hatches (guard our boundaries), man the bilge pump (cry), lower the sail (let go), and pray to a Higher Power for guidance to gentler winds?

Is it possible that our struggles with the problems and challenges that come our way are a means of giving us gifts? Some of us discover that each struggle our Higher Power guides us to produces a gift, if we're open to seeing it. Some gifts are spiritual or emotional—like peace and self-acceptance (calm seas). Some gifts are physical—like the fruitage of applying our unique gifts in our lives as only we can.

If we learn behaviors that deny the storms (changes and challenges) that appear in our lives, we may be inadvertently denying the gifts that can accompany the storms, as well. We can learn not to deny the existence of storms in our lives. Many artists grow to trust that our Higher Power is with us, and seek the rainbows that accompany the storms.

❖ ❖ ❖

I can learn to trust that God is guiding me, even when my life and my art feel like a "storm." I can learn to become receptive to the good or the gift that will result from my faith in God's connection to me.

A Short, but Sweet, Story

By Linda Coons

A young hunter approached the sacred lodge. "Old woman," he called from outside. "They told me to take the path to the right to look for game to feed my people. I feel powerless because there were only open plains."

"Yes," she said quietly.

"Old woman," he continued, angrily now. "Others told me to take the path to the left to look for water to give drink to my family and horses. My life has become unmanageable because there were no rivers."

"Yes," she said gently.

Very inflamed now, he said, "Old woman, I feel it is your fault that I cannot find game and water. What should I do?"

"What do you want to do?" she asked him softly.

"I want to take the middle path, but they discouraged my choice."

"Defy them," she said tenderly.

"Defy them?" he asked in amazement, for the idea had never occurred to him to question what "they" said or did.

"There will be more game and water than you can use," she said assuredly.

"How do you know?" he asked.

"I challenged them. I walked through the brambles and felt the pain they would not allow for themselves. I defied them and learned not to hear their taunting remarks about me. The Great Spirit guided my steps."

"What did you find?" he asked, curious, but now more accepting.

"I found game, and water, and horses, and clay to make bowls, and roots for making paints. And I found peace from their ridiculing remarks about my choice. I found an abundance of gifts from our Earth Mother."

"Why did you come back?"

"The Great Mystery guided me back so I could tell others who ask me which path to take."

"Is the middle path the one to take?" he asked her, more peacefully now.

"If you honor the Inner Mystery within you, then it is."

A new understanding touched his heart. "I thank you, Grandmother. May I enter for your blessing and to see your face?"

"If you choose to," she said gently.

He opened the door flap, and was surprised to find that his young wife had disguised her voice and was the old woman in the sacred lodge.

The Best Revenge

"The best revenge for anyone or anything that ever abused, devalued, neglected, disrespected, or shamed us or our artistic efforts is to live a healthful, peaceful life that expresses exactly who we are by our personal creative choices."

—LINDA COONS

Balancing Discipline
and Spontaneity

Much of our art is created through our ability to be spontaneous—to allow ideas to play in our minds. We encourage the evolution of our art as only we each can with our unique collection of experiences, choices, and possibilities as we see them.

Sometimes we need to let go of traditional discipline concepts and preconceived notions of the results, and listen to our feelings and instincts. Other times we need to employ the time-tested methods and materials of discipline. We may choose to learn techniques, uses of tools, lessons, and principles that serve as a foundation for other efforts.

Perhaps it is an art form to learn to balance these two ideals and have them work harmoniously in our artistic expression. Only we can define how much discipline or spontaneity any undertaking will require at any given time. We learn by trial and error to give expression to discipline and spontaneity in amounts that work well for us in any given moment of our lives and our art.

❖ ❖ ❖

Guide me, God, to seek balance in discipline and spontaneity in my life and my creative works. Thank you for giving me these two gifts.

Embracing Gentleness

Some artists may have schedules that discourage peaceful living. We wake up hastily, rush into our days, work all day, and fall asleep exhausted. We allow no time for feelings, and little time for playful relaxation or spontaneous creative expression. We may or may not identify ourselves as workaholics.

In artistic recovery many of us learn strategies to take care of ourselves by slowing down our pace. We get adequate sleep, waking up gently by allowing time for prayer and meditation and daily affirmations early in the day. We schedule periods of rest, even a few moments, to check in with our feelings. Some may schedule time for prayer and meditation and healthful self-care throughout the day.

We find that our energy level is more balanced and we are able to approach necessary undertakings with a more peaceful and open attitude. We bring our gentleness with us.

Some of us learn to go to sleep with gentleness as well. We journal about our day, meditate and pray, perhaps read daily affirmations, and gently drift off to sleep. We learn to embrace gentleness and trust that God will handle all the things we cannot or choose not to do ourselves.

❖ ❖ ❖

God, help me to embrace gentleness in my life and my art. Thank you for the gift of peacefulness, even if only for short periods of time. I trust that the peacefulness will grow within me as I continue learning and using the skills and strategies of self-care. Thanks for caring.

Days of Special Remembrance

FEBRUARY

Replacing Negative with Positive

In artistic recovery we learn healthful skills and strategies to replace negative, self-defeating thoughts and behaviors with positive, self-enhancing ones. Whenever possible we practice these strategies until they become our honest, spontaneous responses.

We learn to believe "I can do it" rather than "I can't." We tell the truth instead of a lie. We become open to healthful experimentation rather than using manipulation. We express gratitude for what we have rather than feeling resentful of what we don't have. We ask God or others for help when we honestly need it, rather than thinking we can do everything ourselves.

We plant flowers where weeds once grew—some of us figuratively, others literally. We use our gifts rather than wallowing in depressive thoughts. We learn to choose hope over despair. We sincerely compliment someone or his art rather than diminish or criticize him or his art.

Some of us cultivate the art of accepting gifts from God, no matter how small, rather than denying them. We learn to give ourselves healthful treats rather than deprive ourselves. We recognize and explore the variety of choices available to us rather than narrowing our options by controlling or manipulating. We choose to be around people who support our growth and our art over people who have negative or narrow expectations of us or our art. We learn to feel our feelings and listen to them rather than denying that they exist. We pay attention to our instincts, including our artistic inspirations, rather than drowning them with addictive behaviors or sub-

stances. We learn to laugh at our mistakes instead of judging ourselves harshly.

❖ ❖ ❖

God, help me to learn skills and strategies to replace negative, self-defeating behaviors and thoughts with positive, self-enhancing ones. Thank you for your help in this effort.

"At Once Both Grieve and Love"

From the Song "I Saw My Lady Weep,"
Written by John Dowland in the 1600s

In artistic recovery, we do a lot of letting go. Letting go is a grieving process in which we are actually housecleaning our souls of feelings we have worked through to acceptance. Some may refer to it as "cleaning up the wreckage of the past."

We mourn old hurts, relationships that were abusive to us or our artistic efforts, artistic endeavors that didn't work out as we had expected, other losses. We mourn and let go of them so that we can move on in our lives with a more open and receptive attitude that encourages creative expression.

Mourning can be a painful process. We can love ourselves through it, however. It is possible to feel more than one feeling at a time. We can allow ourselves to grieve knowing that our loving Higher Power is with us.

Many artists discover, with experience, that our Higher Power replaces the things we become willing to let go of with something better. We find that the more we become willing to let go, the more gifts we get. Some of us discover that as we become honest about our grieving, we open ourselves to more and more love and gifts from our Higher Power. Some of them guide us directly to our art.

❖ ❖ ❖

I am grateful to know that I can love myself through my times of grief. I am also grateful for the awareness that grieving may be a part of the process of opening my creative channels to receiving gifts and love from my Higher Power.

Letting Go of Relationships
That No Longer Work

As we grow in spirituality and creative open-mindedness, we may find that some relationships no longer work for us as they once did. Some of us find that people and systems with whom we once shared common bonds now feel abusive, un-supportive, or unaccepting of who we are becoming. We may have outgrown them.

With time and experience we learn that we cannot be all things to all people. When we attempt to do this, we discover, we end up feeling powerless over our own lives and our art. Some say that we feel like nothing to ourselves when we try to be everything to everybody else.

Many of us discover that in letting go of relationships that no longer work in our best interests, we often create space for better ones. Our Higher Power guides us in myste-rious ways to new relationships that offer more of what we need than the ones we let go of had available to us.

❖ ❖ ❖

Today, I will meditate on the idea that letting go of some peo-ple who feel abusive to me and my art might make room for oth-ers who may be accepting of me exactly as I am.

Money Issues

In recovery we may need to examine our feelings concerning money. We might ask: What does money mean to me? Is it power? Does it make me feel good if I have more, bad if I have less? Do I think I am a better person if I give to charity, or family, or systems, or pay bills for others who are capable? Do I believe I have to give money or my art to someone or an organization for their purposes that may not agree with my own values?

If I receive money, do I feel guilty? we might ask. Do I feel like I don't deserve it? Am I being shamed into giving money to a person or organization when I may need the money to take care of myself or my art more than to take care of others' needs?

Just like other areas of our lives, we may need to find a healthful balance in our attitudes about money. Money is not power. We may need to set healthful boundaries with people or organizations to claim our personal financial power.

Some of us may need to learn that we have a choice about giving and receiving money. We do not need to feel ashamed if we earn or deserve the money we've been given even if others are envious of what we have. We can allow their feelings to belong to them by respecting boundaries.

With time and experience we learn to say yes and no to money issues based on our own healthful choices, likes and dislikes, and needs. We learn to set financial boundaries in God's own time.

FEBRUARY

❖ ❖ ❖

I am grateful for the awareness that I may need to examine my feelings about money. I can consider, today, whether my art suffers because of my unexamined attitudes concerning money.

Taking Care of Myself
and My Art

Some artists discover a connection between our feelings of depression and our art. When we start to feel down on ourselves, or negative thoughts enter our minds, we often find that we have been depriving ourselves of something creative we may want to express. Perhaps we've had an inspiration we want to explore, or need time to work on a project, or there are supplies of which we have been depriving ourselves, sometimes in favor of meeting others' needs.

Many artists discover that one strategy for growing through our depressive tendencies is to get honest with ourselves concerning our personal and artistic needs. Sometimes we have only a vague notion of what we want or need. Some of us may not feel deserving of what we honestly want or want to create. We may have old shame issues surrounding our honest artistic desires.

Some artists find that by journaling our thoughts and feelings, we are often led to pinpointing what we need to take care of—ourselves and our art. By clearly identifying our needs, we move toward becoming responsible for meeting them. Our artist's needs can sometimes be met simply by doing a project that interests us and involves minimal effort. Sometimes we need only to jot down an idea for a future effort. Sometimes we need to pray about an idea and let go of it until God's time is right for the next step.

FEBRUARY

❖ ❖ ❖

O Great Creator, please teach me the many ways I can learn to take care of myself and my art. I trust that you will guide me and that I am capable of learning the lessons.

Joyride

To many of us a joyride in our youth meant driving a car recklessly—with wild abandon. Let's hope we no longer drive our cars in that irresponsible manner. Some of us, however, come to see our lives as a joyride. We become grateful for the spiritual gift of joy. Our journeys, in artistic recovery, become much lighter when we make the personal connection to trust our loving and creative Higher Power.

We like to have fun, laugh, watch comedies, dance, sing, make noises, create. We become grateful to find people who are spontaneously witty, creative, and very much alive. They replace those we learn to let go of who are addicted to misery, or substances, or others.

Some artists find that we do not allow those who want to control our joyride much space or time in our lives. We simply do not stay around them. We want to be around people who encourage us to make our own choices, who support our artistic efforts, who accept us exactly as we are. Or sometimes we may choose to be alone.

With time, we learn to allow those who want to be on a misery ride to do it—but without us. We learn that we cannot change them. They may be threatened by our joyride and try to entice us to join their misery ride. We can choose not to go. Our joyride is much more fun, we find. You see, God is driving now. We may not know where we are going, but we trust that it will be good and joyful.

FEBRUARY

❖ ❖ ❖

Thank you, God, for inviting me on this joyride with you. I am grateful that my journey has led me to feel this gift of joy. If I am new to recovery, I can hope that, with time and effort, I may be able to feel the joy others know.

Timing in Recovery

Many artists become aware of and learn to accept that their lives and their art unfold and evolve in God's own time. Some of us may have spent a great deal of time worrying, perhaps manipulating, impatiently trying to change or control things or people so that the outcome would be according to our schedule. We felt anxious throughout the process.

In recovery we may become aware that our anxiety is actually created by our nonacceptance of God's timing. If we become willing to let go of our expectations about timing, and allow our lives and art to unfold as they will in God's own time, many of us discover that we let go of our anxiety, as well. We open ourselves to the serenity that is the gift of "accepting the things we cannot change." We learn to allow our lives and art to evolve gently.

Some artists discover that often God's plans and timing are better than our own. By allowing our lives to unfold without our interference (worry, manipulation, or attempts to control), we and our art often evolve more satisfactorily. With time and patience, many of our creations evolve much better and more freely than if we rush anxiously and try to control their completion.

Timing is everything, some of us believe. God's timing is awesome, many of us learn to trust.

❖ ❖ ❖

It is possible to learn that God's timing is a spiritual gift that, properly used, can enhance my creativity and guide me to feeling peaceful about my efforts. I will open myself to trusting in God's timing.

One Artist's Prayer

O Great Creator,

I am here by your gift of life that I may serve you and your highest purpose for my life. I ask for your guidance on my journey; for your inspiration in my creativity; for you to open my mind to greater ideas each day. I ask you to help me to accept myself as an artist.

I am grateful for each gift and talent you give to me, no matter how small or large it may seem. Thank you. Teach me to use each one to its best purpose.

I believe that you are always within me to guide me, and that I can trust following your lead as you unfold my life according to your plan of goodness for me and my art.

Help me to strive for health by eating healthful foods, by exercising, by getting proper rest, by expressing my feelings and my gifts, and by thinking positive and loving thoughts about myself, my art, and others.

I ask you also to help me to strive for balance without being too submissive or too demanding; for balance between expecting too much and expecting too little from myself, my art, and others; for that sensitive balance between spontaneity and discipline in my creative endeavors. Above all, help me to feel gratitude to you. Thanks for caring.

Role Models in Recovery

Support groups and therapy may offer us a gift of people from whom we can learn lessons of healthful role modeling. As we listen openly to others when they share, we can find examples of how to respond to situations. We can learn skills and strategies from others' examples of solving problems. We can learn to take positive risks based on the experience, strength, and hope others are willing to share. We can grow into new healthier attitudes about our lives and our art. Some artists gain a new expanded perspective on what is possible by modeling others' behaviors.

We may learn to identify our own feelings as others share theirs. Sometimes, by watching others, we get in touch with feelings we may have been denying. We may discover strengths and interests we didn't know we had. We open our souls to awareness. We may choose to grow from others' examples.

Sometimes in artists' support groups, we might identify with a new art form we'd like to try. We might experiment with paints or poetry, music or dance, or lots of other art forms. We might try a hairstyle we like, or lose weight because we admire someone else's figure. We might follow the example of others who made healthful decisions to let go of self-sabotaging habits like smoking or drinking, or others, and invest our efforts in our art instead.

Others may identify with our feelings as we share who we are, as well. They may model how we dealt with a situation or an artistic discouragement or accomplishment. When we share, all we need to do is be who we are. If healthful boundaries are set and respected, role models can provide a gift for

personal and artistic growth. We give back to the collective body of those who gave to us. It is how the recovery program works.

❖ ❖ ❖

I can learn to listen to and share feelings in my support group or therapy. I can learn to respect my own and others' boundaries as a healthful strategy for awareness. I am grateful for the gift of healthful role models in my life.

Deprivation Thinking

If we have felt deprived of something—physical things like appropriate clothing, food, healthful care, money, or resources to get what we need to take care of ourselves and our art; or emotional and spiritual things like love, acceptance of who we are, support for our artistic efforts, or other things—we can easily get caught in what is known as deprivation thinking. We may feel deprived in our souls. We may have learned to continue to deny ourselves these things, which might otherwise bring joy or improved quality to our lives.

Our minds may perceive these deprivations, this lack of things or feelings, as permanent. We may believe that, because we have not gotten what we want and need, we don't deserve to have it. We can feel like God's forgotten children. Some of us may get caught in a self-pitying and victimization role, which we may have accepted as reality. We might forget that God can often "grant us the courage to change the things we can."

We can consciously choose to examine our choices and learn healthful skills, strategies, and attitudes to change for the higher good. By putting them to work for us, we can learn to let go of the deprivation thinking that has discouraged and limited our concept of who we are and what is possible in our lives and our art. We can change the attitude in our souls, if we are willing to do the necessary work of recovery.

FEBRUARY

❖ ❖ ❖

Today, I will examine whether I can change things of which I have previously felt deprived, or have denied to myself. I will seek guidance for letting go of my deprivation thinking.

And Yet Have Believed

Blessed are they that have not yet seen, and yet have believed.

—JOHN 20:29
KING JAMES VERSION

Who We Are Matters to God

Some artists in recovery share that as children they felt as if they didn't matter, or as if they were a bother to those around them, or that they felt lost in crowds. Many of us become aware that these messages may have a powerful impact on our self-image, even into adulthood. Our sense of creativity may become discouraged through old messages like these. If we felt discouraging messages, we can work through our old feelings. We can grow to believe that we matter to God, that we have a personal relationship with our Higher Power, and that in crowds our spiritual light can shine as brightly as when we are alone.

In working on our spirituality, we can learn to feel a personal bond with our Higher Power. Some of us come to feel we have been given many gifts just for being exactly who we are, even if we may be different from others around us. We trust that we are always guided by God, so that if we create something and it is healthful and respectful, it is okay, despite others' opinions of our creative choices.

Our art may be seen by some as our own expression of the spiritual guidance we feel from our Higher Power. It matters a great deal to God that we be exactly the person we are meant to be. Our gift back to God is that we each be our most creative self.

❖ ❖ ❖

Thank you, God, for the feeling that I matter to you. It is a mutual feeling. You matter to me, and I am grateful for your presence in my life.

Fear of Change

We may need to become aware of subtle distractions that may hinder our artistic growth if we allow them to. Some artists believe that our ideas of change are related to our expectations. We may have expectations of ourselves and our art. We might find that we live up to or down to those expectations.

We might expect our lives and our art to unfold in a certain predictable way. The truth is that, sometimes it will, sometimes it won't. Some of us find that if we let go of our expectations, our art often turns out much better than our previously held expectations.

Other people's expectations may have an impact on our self-image as well. We may live up to or down to others' expectations of ourselves and our art. Sometimes we do this at the expense of our own greater expectations or of creating our art as we honestly feel it.

It is possible to learn to get in touch with the feelings we associate with our expectations. Many artists learn to feel the fear, anger, hurt, guilt, or other feelings we may have been denying. Then, as we choose to let go of them, we open ourselves to changing our self-image to one based not on limited or discouraging expectations, but on trusting in the highest good for our lives and our art. We can begin to live our lives honestly, not because we are afraid to change, but because it is how we choose to live, despite what others expect of us.

We can learn to set healthful boundaries and balance our lives by choosing to be around people whose expectation for us is that we be who we are. We can let go of fear of change

and embrace our spirituality by trusting that God is leading
us even through sometimes troubling changes.

❖ ❖ ❖

*Today, I will be aware of expectations from myself and oth-
ers. I will be alert for signs of fear of change in myself.*

Identifying Ourselves
by Our Creative Gifts

Some of us may have learned to identify ourselves by our shortcomings. We may have been in support groups that emphasize our getting honest with the addictions that have had a profound impact on our lives. This is an important step in the spiritual and artistic growth of many artists.

Another important step many of us take is to let go of emphasizing our shortcomings and open ourselves to embracing our gifts. For many of us, this is more threatening than owning up to our shortcomings. We may have learned to deny or downplay our gifts just as we once did our shortcomings. We may have been around others who have persistently pinpointed our shortcomings and paid little or no attention to the things we did well or creatively. In order to become spiritually whole, many of us believe, we need to embrace every aspect of who we are, including our creative gifts and talents.

Some of us may find that it is difficult to develop the healthful perspective that places emphasis on our gifts. The process of shifting our focus to our gifts may be painful. There may seem to be fewer people who identify themselves by their gifts on whom we can model new behavior. We may feel abandoned by the majority. Many of us work through these feelings and find the effort to be worthwhile. We discover that the more we let go of, the more clear we become in making creative choices that identify ourselves as the creative people we truly are.

FEBRUARY

❖ ❖ ❖

God, I am grateful for the awareness that I can grow to accept myself as an artist. I can learn to trust that, in shifting my attention to my gifts and talents, my shortcomings will find their own perspective in my life.

Reprogramming

The process of recovery might be envisioned as being similar to the reprogramming of a computer. The computer can put out only information that is put into it.

Similarly, all of us were programmed earlier in our lives to think, feel, and behave in certain ways. Many of these ways may inadvertently have led us to discourage our thinking of ourselves as artists. We may have been programmed by our role models to think, feel, and behave to please others. We may have been taught to deny our true feelings, including our creative inspirations, rather than express them. We may have been programmed to take care of others who are capable at the expense of taking care of ourselves and our art.

In artistic recovery, we can open ourselves to the healthful reprogramming of our souls. We learn the sometimes painful lessons of our limiting programming and thinking. We work through the pain to the reprogramming stage. Then, using positive affirmations, prayer and meditation, journaling, setting limits and respecting boundaries, reading and incorporating recovery information, using the gift of awareness, and other skills and strategies available in recovery, we go on to reprogram ourselves. We educate ourselves to integrate all our gifts, often joyfully, in ways that are unique to us as individuals.

FEBRUARY

❖ ❖ ❖

If I am new to recovery, I will trust that the process of my healthful reprogramming will, in time, guide me to peaceful feelings about myself and my art. If I am currently reprogramming or have been reprogrammed, I will express my gratitude to my Higher Power by creating my art joyfully and willingly.

Pricing Our Art

Many artists struggle with the issue of determining the monetary value of our artistic efforts. Perhaps the pricing of our art is an art form in itself. Maybe it requires its own skills and awareness. Like everything else in the healthful lifestyle to which we aspire in artistic recovery, pricing our art needs to be balanced, too.

We do not want to price our works too high. This could be a sign that we are unwilling to let go of our art. It may indicate a self-sabotaging attitude. "If my art doesn't sell, I guess I'm not an artist, after all" may be the subconscious message behind pricing too high. Then we may validate our continued thinking of ourselves and our art in negative terms.

On the other hand, if we want to make our living from our art, we do not want to underprice it. We have labored diligently, willingly learned the skills of our individual gifts, paid the emotional price required in thinking of ourselves as artists, and earned whatever is determined as a fair price for our art. Perhaps if a formula exists for determining exact market value of our individual art, we each need to find what it is for ourselves.

Since our art is a gift from God, some of us learn that if we pray for guidance, the answers we receive intuitively serve as directions. We can learn to trust our instincts and spiritual guidance about pricing our art, as with so many other areas of our creativity.

FEBRUARY

❖ ❖ ❖

God, please help me to determine a fair market value for my art. Help me to have faith that you will guide me to lessons I need about pricing my art.

Mysterious Ways God Works

A Personal Sharing by the Author, Linda Coons

As I work on my recovery, I am continually amazed at the mysterious ways I see and feel my Higher Power working for me and my art. When I discover a need in a relationship or creative endeavor, I've learned to pray about it. Then I wait patiently. In God's own time (sometimes quicker, sometimes longer than my own expectations), I discover the idea, the words, the supplies, or the direction I was seeking. The answers arrive almost always to my pleasant surprise.

Sometimes I get things I did not even consciously ask for—like this book. In turning my will completely over to the God of my understanding, I had no idea that I would be guided to write a book that could serve to guide artists to their own unique creative spirits. Surprise! It is what I believe God wants me to do, and I am willing to follow God's lead as I feel it. I find it to be wonderfully mysterious.

I've come to be grateful for the mysteriousness of God's ways. It keeps my life interesting. I can hardly wait to see where I'll be guided next. I do not pretend to know what God's will is for me in the future. I have faith, however, that it will be good.

❖ ❖ ❖

God, I am grateful for the mysterious ways you work. I ask you to guide me to keep my mind and my attitude open to your mysterious ways. Teach me to become willing to receive the gifts you offer me in my artistic recovery and in my life. Thanks for caring.

Lessons from Failures

In artistic recovery we can gain a new perspective on what we once may have called failures. They are not necessarily bad. By trying and not getting the results we sought, we can often learn important lessons.

We may learn what not to do again. We may learn where not to go again. We may learn whom not to ask again. We may learn lessons of trust. There may be lessons of instinct to learn.

We may not always recognize it, but the lessons we learn from what we perceive as our failures are building our character, too. We are gaining life experience. Our Higher Power guides us to where we're going in mysterious ways. Sometimes, when we perceive an artistic effort as a failure or an art disaster, we are being prepared for something better. We may only recognize later, when we've let go of thinking of our efforts as a failure, that we were in the process of preparation for the next step in our growth.

We can learn to accept each attempt of our art for what it is, not as good or bad, success or failure, but as our best effort in the moment. We can trust that God will use it to the highest good.

❖ ❖ ❖

God, help me to accept each of my attempts as useful efforts on the pathway to my highest good. I am grateful for each lesson on my journey, even the painful ones. I trust that you are guiding my artistic path.

Recognizing Shame

In recovery, we can learn to recognize shame for what it is—a controlling mechanism. Others may have taught us their shame by controlling us, rather than giving or allowing us choices. We may have come to feel shameful about ourselves and our art because of discouraging behaviors others modeled for us.

We can learn to recognize shame and learn skills and strategies that will healthfully detach us from others' "shame game." We can learn instead to feel positive, by choice, about ourselves and our art.

Some artists may compare shame with brainwashing our feelings. Others have imposed their feelings, opinions, and beliefs on us about who we are or what our art should be because we haven't learned healthful lessons of asserting our own choices. Until we learn and come to believe in our souls that we have a choice about accepting others' values, or setting healthful boundaries that allow others to own their feelings, opinions, and beliefs, we may feel a lot of shame.

When we learn to perceive shame and set and maintain our boundaries, we can become empowered to allow the shame to belong to others with whose feelings we may disagree. We can detach from those who want to control us for their purposes and seek to be around those who want to nurture, love, and accept us and our art exactly as we are.

FEBRUARY

❖ ❖ ❖

Today, I will watch for and become aware of signs of shame in my life. I will consider whether I may need to examine my boundaries to nurture myself and my art.

Setting Limits

There is a recovery strategy we can learn and practice that can lead us to own quality time for ourselves and our art. It is setting limits.

We each have the God-given power to choose how we'll spend each moment of our days and, in fact, our lives. Many of us, however, have learned to give away our time, skills, and energy so we would feel liked or accepted by others.

Some of us continue giving ourselves away until we feel depressed or angry that there is no time for the things we want to do for pleasure or creative expression. We give, unceasingly, hoping for a small amount of time or energy for ourselves.

When we learn the healthful strategy of setting limits, our lives can change for the better. We learn to say no to requests from those who are capable of undermining our own needs. We limit the time, energy, money, love, or anything else that is ours, to the boundaries we determine by our honest choices. We trust the answers we hear from our Higher Power for guidance, and honor them as guidelines. We choose limits that encourage peace, balance, and self-acceptance for ourselves and our art.

❖ ❖ ❖

The recovery strategy of setting limits is one I can learn and practice so that I have the time, energy, supplies, etc., I need for my artistic expression.

Choices and Art

If creating our art is about making choices, can our lives be any less than an art form? Every day we make choices that help to determine the quality of our lives—what we eat, where we go, with whom and how we choose to spend our time, how we dress, what and how we create, and many more. Are not our lives and our art intertwined?

If we choose to eat healthful foods, the results will be physically tangible. If we choose to say no to unhealthy drugs, substances, or behaviors, there will be positive consequences in our lives. If we choose to establish and maintain healthful and honest relationships, we become free to express our art as we imagine and feel it.

Each healthful choice we make helps to establish our creative boundaries. By saying no to things we don't want, and yes to things we do want, we are defining and creating who we are. By making healthful choices, we can create the best self we know.

❖ ❖ ❖

The choices I make reflect who I am, or perhaps want to be. Today, I will meditate on the idea of choices for my life and my artistic expression.

ABCs of Artistic Recovery

Here is a simple checklist we can review when we feel discouraged or down on ourselves or our art:

A. What is my ATTITUDE? Am I trying to do too much; be something I am not; be all things to all people so others will like me or my art; be nice, rather than being honest about my feelings? Do I feel good enough, capable, competent, and creative in my choices, worthy to be called artist? If not, I may need an attitude adjustment.

B. How are my BOUNDARIES? Am I caregiving someone else who is capable, at the expense of taking care of myself or my art? Am I permitting someone to invade my boundaries when I need space, support, or solitude to be exactly who I am? Can I say yes or no as I feel the need, to take care of myself and my art? Are my boundaries out of balance? What skills and strategies can I use to take care of myself and my art?

C. Do I feel a CONNECTION to a power greater than myself? Am I willing to trust that "this, too, shall pass"? Do I believe that, with faith in my Higher Power, I can be restored to the balance of peace and calmness in which I'll be guided, in my Higher Power's own time, to my creative self? If not, do I need to stop what I am doing, calm myself, and pray and meditate?

If we can remember attitude, boundaries, and connection, we may be able to work through our slumps. Sometimes we may only need a quick review of the ABCs to spot what we need to change. Other times we may find help in journaling about our feelings, sharing in support groups, or seeking therapy on an issue.

FEBRUARY

❖ ❖ ❖

When I feel discouraged I will review the ABCs. I will consider if I need to make changes to take care of myself and my art.

Developing Trust in Our Instincts

Our instincts are a spiritual gift that can guide our lives. Many of us have been taught not to trust them. We may have been shamed into believing that what we feel is not acceptable. We may have learned not to trust our honest feelings.

With time and experience, many artists learn to trust our instincts. Courage and faith in ourselves are the necessary beginning of listening to our instincts. We may make attempts honestly, and others may shame us for our efforts. We may try again and feel guilty. We can learn to trust that our Higher Power is guiding us as we work through these feelings. As we attempt our art more often and succeed, we will learn that our instincts are ours. Our boundaries will teach us when the feelings are our own, and when the shaming and guilt belong to others.

Our instincts and our Higher Power can guide our artistic efforts if we open ourselves to become willingly guided. We might ask ourselves: What feels good when I am creating? Where do my gifts lead me? Is there a creative dream or goal I can honestly act upon? What do my healthful impulses want to reveal to me? Learning to trust our instincts can lead us to our creative selves. We can become free to become who we honestly are.

❖ ❖ ❖

I am becoming strong and courageous enough to risk trusting my healthful instincts for my life and my artistic expression.

Backsliding

Sometimes, even when we seem to be working on a faithful artistic recovery program, we may discover that we have been backsliding. We may have retreated to some of our old familiar self-defeating behaviors.

Some of us, for example, may discover that we have returned to our old "work to exhaustion" behaviors, though it seldom feels like it until we are near exhaustion. Many artists learn to stop where we are, reevaluate the urgency of what we are doing, and consciously repace ourselves. We may find balance by thoroughly resting and by recognizing that we are doing the pushing ourselves from old habits that work against our best interests. It is not someone outside of us forcing the pace. We learn to take care of ourselves by slowing down.

We can learn not to judge ourselves harshly or wallow in guilt for these lapses back to old patterns of behavior. They are part of the lesson package our Higher Power has designed uniquely for us. We can find our way back to the balance of peace, where we allow ourselves to create in God's own time. Some of us learn that God's time is a much gentler pace than our own. We allow ourselves to receive this gift of a gentler pace.

❖ ❖ ❖

Thank you, God, for the awareness that backsliding may happen as part of my recovery. I ask you to gently remind me that the balance of peace is a choice I can make and work toward when I recognize that I have retreated to my old self-defeating behaviors.

Attitude of Experimentation

Some of us have learned limiting lessons concerning experimenting with our relationships, our environment, or our art. We may mistakenly believe that life has to be just the way we have been taught it should be. We are closed to changes and considering other possibilities, even if they may actually improve the quality of our lives.

As we learn to explore our honest feelings in recovery, we may find that more possibilities come into our awareness than we ever imagined. We make the personal connection to a loving God and discover that choices appear in our lives and our art that were nowhere in our awareness before we made that connection. We are opening ourselves to love and healthful experimentation.

We continue our recovery by maintaining our personal connection with God through prayer and meditation. Sometimes we feel guided to experiment with new styles in our chosen art form. Sometimes we try new art forms and happily discover that we have a new God-given talent in a previously unexamined area. We learn to become grateful for our attitude of experimentation.

❖ ❖ ❖

Today, I will consider my ideas about experimentation. I will examine ways I might enrich my life, my relationships, and my art by creatively using healthful experimentation.

Some Things Are God's Business

Perhaps it is impossible for us to understand absolutely everything in our quest for spiritual awareness. We may feel glimpses of understanding the unique mysteries of who we are and what our art involves. We may express these glimpses of ourselves in our art. Our art expresses who we are in the moment.

As we continue to explore and express ourselves, we may discover more questions than answers. Some artists in recovery learn that unanswered questions are not roadblocks, but road signs. We learn that we have a choice of paths to take, each path or choice offering alternatives; perhaps none right or wrong, each only different from the other. It is a matter of choosing how we see ourselves and our situation in the moment.

Many recovering artists learn to turn a lot of things we previously worried about and agonized over to God's care. We allow God to take care of God's business. We find that in exchange we get a lot more time to just be who we are—creative children of God who express who we are by using our gifts.

❖ ❖ ❖

God, just for today, please teach me to take care of my own artistic business. Help me to trust that you will manage everything that I cannot handle myself.

Accepting Compliments

As children, many of us were taught to say a polite "thank you" when someone gave us a gift. Some of us may not have learned to consider a compliment as a gift. When someone says she likes something about us—a positive quality, choice of clothing, or our expression of our art, for example—we may brush off the compliment. We might say that we could do better, or it really wasn't hard, or it's not as good as someone else's.

It is possible to encourage ourselves by receiving the positive feedback others offer to us as gifts. We can learn to say "thank you" as clearly and directly as possible. This will help us to affirm ourselves as the artists we are striving to be. It will give a message to the sender that we are serious about our art. He, too, may learn to take our art seriously.

If we catch ourselves discouraging a compliment, or if it feels awkward at first, perhaps the slogan "fake it till you make it" could help until it does feel honest and comfortable. Some of us learn to say "Thank you for that feedback."

❖ ❖ ❖

If I am unaccustomed to the skill of accepting compliments clearly and directly, I will become aware that learning this skill may have a beneficial effect on my artistic attitude.

The Gift of Believing

It takes great faith to believe in our artistic ideas. Often, as artists, we strive to bring ideas to life that we see only in our imaginations. Sometimes we envision them clearly, sometimes only vaguely. But they do not exist in reality.

It is a labor of love to believe that our ideas can come to life and exist in reality. By asking for Divine Guidance and assistance, many artists believe, we open ourselves and our gift of believing to employing our spiritual selves as well as our physical and mental selves.

Our artistic endeavors may begin with our believing in the possibility of their expression. With the help of spiritual assistance, we open channels for our creativity to express itself. Projects, many artists find, take on a life of their own if we remain open-minded with faith that they will evolve according to God's will, God's way, and in God's time. Sometimes we are pleasantly surprised that the results are even better than we had imagined. Our faith has served to expand our possibilities.

❖ ❖ ❖

I can become willing to believe that my healthful artistic ideas are possible to achieve. I trust in the possibility that my Higher Power will encourage my creativity to express itself fully when the time is right.

Leap of Faith

Sometimes our recovery progresses slowly with little evidence that we are feeling better about ourselves or our art. Other times we take a giant leap of faith and let go of a lot of discouraging issues at one time.

Whichever method our Higher Power chooses for us, we can learn to trust that it is all going as planned. We learn that the pace is gauged precisely for us so that we are neither overwhelmed nor understimulated.

We keep plugging away at our art, sometimes feeling neglected spiritually and other times feeling bathed in the grace of our Higher Power's creative light. It is all a part of God's will, many artists come to accept. We learn to trust the process, no matter what the process is in the moment.

❖ ❖ ❖

Today, I will trust that my Higher Power is guiding my artistic recovery and that it is progressing at the perfect pace for me.

Days of Special Remembrance

Days of Special Remembrance

MARCH

Finding Healthful Levels of Involvement

Some of us may need to examine the issue of finding healthful levels of involvement in our work, our relationships, systems in which we participate, and our art. Each of us needs to explore and discover how much we are honestly willing to commit to the various areas of our lives needing attention.

If we do not commit enough, we may miss out on the positive benefits some involvements might bring to our lives. Conversely, overinvolvement in some areas of our lives can leave us without the resources—time, energy, money, etc.— we may want to invest in other areas of interest, such as our art.

As we learn to honestly examine the levels of involvement we are seeking, we may find the skills and strategies available in recovery, such as boundary work, limit setting, trusting our instincts, and others, to be beneficial. Using these techniques, many artists are guided to the levels we feel appropriate and peaceful for the expression of ourselves and our art.

❖ ❖ ❖

The healthful levels of involvement I am seeking are available to me. I can use recovery skills and strategies to gently and patiently work toward them.

Creating Our Own Choices

As we grow in spirituality and learn to trust our unique inner voice, we become open to envisioning more choices available to us. By letting go of limiting beliefs and discouraging attitudes, we encourage creative thinking. We expand our awareness to more and more possibilities. We learn to trust in a capacity that is greater than our current reality.

For some artists, creating choices becomes a way of expressing ourselves. We may be around others with limited concepts of reality. They may have a need for us to fit their expectations of who we should be or what or how our art should be expressed. We can learn to set creative boundaries that respect both who we are and respect others' boundaries as well.

We can open ourselves to fresh awareness, new variations of old or traditional themes, inventive applications of ideas as we feel them, and openly combining our choices to best express ourselves healthfully.

❖ ❖ ❖

Today, I will watch for healthful opportunities to create my own choices. I will give attention to the unique healthful inner voice inside me and trust following its lead while respecting my own and others' boundaries.

Going with the Flow

We may have learned that in order to succeed in life we have to work hard, struggle, and tackle difficult obstacles and goals. This strategy may work for us sometimes. The words that might lead to emotional problems are "have to."

We may not have learned that we have a choice. In order to become full and balanced human beings, we may need to learn to balance our hard work with play, with being spontaneous, with enjoying life and not struggling every minute, with going with the flow rather than battling the currents all the time. We may need to open ourselves to choices that encourage bringing pleasure to our lives.

We can learn to allow our lives and our art to evolve in God's own time and way by letting go of our "have tos" and accepting reality. The reality is that we have a choice. Many of us simply haven't learned that we do.

We can learn to play more, to laugh at our own "have tos," and replace them with acceptance of God's will for our lives and our art. When we do, many artists open ourselves to the valuable gifts of peace and acceptance. We let go of the anxiety caused by our "have to" attitude.

❖ ❖ ❖

Please teach me, God, in your way and time to let go of the "have tos" in my life and my art. Show me how they limit my creative thinking and spontaneous expression.

The Fog Will Burn Off

Some of us observe the gloom a foggy morning can bring with it. We may lose hope that the sun will shine. Our spiritual lives can sag. Depression may take over our spirits. We can lose sight of any good we have in our lives, seeing and feeling only negativity.

Artistic recovery can be like the sun shining through the clouds of our despair to burn off the fog of our negativity. Many artists feel the first rays of hope when we surrender our will and our lives to our Higher Power. We learn about the skills and strategies available to us and begin, with faith, to clear up the leftover feelings of our sometimes foggy pasts.

We work through our confusion, sometimes taking new risks and trying on new attitudes. With courage we continue through the fog, and begin to see more and more clearly who we are. In time, the sun shines through and we see, with gratitude to our Higher Power, that we are capable and creative artists with God-given talents to express.

We become ready to create in ways that are uniquely our own. No one else has lived exactly the life we have. Our ideas, experiences, and choices are our gifts. We use them as an act of worship to our Higher Power to express who we are. The fog burns off and we learn to be ourselves, encouraging the sun to shine brightly and freely on us and our art.

❖ ❖ ❖

I ask for your guidance, God, when I feel lost in the fog of negative attitudes about myself and my art. Help me to focus your healing, encouraging light on my creative gifts. Guide me, please, to use my gifts as an act of gratitude for your having entrusted them to me.

Being Hard on Ourselves

Some of us were taught that being hard on ourselves, continually pushing, having no compassion for ourselves or others, and keeping a "stiff upper lip" were necessary attributes for success in life. We were not encouraged to listen to or trust our feelings. Those who taught us these things learned these attitudes from others as the only way to be. They may have worked for others in their lives, but perhaps at the cost of their healthful self-esteem or most creative good.

As recovering artists, our task is to let go of these severe concepts of how life can be and learn to treat ourselves more respectfully. We can educate and nurture the artist within our souls by living life gently and not continually pushing ourselves. We can open ourselves to our healthful and creative feelings. We might free up some time in our schedule for our art, perhaps by saying no to something else we honestly don't want to do that we previously pushed ourselves to do.

We might continue to explore small ways of taking care of ourselves and our art. We might ask: Would a massage help to ease my stress? Can I allow myself a day, or at least a few uninterrupted hours, to read that novel? What supplies or equipment could make my artistic expression work better for me? Would a trip to the florist to buy flowers just for me perk up my spirits?

By treating ourselves with more respect, many artists discover, our self-image improves, our artistic juices flow, and our creative energy awaits being put to use in the unique way each of us is guided by our Higher Power.

❖ ❖ ❖

I can examine my life honestly for areas where I am being hard on myself. The courage waits within me to change my attitude about myself so that my art has a chance to express itself.

Passion for Our Art

Many artists discover that passion for our art serves to out-weigh or diminish our addictive and self-limiting behaviors. We find, in working on our artistic recovery, that the energy we once devoted to our self-defeating behaviors and attitudes becomes available for us to invest in our artistic expression, if we honor our creative choices.

When we learn to honestly define and healthfully pro-mote the gifts and talents to which we feel emotionally drawn, we open creative channels to the intensity of our emo-tions. We encourage passion for our art.

No one can create our art as we can. Our experiences, choices, feelings, and energy are our creative resources. We each combine these and many skills and strategies in ways that are inspired by our Higher Power. It is our combining them all with passion that encourages our creative growth and our self-expression as we feel it.

❖ ❖ ❖

Great Creator, I ask you to guide me, please, to the passion that is possible for me to feel for my art. Show me choices that guide my energy away from my self-defeating behaviors and at-titudes and toward healthful expression of my most creative self.

Giving Ourselves Nurturance

Some of us may have learned that it is selfish and undesirable to do certain things or obtain things we enjoy for our own pleasure. We have picked up self-defeating or shaming behaviors that discourage or deny our art as we feel it. We may have learned from those around us that we should put everyone else's wants and needs ahead of our own, including our artistic needs.

No matter where we are in our recovery, there are lessons we can learn about taking care of ourselves in healthful ways. We learn to nurture ourselves so that our spirit is available for our Higher Power to use in whatever artistic capacity we feel guided.

It is possible for us to unlearn, or let go of, the old lessons and make room in our souls for new ones that will enhance our honest self-esteem. We can learn to balance ourselves emotionally by putting our own needs and wants in a healthful perspective with those of others around us. We can learn not to give away our personal God-given power to make choices. We can make a priority of choosing to obtain the things we need—emotional support, supplies, time, space, quiet, whatever we need—so we can create in a peaceful atmosphere.

✦ ✦ ✦

I can learn to give myself the nurturance I need to be the artist my Higher Power knows is the best I can be.

What Do I Want?

In artistic recovery we learn to stop neglecting ourselves. We've discovered that many old lessons we learned in life no longer work for us: taking care of everyone else at the expensive cost of taking care of ourselves and our art; addictive and compulsive behaviors; denying and discouraging our honest feelings, including that we deserve to create our lives in our own unique ways; attitudes that work against our best artistic and expressive interests, and others.

We begin to see our self-defeating behaviors as things we can change, with courage from our Higher Power. We learn new behaviors like setting boundaries, expressing our feelings, asking for what we want and need, allowing ourselves to receive the goodness we deserve, and being who we are. In turning our will and our lives, including our art, over to the care of God, many of us joyfully find that God wants the best for us and our art.

By asking for, receiving, and using the things we want, we are defining who we uniquely are—capable, competent, and creative children of the Great Creator. We continue growing creatively by learning to express our gratitude by willingly using the gifts we asked for and received.

❖ ❖ ❖

God, please guide me to accept my honest wants and needs as a realistic part of who I am. Teach me to ask for what I want from those around me and by prayer and meditation, trusting in your way and time. Then grant me the patience to wait for my life and my art to unfold according to your will for me.

Detachment and Our Art

Some artists may not know that detachment can be done in healthful ways, by choice. We may leave relationships, jobs, or situations only when they end in anger or by means other than our personal choices. Some of us discover the strategy of detachment as a gift of our efforts in recovery. We learn that we can detach from people and systems as we choose if we feel they are working against our best interest.

We learn that when we are in unhealthy or discouraging relationships or systems, the one who suffers the most is ourself and our creativity. We learn to detach from these systems or relationships to make available the time, space, and energy we need and want for ourselves and our art.

When we feel caught in an unmanageable situation, we might try using our imagination as a skill for gaining a healthful perspective. We might imagine ourselves in a small room filled with everyone and their problems. We can feel the anger and frustration of there not being enough space for ourselves and our art. Then we pray to God to turn our anger into healing, nourishing energy for us and our art.

One by one we assertively give each problem back to whom it belongs, allowing each capable person to assume responsibility for it himself. We feel the joy of having enough space and time for the thing that brings us the most joy— creating our art. When we return to reality, we may choose to make a conscious decision to do what we need to do to make that joy a reality by detaching from relationship or situation issues healthfully as needed.

MARCH

❖ ❖ ❖

I am grateful, God, for the awareness of the strategy of detachment as a healthful choice in my recovery. Please show me how learning and using detachment can work to encourage my artistic expression to the highest good.

Semi-Detachment

The concept of detachment is not necessarily a "black-and-white" idea. There are any number of shades of gray from which we can choose as we define our boundaries involving people, places, and things.

As we grow in our relationships and our expression of our art, our levels of involvement on many issues may change colors any number of times as part of the process of growth. We may sometimes semi-detach; that is, invest less time, effort, emotional energy, or other resources than our previous levels, while remaining connected in the relationship or effort. Or we may decide to detach completely, knowing that we've had enough of what that relationship or effort has brought to our lives. Sometimes we detach completely and may later stay detached, or work our way back emotionally to reattachment or semi-attachment. We may possibly return to an original situation with different attitudes. The combinations and choices of attachment, semi-detachment, and detachment on the canvas of our relationships shape the picture of our lives.

When we encourage ourselves to make honest choices for our lives and our art, we learn to trust our instincts for a balanced level of detaching and attaching in relationships. Some artists may learn by experimenting. We might question ourselves: What feels good to me in relationships? Am I investing too much of myself in some relationships, and not enough in others that matter more to me? What do I need more of to feel balanced, creative, and healthful? What feels abusive? Have I had enough of it? Do I know that I have the

courage inside myself to let go of it by detaching or semi-detaching?

❖ ❖ ❖

God, help me to seek the healthful levels of attachment, semi-detachment, and detachment in all my relationships that will guide me and my art to full expression. Thank you for the awareness that detachment and attachment are choices involving a full spectrum from which I can choose.

Trusting That There Is Enough

Some artists among us may feel that there is not enough of certain things in our lives. Some of us may not even be aware that we feel this void. Perhaps, on a level deep in our souls, we feel there is not enough food, money, ideas, art supplies, love, support, or time to express our art. We may have assimilated messages from old feelings deep in our souls as a result of past experiences. We may have learned to manipulate, control, or abuse ourselves or others to obtain enough of whatever it is we feel there is not enough of to fill that old need.

In artistic recovery many of us learn to identify that "soul need"—that craving. We examine our fears and concerns connected to the need. By exploring our feelings, we come to accept some of our needs and learn healthful ways to go about meeting them. Some needs we willingly turn over to our Higher Power as no longer a reality in our lives. Still others we use to our highest good, perhaps by expressing them through our art.

In turning our will and our lives over to the care of God, we learn to trust that everything we truly need will be provided. We reach a feeling of gratitude and acceptance when we connect with our Higher Power, believing that our needs are and will be met in God's own time and way. We come to trust in our souls that there is enough of everything and that God's will for us and our art provides everything we need to be our most creative selves.

❖ ❖ ❖

I am grateful, today, to feel that there is enough and that all my needs will be met in God's own way and time.

In the Moment

In its simplest terms, it may be said that we live our lives one moment at a time. Yet, some of us choose to invest a great deal of time and effort worrying about what may happen at some future time or trivializing our past mistakes and misfortunes.

If we learn to live life as it unfolds, one moment at a time, in our most creative ways, our lives and our art can evolve to the best advantage. The time and effort we previously invested in worrying and trivializing can become available for us to use productively. Our artistic lives can benefit from the efforts we invest in ourselves to focus on what is occurring in the moment.

One requirement for living in the moment is faith that a power greater than ourselves is guiding our lives and our art. We learn to feel safe and to trust that our pasts brought necessary lessons for our spiritual and creative growth in the present. We trust, too, that our future will unfold peacefully to reveal the highest good.

❖ ❖ ❖

Help me, God, to learn to be my most creative self IN THE MOMENT. I am grateful for the awareness of the choice to live in the moment, and for the possibilities and opportunities my faith may open for me.

Metamorphosis

Lyrics to a Song by Linda Coons

The seasons come. The seasons go.
And if we watch we can see how we grow.
What lies ahead we don't always know.
But change takes place; sometimes fast, sometimes slow.

Some changes require a gamble. Others need a plan.
Some changes simply happen when a woman meets a man.

The changes hurt. We feel the pain.
Some things we lose. Some things we gain.
If we look from the inside out.
We'll see someday it's all worth the doubt.

Just like butterflies we go through phases.
It's all part of the strife.
Change occurs; some doubt it raises.
It's the mystery of life.

As time goes by and as we grow
We'll see the change and then we'll know.
As change takes place, we all run the race.
No one can tell where'll be the finishing place.

Change is part of life.
And so, dear friends, I'll tell you this:
That's how the story goes.
It's all part of the METAMORPHOSIS.

God's Gifts, God's Way, and God's Time

Many artists, with time and experience, arrive at the awareness that much of the anxiety, stress, and frustration we feel is related to our wanting and needing to control people, places, and things. We expect our lives and our art to unfold in a certain well-defined manner, according to our own controlling will and confined expectations.

In artistic recovery we discover that the expectations to which we cling serve only to limit us and our creative potential. When we learn the difficult lesson of letting go of them, we open ourselves to more possibilities than we had previously imagined to be possible.

By letting go of limiting expectations, our spirits become available to perceive many more choices, gifts, feelings, and other experiences from mysterious, often joyful, sources around us. Many of us learn to make choices that encourage the peaceful unfolding of our lives and our art. We become willing to trust in a spiritual direction that is greater than our own.

❖ ❖ ❖

I am grateful, today, that I have chosen to accept each of God's gifts to me. I am grateful, too, for the awareness that it is possible to trust my life and my art to unfold in God's time and God's way.

What's Your Excuse?

There are any number of excuses and rationalizations for not expressing our art. We're too busy, we don't have supplies, we have to take the dog for a walk, we're having a bad-hair day . . . anything will suffice when what we want is an excuse.

Often what is really happening is that we are giving our God-given power discouragingly to our fears. On the surface, we may call it fear of failure—we might not be good enough, others might not like our work, others might feel jealous or envious if we succeed, we might be too old. The truth might be that we are afraid of success.

If we attempt our art—which is our truest, most healthful self-expression—we reveal our souls to the world. We "come out of the closet" of fear and say, "Here I am, world. These are my gifts and this is what I have chosen to do with them." We risk putting our souls out in public. This frightens many of us.

We can learn through artistic recovery work that many artists bear criticism by setting healthful boundaries and allowing others to have their opinions of our art. We learn to respect ourselves and our art enough so that others' opinions do not overwhelm us. We grow by stretching our previously held limits of what is possible, by keeping our minds open to inspiration, by creating as we feel guided by our Higher Power, and by trusting that our art will unfold in its own time and way. We become grateful for every gift we're given. And we create our art and our artistic lives rather than creating and giving our power to excuses.

❖ ❖ ❖

What's my excuse?

Being Different

The ability to think, behave, or create differently than those around us may require courage. Because society's purpose is to mold us, to teach us to conform to what is perceived as normal, artists often feel as if we don't fit in. It is the spiritual price we are asked to pay for being different.

We learn to acknowledge the pain we feel as others attempt to shape us, sometimes using controlling behaviors, into being like the majority. It is okay to feel hurt if our art, ideas, or feelings are judged negatively by others when they are our best effort in the moment. We look inside ourselves for the courage to get beyond that pain and hurt to the emotionally healthful position of acceptance of our efforts and ourselves.

Many of us find that as we begin to accept and respect ourselves and our art, others begin to respect us and our art, too. The timing, of course, is God's own, but respect begins within each of us. Many artists learn that it's okay not to fit in.

We learn to look for healthful support groups, or possibly therapy, for the encouragement we need to work through these feelings. Artists before us have found the courage within themselves to be who they are. They create as only they can. In their uniqueness and successful creative expression, a Higher Power has shown them that being different is not necessarily a negative experience. They keep the light on by sharing their experience, strength, and hope so that we can find the way to be who we are, too. Then we keep the light shining for those who are looking for it. That's how recovery works.

❖ ❖ ❖

Beginning today, I will be grateful to my Higher Power for the courage to think, behave, and create in my own healthful way, even though it may be different from those around me.

Lead, Follow, or Get Out of the Way!

This expression may change in perspective for artists at various stages of our personal growth. We may find ourselves in leadership or following positions and learn many lessons from each experience.

Some of us in our continuing spiritual growth feel more and more guided to choosing to "get out of the way." By getting out of the way of God's will for ourselves and our art, we discover that more choices exist than we had imagined. By not controlling people, places, or things, we learn to "let go of the outcome."

By getting out of the way, we open our attitude to accept the things we cannot change, and encourage our lives and our art to evolve as they will to the highest good, not our limited, controlled expectations.

By getting out of the way and listening artistically, some artists come to feel guided in directions they alone, without their spiritual connection, would never have foreseen. We become directed to expanding possibilities. Some of us learn to listen and choose to follow where we feel guided.

Getting out of the way is a choice we become grateful for. It is one many of us do not recognize until we get into recovery.

❖ ❖ ❖

I am grateful, Great Creator, that you've shown me choices to lead, follow, or get out of the way. I ask you, please, to guide my path toward getting out of your way of goodness for my life and my art more each day.

Capable, Competent, and Creative

Many of us discourage our creative efforts by our own negative thinking. "I can't do it." . . . "I'm too old to try anything new." . . . "Who am I to think I could be creative?" Thoughts like these crowd our minds and control our attitudes, taking on their own life and discouraging our true artistic energy.

We can learn to surrender this negative thinking to our Higher Power. We can pray fervently for guidance to more positive thoughts. By letting go of our negative thinking, we can make room for more healthful positive thoughts about ourselves and our art.

A daily affirmation some artists use and find helpful is this: "I am capable, competent, and creative in the endeavors in which I choose to involve myself." When we begin an artistic effort and become aware of our feelings returning to our discouraging thinking patterns, we encourage ourselves by remembering the three Cs. We replace our discouraging thinking by saying over and over to ourselves, "I am capable, competent, and creative."

Some of us become amazed at the transformation that takes place. We find ourselves growing into the feeling of actually becoming capable, competent, and creative in our efforts. When we finish, we learn to express our gratitude to our Higher Power for giving us the gift of feeling capable, competent, and creative.

❖ ❖ ❖

I am grateful, God, for feeling capable, competent, and cre-ative in my artistic efforts. Please help me to remember this slo-gan when I feel caught in a discouraged attitude.

Risk Taking

Some artists may limit our thinking by our own fears connected to taking a risk in a relationship or with our art. If there is a new style or process we'd like to experiment with, we may stop ourselves because of our fears. If there is someone with whom we'd like to share our feelings, perhaps, we don't take the risk but make a choice to stop ourselves.

By trial and error over time, many artists learn to trust our instincts and have faith that our Higher Power is guiding our actions—even unfamiliar, risky ones. Often we find that by taking healthful risks with faith, we grow in relationships and as artists.

The taking of risks, experimenting, leads many artists to the peace we experience in artistic recovery. Our spirituality continues to grow as we feel closer to our Higher Power as a result of the lessons we learn from risk taking.

Sometimes we learn not to do a certain thing again. That doesn't mean our risk is a failure. It may mean the experiment has guided us in a different (but not necessarily bad) direction.

Other times risk taking can produce mind-opening results. We find we *can* do the thing we were afraid we couldn't—that new twist on an old art form, for instance, or sharing an intimacy with a close friend. Risk taking can guide us toward greater self-acceptance.

❖ ❖ ❖

Today, I will consider the choice to take a healthful risk I may have been pondering. I will trust that, if I keep my mind open, I can learn a lesson.

Artistic Audacity

One of the qualities that may make artists distinct from others is our audacity. Not only do we have the courage we need to be distinctly ourselves, but we may imagine that our Higher Power supercharges that courage with extra healthful portions of boldness and daring. Our souls, it seems to some of us, are endowed with strength in amounts greater than ordinary.

These are necessary ingredients for us and our creative tasks. Because, as artists, we often make choices that do not "fit in" with those around us, we need this supercharged courage, or audacity, to maintain our emotional balance. Artists are often the agents of change and bear the burden of tackling the status quo. We are often attacked for merely being different.

The risks many artists take by expressing ourselves uniquely would lead to self-effacement or denial of our honest selves, if we were only nominally courageous. Our audacity encourages the self-confidence to withstand criticism, attacks, and misplaced jealousy and envy intended to keep us in line; that is to not think, behave, or express ourselves differently, which very often for us is creatively.

Our Higher Power provides us with the gift of audacity as a means to keep us spiritually strong for the work we've been guided to do—to create.

❖ ❖ ❖

I can discover the audacity within myself to express my art in the creative ways my Higher Power leads me.

Effects of Shame

In recovery many artists discover the effects that shameful thinking has brought to discourage our artistic expression. At the core of our souls may be the dark and limiting feelings "I'm not good enough," "I don't deserve to think of myself as an artist," "What I believe and want to express may not be the right thing." These and other discouraging and limiting thoughts and attitudes may have been planted in our souls by role models, some of them years ago.

We may have come to believe that these thoughts are true for us unless we review and examine them and the feelings we have associated with them. By looking at them honestly, we can shed the light of our currently expanded truth on them. We learn to let go of the shame we have connected with these attitudes that discourage our healthful artistic expressions.

Shame can have a blocking effect on our self-esteem, some of us learn. It limits our capacity to creatively express who we honestly are. By doing our emotional work in artistic recovery, we expose our shameful thinking to the healthful light of healing and open our minds to the possibility of being who we truly are without all the self-destructive shaming messages. We find that we truly are unique, capable, competent, and creative children of the Great Creator.

❖ ❖ ❖

Today, God, please grant me the courage to examine any shameful messages or attitudes that block my artistic expression. I am grateful that you have guided me to the encouraged path for my creative expression. Thanks for caring.

Housecleaning Our Souls

Artistic recovery might be described as "a thorough house-cleaning of the soul." When we clean a closet or drawer, we examine our clothing to decide if each garment is appropriate to our current needs, correct size, style-timeliness, and appealing to who we are now. We often find that many items no longer fit, are out of style, or are unsynchronized with the image we currently want to express.

It could be said that this process is also true of artistic recovery. In seeking a balance in our lives and art, we examine the many ideas, feelings, and beliefs that may have been in our "spiritual closets and drawers" without our ever honestly looking at them. We find in our growth process that we may need to discard, or let go of, some of our old ideas, feelings, and beliefs to make room for updated versions that work better for who we currently are and what our art involves.

Some of our ideas, feelings, or beliefs may simply need to be given a new perspective, as a garment may be revived by mending, cleaning, or other personal care. They can then work in our best interests again with the attention we give to them. We may decide that other of our ideas work well exactly as they are, and, in the process of acceptance, we enhance our self-esteem.

❖ ❖ ❖

I can examine my "spiritual closets and drawers" for ideas, feelings, and beliefs that discourage my acceptance of myself and my art. I am grateful to know that I have a choice of letting go of, changing the perspective of, and replacing those that no longer work for me.

Focus

One of the challenges artists face is keeping the focus on ourselves and our art. If our boundaries are unclear, it is sometimes easier to listen to and accept other people's opinions and ideas than it is to do the emotional work of staying focused on our own ideas and opinions. We can learn, however, that the work we do on self-acceptance and acceptance of our art proves worth the investment.

We learn skills and strategies that guide us to clarify and strengthen our boundaries. We learn to healthfully listen to others while filtering out whether we agree or disagree with their ideas and opinions. We trust our Higher Power for guidance in letting go of those that do not work in our most creative interests. The more we do this, some of us happily discover, the clearer and more focused we become about who we are and how to express ourselves and our art.

❖ ❖ ❖

Today, I will examine where my focus is. If it is not on myself and my art, I will meditate on whether this is something I need to work toward changing, knowing that all things occur in God's own time and way.

Balancing Gratification

Among the issues in our lives and art for which we seek a healthful balance, one that may be overlooked is the idea of gratification. We may have been taught about the need to delay gratification until the time is right for us to have what we seek, or to achieve our artistic goals. This, too, happens in God's own time, we learn in artistic recovery.

Some of us may lack awareness of the choice to let go of delaying gratification. We may deny ourselves the courage to claim the things we've longed for, dreamed about, and delayed for whatever reasons or length of time.

We can get caught in a discouraging web of delayed gratification. If our current reality becomes such that we can financially or spiritually afford the things we've delayed, we may continue to delay our emotional gratification. We may be afraid of the possible changes in our way of thinking that are required, even for better situations than our current reality.

By honestly examining our needs and resources, we can determine when it is appropriate for us to delay gratification, and when to let go of the delay and enjoy the gratification that is the positive result of our efforts.

❖ ❖ ❖

I can trust my healthful feelings to learn to balance gratification in my life and my art.

Using Our Gifts

Each of us, regardless of whether we identify ourselves as artists, is given a unique set of gifts—a special combination of attributes and talents, like a fingerprint or a single snowflake, that identify us individually. Often it is the artist's willingness to use these gifts to best advantage that gives one person distinction over others.

There are those among us who believe that the gift chooses the person, perhaps as part of a spiritually mysterious process. As we learn to identify and use our gifts, experiment with them, take classes or lessons to get others' perspective, put our own applications to creative use, and ultimately share them with others, we are revealing our truest selves to those around us.

By using our gifts, we express our gratitude to our Higher Power for having been entrusted with them. By being who we are, honestly accepting and creatively using our gifts, we complete a unique connection with our Higher Power. Many artists find that we are then given more and greater gifts and entrusted with their best use.

❖ ❖ ❖

I am grateful for the artistic gifts I have been given. I am willing to follow God's guidance for the best use of my gifts.

Do One Thing

Some artists become discouraged with overwhelming thoughts and feelings when we begin a new project, tackle a new endeavor, or face an emotionally trying experience.

A strategy many artists learn to use in these stressful situations is to choose one thing and focus on doing just that one thing. We learn to have faith that God will take care of the things we cannot do in the moment. We trust that they, too, will be handled in their own time; perhaps by us, perhaps not.

We find that by focusing on only one thing at a time, we are able to give our full attention, emotions, and creative instincts to the completion of that one thing. When we finish that, we can let go of it and give full attention to the next thing. This series of small, creative endeavors helps us to break tasks into manageable portions. We discover that we are able to approach endeavors with a peaceful, creative attitude. It is a strategy some artists find encouraging in working through overwhelming thoughts and feelings.

❖ ❖ ❖

When I feel discouraged or overwhelmed by my projects, endeavors, or feelings, I will choose one thing and give my full attention to it. Then I will choose another and focus on it. I am grateful to learn this stress-management strategy.

Whose Problem Is It?

In defining ourselves and our relationships, we may run into many boundary issues. There is an art to learning to recognize to whom a problem belongs. We may have learned in our development to take on responsibilities so that others will like us or our art. We want to be "helpful" so we volunteer for committee work, only to become aware that our art suffers for lack of time because we have overinvested in others' concerns.

We learn slowly, by experience, to allow other people and systems who are capable, to own their own problems. We determine the healthful limits of our own giving, so that our art has adequate time and energy available from us. We learn to respect others by allowing them to own and solve their own problems.

In artistic recovery, we learn to trust that, if we don't take on and solve every problem ourselves, others who are capable are given an opportunity to learn to solve their own problems. In the process they, too, can grow creatively.

In resolving issues of problem ownership, we free ourselves emotionally, artistically, and sometimes in other ways that can lead to enhancement of our creative expression of ourselves.

❖ ❖ ❖

In my relationships, I can learn to honestly examine "Whose problem is it?" If it is truly my problem, I can work peacefully toward a solution. If the problem is someone else's, I can respect their boundaries by allowing the problem, solution, and consequences to belong to the person to whom it belongs.

Pruning As Letting Go in Faith

Gardeners know that by cutting back or pruning many varieties of plants, the plants are encouraged to become fuller of fruit or flowers, produce more and bigger crops, and display greater foliage.

Some artists may envision a parallel for our creative lives. When we discipline ourselves and our art by pruning or letting go of people, places, and things that discourage our true creative capacity, we encourage our art, by offering more space and life-giving energy, to be fuller, more abundant, more fully developed.

In faith we prune away our addictive, limiting, self-defeating behaviors and attitudes. We let go of actions that serve the needs of others who are capable at the expense of our own need to be who we are. Many of us discover that these codependent needs have taken a heavy toll on our crop of creativity.

It may seem a harsh thing to do to cut away a part of a rose bush, for instance. But when the bush is thriving and beautiful in harvest, the pruning is revealed for the necessary step that it is. So, too, in recovery, we feel our pain as we work through letting go of issues that have crowded our true selves and our budding artistic expression. In the blossoming of our artistic lives, however, we show our gratitude by using our harvest—artistic gifts—to the highest good of which we are capable.

In the blossoming of our artistic lives, we come to feel grateful to our Higher Power for having granted us the courage to change the things we could—the pruning of our personal lives of self-defeating behaviors and attitudes. We

come to value the faith we invest in a God who guided us through the pruning to the abundance of our artistic gifts. We show our gratitude for the bountiful crops and flowers—artistic gifts—by using them to the highest good of which we are capable.

❖ ❖ ❖

I am grateful for the awareness that letting go is a necessary step in my spiritual growth. I will trust that my pruning of my self-defeating behaviors and attitudes will, in God's own time and way, if not immediately, encourage the blossoming of my creative gifts.

Accepting New Needs

Sometimes we may feel afraid to accept a new need as we become aware of it. We may believe that it will appear greedy, or that others need things more than we do, or that we don't deserve to have our needs met. This is discouraged thinking about ourselves and our art. It is possible to change our attitude into healthful, balanced thinking.

We may ask questions of ourselves to encourage our acceptance of new needs: Do I need someone to support my artistic efforts? What about those dance lessons I've wanted? Am I ready to try that? Do I need art supplies? Do I have enough quilting thread? How about some balsa wood for that carving project I've wanted to try? Would a new tip for cake decorating open more creative options for me?

What other needs come into awareness? These are all legitimate needs for our art. So is a need for quiet time, a studio, a spiritual connection, a friend, and many more.

The first step toward receiving answers to our needs is to recognize that the need exists. Then we can pray and meditate about it, turning the need over to our Higher Power. "Desire, ask, believe, receive," it has been said. "Then express gratitude by using the gifts that fulfill the need to our best advantage," we might add.

❖ ❖ ❖

I can trust that I am being guided by a power greater than myself to the things I need to express myself creatively.

Acting "As If"

Acting "as if" some spiritual quality is true of ourselves can be an empowering strategy for artistic recovery. Though we may honestly hold on to some self-doubt, we can change our thought patterns by acting "as if" healthful, positive feelings are already true of us. Some of us learn that our imaginations can be used to help us to change our discouraging feelings and behaviors into encouraging ones.

One recovering artist shared this account of her first time of acting "as if":

When I agreed to do all the flowers for my daughter's wedding, though I was new to floral design, I had great success acting "as if." In my support group, I had heard others share their success stories of acting as if positive things they wanted to attempt were quite manageable and were already true. I found the courage inside myself to say, "I feel capable, competent, and creative in my ability with flowers." At first I even surprised myself by saying it.

It was only after the wedding flowers were a success that I shared with my group that I had really been only about seventy percent honest in my feeling capable, competent, and creative. The acting "as if" I was capable, competent, and creative had provided the faith that I could do what I had faith enough to act "as if" I could.

I have used it many times since then, not to deny reality, but to coach myself through things I honestly want to do in spite of my old self-doubts. I have found that my Higher Power provides me with the spiritual energy to

bridge the gap between acting "as if" and a positive new reality if I am willing to do the act in faith.

❖ ❖ ❖

God, help me to act "as if" when my self-doubt discourages me from creating something healthful I honestly want to express. Please guide me to learn to experiment with my imagination to change my self-doubting attitude into a self-enhancing one so that I can be my most creative self. Thanks for your help.

Journaling As a Recovery Skill

Many artists find journaling to be a valuable skill in recovering our sense of ourselves as creative people. By writing our feelings, ideas, insights, or just events of the day, many of us come to feel greater clarity and directed purpose in our lives and art.

Some artists establish a sacred time to journal. We learn not to be so rigid about it that we never miss writing, nor so flexible that we only journal occasionally. We find a balance that works for us individually. It is a gift we give to ourselves continually.

We may discover that by writing our feelings, we are able to consider them from different perspectives. We sometimes connect them to other feelings or events and may find a pattern or recurring theme. We sometimes get new insights into artistic ventures or ideas.

Some artists find that by writing the words "I now let go of . . ." or "I now turn . . . over to my Higher Power," they are able to become emotionally detached from situations in which they feel powerless. Many of us find that we become open to whatever outcome our Higher Power guides us.

One artist noted that by writing just before bedtime she was able to tie up loose ends and resolve unbalanced feelings of her day. Sometimes, but not always, she made plans for the next day, at least on paper. Sometimes she just wrote about whatever came to her momentary awareness.

Some artists share that journaling can be a healthful substitute for addictive sleeping substances. We discover that journaling contributes to peace of mind that encourages more healthful sleep patterns.

❖ ❖ ❖

Today, I will consider whether journaling might serve to encourage creative growth for me and my art. If I already journal, I will be grateful for this gift I give to myself.

Days of Special Remembrance

Days of Special Remembrance

APRIL

Let Us Not Be Fooled

Let us not be fooled in our thinking of ourselves as artists. We are not okay human beings *because* we perceive ourselves as artists. We are okay human beings because we exist, because we are spiritually connected to the universe and our Higher Power. Our art is not the sum total of who we are. It is merely the manifestation of how we have chosen to express our gifts in the moment. Our okayness is a separate issue from our artistic expression, unless we allow ourselves to be deceived in our thinking that they are the same.

We are neither any better nor any less than any other of God's children because we see ourselves as artists. We have, however, learned to use the creative gifts we've been given. They were given to us in faith that we would use them, and we have chosen to receive and use them. We learn to humbly accept our gifts as spiritual tools for our expression.

Some of us are given dreams and visions that might seem unlikely to ourselves or others to become reality. With faith, we may courageously choose to pursue them anyway, using our spiritual and artistic gifts as we feel guided. We discipline ourselves with positive thinking and attitudes. Praying openly for guidance, we listen to our feelings and learn to trust the spiritual forces greater than our own human perceptions. Some of us may call it God's Divine energy working through us. Sometimes we are miraculously led to bring the unlikely dreams to reality. We learn to feel God in action and pay attention to it. We choose to serve as a channel for God's creative expression through our souls.

Our creative use of our gifts is our expression of God

through our human spirit. It is, consequently, an act of worship to our Higher Power to use our creative gifts.

❖ ❖ ❖

I am grateful, God, for each gift you have entrusted to me. Help me not to be fooled into thinking that my art is who I am. Guide me, instead, humbly to use my gifts to my best capacity as an act of worship to you. Thanks for caring.

Work Before Play

As part of the discipline of our earlier development, we may have been taught that we need to complete all our work before we are allowed to play. Play may have been used as an incentive for teaching us to complete our tasks.

As adult artists, these lessons may work in our favor or against our best interests. If we view our art as our work, we may employ this attitude in positive ways to express our artwork toward completion.

We may see our art as adult play and separate from our work, however. We may then have learned to put off our art, which could bring us much pleasure, in favor of completing other tasks we might now define as work. We may feel an accompanying loss in self-esteem because we deny ourselves the satisfaction of doing healthful, pleasurable things—our art—for ourselves.

Some artists may need to examine the feelings we have associated with the idea of getting our work done before we play. Some of us may choose to work toward changes that allow us to become involved in healthful activities that bring pleasure and creative expression to our lives. Others among us may consider changes in our attitudes about what our art means to the full expression of our lives.

❖ ❖ ❖

Today, I will contemplate the idea that I have to finish my work before I am allowed to play. I will consider whether my old ideas might hinder my artistic growth. I can remain open to examining this issue and courageously work through the feelings I have connected with it.

Allowing Myself an Artist's Day

Some of us may need to grow gently into thinking of ourselves as artists or as having creative gifts and abilities. We may have been taught that artists were born gifted, or have been taught by the right teachers, or were chosen to be gifted by God. We do not fit into these categories, we may believe.

By gently opening our minds to the possibility of expressing ourselves creatively, some of us may grow to see that we, too, deserve to think of ourselves as artists. In our spiritual growth, we may gradually become aware that the positive things we believe about artists are true of ourselves as well. We happily discover that we do fit in with artists.

It is possible for us to grow into thinking of ourselves as artists by taking small steps rather than one giant leap of faith. We might start by allowing ourselves perhaps an hour or a half-day of artist time a week. We encourage whatever period of time we choose to explore whatever feels healthfully creative to us. Over the course of time, we might value this experience enough to extend the time and give ourselves the gift of a whole day per week to devote to our creativity.

Some of us find that we like this so well, and continue to grow spiritually stronger, that we increase our time to two whole days per week of thinking of ourselves as artists. Over time, we find it so pleasurable, and keep extending our time, that we come to think of ourselves as artists *period*. "I am an artist," we can learn to honestly say, and feel it in our souls.

❖ ❖ ❖

If I have difficulty thinking I deserve to call myself an artist even though I know I have creative talents, I can allow myself brief periods of time to explore myself as an artist. I can give myself the gift of opening my feelings to express my unique God-given gifts.

Learning That We
Always Have Choices

As recovering artists, some of us may need to learn that our art and our lives unfold by the choices we make. Do we choose to see and accept ourselves as artists? By what medium or art form(s) do we choose to express ourselves? What style(s) expresses our unique spirit? Where can we find others who will support and nurture our artistic and spiritual growth?

Everybody, artists included, lives each day by making choices, both consciously and unconsciously. Often we live our lives, especially before recovery, by unconsciously accepting that what we were taught by those around us is the way life has to be. We don't consider that there are many other choices available to us because we have not examined our choices.

In artistic recovery, we learn to look at ourselves honestly and examine issues, sometimes painful ones, sometimes joyful ones, in which we learn the *untruth* that we are not living our lives by our own honest choices. By working through the feelings surrounding our old issues, we eventually learn the new (to us) truth that we always have choices. If nothing else, we can choose our attitude. We become open to living our lives by the choices we make that express who we are.

❖ ❖ ❖

God, please guide my artistic growth in ways that show me that I always have healthful choices about my life and my art. Help me to trust that my choices will ultimately lead to the Higher Good that is your purpose for my life. Thanks for caring.

Unexpected Goodness
in Our Lives and Art

Many artists in recovery learn to appreciate unexpected gifts that come to us by our willingness to become open to receive them. We learn to maintain an open attitude rather than assuming fixed ideas about how life and our art "should be."

In letting go of our limiting expectations, we open our minds and souls to a virtual wealth of ideas, inspirations, relationships, and creative energy from a variety of sources.

Some of us learn to listen to our feelings, trusting that they, too, are a gift from God that have a positive purpose. With patience and experience, we learn to trust the direction our feelings guide us. We often find that they lead us to unexpected goodness in our lives and art. We learn to express our gratitude by making the best use of the gifts we've been given, even the unexpected ones.

❖ ❖ ❖

Today, I will consider whether limiting expectations are discouraging me and my art from willingness to receive unexpected gifts. I open myself, just for today, to gifts from any source, including the mysterious goodness of my Higher Power.

Artistic Development

Artistic recovery and development is a lifelong process for each of us. None of us trudges along and one day suddenly wakes up and says, "Okay, now I am an artist. My artistic recovery and development is complete."

Some of us may learn to recognize and accept some of our gifts, only to later deny or discount them. Our souls seem to play tug-of-war with our minds. We may think we have particular gifts, then become discouraged, perhaps by others' or our own limiting expectations or opinions of our efforts, or by our own discouraging attitude or addictive behaviors.

Others may point out our gifts to us continuously, perhaps by giving us compliments. We may discourage ourselves by not receiving them. Possibly because we haven't learned to focus our creative energies, we may be unable to discern our gifts as being spiritually oriented, that is, connected to God.

Many artists discover that our artistic development unfolds mysteriously along parallel lines with our spiritual development. When we make the personal connection with the power greater than ourselves, we open ourselves to sources beyond our meager self-will. We let go of limiting influences that would define what is possible to create. The process of letting go, we discover, continuously encourages our artistic development.

APRIL

❖ ❖ ❖

God, please stay with me as I continue my artistic and spiritual development. As gently as you possibly can, teach me lessons that will guide me to my creative gifts. Guide my path, too, to creative ways to use my gifts to the highest possible good. Thanks for caring.

The Gift of Discernment

The ability to clarify what is obscure in our minds and emotions is a gift that can encourage our artistic development. Many artists believe that the lessons we learn as we become aware of and guided by our feelings point us directly toward our gifts.

If we feel angry, perhaps, at someone's response to our choice, we can use the message of that anger to discern, or clarify, our own wants, needs, expectations, or choices. We are often being guided to establish or maintain boundaries that lead to more healthful relationships.

From this perspective, our anger as a result of an interaction might be perceived as a gift from the person with whom we interacted. It may pinpoint a new need for us. Perhaps we need to set a boundary if we feel shamed for our choices by others' responses. Perhaps we need to detach from others' expectations, if we have done our best and they expect us to be perfect, or as they want us to be without regard for our choices. Perhaps others want us to take care of them in some way at our expense and the expense of our art, when they are perfectly capable of their own self-care. There are any number of alternatives when we learn to discern our feelings.

We can educate ourselves to use our feelings to the best advantage. When we do, many of us artists become gifted with discernment that guides us to our most honest creative selves. We use the messages as we perceive them from others as healthful guideposts to be who we are.

APRIL

❖ ❖ ❖

I can become educated to healthful communication skills if my feelings are unclear to me. I can trust that my Higher Power is guiding my path toward my gifts, even if I may not be aware of them today.

Willingness

Willingness is one method our Higher Power may use to bring gifts to us. By becoming willing to do a certain task or endeavor, we may open channels for receiving benefits from that willingness. As artists, for instance, we may take classes or lessons in areas that interest us. We pursue the things we feel guided toward. Our willingness serves as the channel to discovering our unique talent. Had we been unwilling to do the necessary tasks involved, we might never have been directed to the gifts.

When others are jealous or envious of us or our accomplishments, we may need to remind ourselves that, at one time in our artistic development, we chose to become willing to do the tasks necessary to accomplish what we have. We have invested our time, energy, interest, and money in our art by our willing choices. We can honor boundaries by allowing others to have their feelings, even about our accomplishments.

We can learn to let go of guilty feelings connected with our accomplishments, as well. We have been willing to pay the price required for our gifts. We earned them. They are ours by our willingness to become open to, receive, accept, and use them.

❖ ❖ ❖

I can accept that I have earned all my gifts and talents by my willingness to make the healthful choices and do the tasks required for my art.

Success Breeds Success

Many artists discover that when we learn to focus the courage, willingness, skills and strategies, and all the other ingredients we need to achieve artistic success, often other successes closely follow. Success in one endeavor can often lay the groundwork for success in another, as well.

Some of us believe this happens as the result of a positive, confident attitude. We learn to feel the healthful boost from our soul that accompanies our successful efforts. Then we seek to continue the encouraging momentum we perceive from our own efforts. Just as some of our previously learned discouraging attitudes may have kept us thinking negatively about ourselves and consequently limited our success, so can new healthful attitudes lead us on toward more successes.

For this reason it is important for us to recognize our successes, even if they are small. We learn to be grateful, even for small gifts. It has been said that success occurs in small increments. We might also like to remember that huge snowballs begin with a small handful of snow, perhaps a few snowflakes.

❖ ❖ ❖

I can learn to recognize and honor my successes, no matter how small they seem to me. I can express gratitude to my Higher Power for even small gifts, with faith that they may possibly snowball into larger gifts in God's own time and way.

With Time and Patience . . .

With time and patience, the mulberry leaf becomes satin."[1] This Chinese proverb speaks to lessons involved in all creative endeavors.

As artists, many of us are given the gift of envisioning. We have the capacity to visualize in our rich imaginations how our art might look, feel, sound, or function. We can hold on to the image in our minds.

Sometimes we may need to do emotional work on the processing stage of our artistic evolvement. Because we can envision our completed work, we become impatient to bring it to life and reality. We forget that time is a necessary ingredient for all art.

We may need to remind ourselves of the reality that there are steps of process in any artistic endeavor. One step leads to the next, time passes, we learn to become patient with ourselves, our art, and our Higher Power. In God's own time and way our art is revealed. Sometimes it is as we envisioned it, and other times in a different form that became altered by the process of time and patience. Sometimes it is better than our greatest vision of what it might be.

❖ ❖ ❖

[1] The raising of silkworms requires a great deal of care and patience. The silk farmer supplies them with fresh mulberry leaves every two or three hours. Later in its development, the worm forms a cocoon, which is the silk.

Satin refers to silk with a unique satin weave, smooth and shiny.

APRIL

God, I am grateful for the gift of envisionment of my creative efforts. Please teach me the lessons of patience and time that will lead me to peaceful efforts in the time of production.

Learning to Feel Satisfied

We can become willing to believe that who we are is good enough; what we have is adequate; our artistic gifts are exactly right for us right now; and that we are capable of dealing with our challenges in competent and creative ways. We can learn to feel satisfied, rather than obsessing on the things we lack, or whining about the things and artistic talents others have that we don't. We can grow into expressing our gratitude to our Higher Power for the gift of feeling satisfied with our lives and our art exactly as they are.

When we begin to focus on the joy that exists within us right now, we take a step toward the balance we may be seeking. We mindfully let go of our unsatisfied, unbalanced feelings and open our souls to the joy that satisfaction can bring to our lives. We encourage ourselves to become more spontaneous in living and creating because we are not so wrapped up in obsessing over our needs and wants. We trust that they are being met. We trust that our Higher Power will continue to meet all our needs and wants in satisfying ways.

❖ ❖ ❖

I am grateful, God, for the feeling of satisfaction in my life and my art.

A Cheer for Me

One recovering artist shared this creative method of focusing:

> When I'm working on a project and feel myself getting pushed aside by others' needs and wants, I've created a little fantasy image that helps me to return the focus to myself and my art. I visualize myself using a football-type cheer for myself.
>
> I imagine myself in cheerleader's costume with pom-poms in my hands. And I see myself chanting (if I'm alone I say it out loud):
> Push 'em back!
> Shove 'em back!
> Waaaaaaaaaaaaaay back!
> Sometimes this little pep rally inspires me to say no to people and things that are discouraging my artistic efforts. Sometimes it encourages me to claim the time and/or space I need to work on a project. I often turn to asking others for help or for respect for my artwork. Usually it helps me to focus on expressing my art, keeping myself in healthful perspective with others around me. It clears the air for me.

❖ ❖ ❖

There are many styles of focusing. I can become open to finding a style that works to keep my interest healthfully centered on my expression of myself and my art.

The Great Art Project

Some artists learn to participate healthfully in what we might entitle the "Great Art Project." We learn that it is a mosaic of hundreds, thousands, maybe millions of our choices. It is designed in colors, shades, and combinations of what we like, what inspires us, and what brings peaceful pleasure to our lives.

The lyrics or poetry may be words based on our feelings, moods, and attitudes. They are set to a tune only we can sing, inspired by the Higher Power that guides all our creative efforts. Our gifts are the manifestation of the warmth we feel for ourselves as we create using our talents as an act of worship to the Great Creator.

This project is framed by the boundaries that make each of us a creation different from every other creation. All these creations are connected by one Universal Spirit—the Divine source of life.

The Great Art Project, we discover, is our lives.

❖ ❖ ❖

I am grateful, God, for the awareness that my life, as I live it and express it by my healthful choices, is the Great Art Project. I trust that you are guiding my efforts and that it is safe to follow where you lead me. Thanks for caring.

Judging Ourselves Harshly

We may have spent our early developmental years around people who judged us harshly. There may have been those who criticized our beginning artistic efforts as if we should be accomplished at our art from the start. We may not have been healthfully nurtured for our imaginative endeavors. Others may have lacked patience with our efforts, so we learned not to be patient with ourselves.

Some of us may need to learn, wherever we are in recovery, that we can let go of the harsh judgmental attitudes we've acquired earlier in life. Through daily affirmations, and by other methods, we replace the old messages with gentler ones that encourage our honest expression.

Some artists learn to say and believe, "I am capable, competent, and creative." Before starting a work, we might pray, "God, guide my hands (or feet, or words, etc.) in these creative endeavors." "Show me the way" is another favorite. "Teach me to be gentle with the unfolding of myself and my art" may be another.

❖ ❖ ❖

I can replace the harsh, judgmental messages of my past with gentler, more positive attitudes that can work to encourage me and my art today.

Moving Forward by Letting Go

We can't take everyone we've ever known along with us on our creative journey. Imagine how crowded our lives would be if everyone we've met in schools, groups, jobs, families, religious institutions, etc., were still prominent in our lives. There would surely be no space or solitude for ourselves or our art.

We may need to learn to let go of our unhealthy attachments to people—their expectations for us, their ideas, their problems, their lives. We can define our boundaries by practicing the strategy of saying no and meaning it. It is a strategy that may require constant use.

Some artists discover that there are people who do not hear "no." Sometimes we need to say it several times until the message is clearly heard. Sometimes we may need to detach completely in order to take care of ourselves and our art. We find that the results are worth the effort we invest when we feel the peace of owning our God-given power.

By hanging on to caregiving others excessively, we limit the time available to give to ourselves and our art. By learning to allow people who are capable to tackle their own problems and discover solutions in their own way, we free two people. We allow others to proceed with their own creative development, and we free ourselves to move forward on our own creative journey.

❖ ❖ ❖

If there are people I need to let go of in order to move forward on my own creative journey, I can become aware of this need. If I feel the need to practice the strategy of saying no to take care of myself and my art, I will seek the courage to do it today.

Getting Through the Rough Spots

Some days, it seems, nothing goes right for us. Our relationships are not working, we don't feel spontaneously creative, our projects fall apart or fall through. It may feel as if our Higher Power has abandoned us. It happens to all of us now and again, even after years of recovery. We may temporarily lose our spiritual connection.

What do we do? Do we throw in the towel? Do we give up on our creative dreams and ideas? Do we discredit hope and believe that recovery doesn't work?

We can learn to express our discouragement, if not verbally to someone, perhaps by journaling and/or prayer and meditation. We can write our frustrations and fears out of our souls. We might connect our current feelings with previously felt emotions and look for a pattern in our responses. Perhaps we need to make changes, maybe in our attitude. In writing, praying, and meditating, we might "turn it over" to God.

We might call a trusted friend or seek a support meeting. We can learn to accept that, even in recovery, there may be rough spots. We do not need to resort to sabotaging the progress we have made in our recovery so far. With faith, time, and patience, we learn that we can get through the rough spots and back into balanced and creative space.

❖ ❖ ❖

When I reach rough spots in my artistic recovery, I can express my discouragement in the healthful, creative ways of my choosing. I might choose to trust that I can get through them to peaceful and creative space in God's way and God's time.

Changes in Perspective

As we grow in artistic recovery, our sense of who we are, what is possible to create, and how we fit in with the larger picture of the world around us may change. Sometimes the changes are dramatically obvious. Other shifts in our focus may be subtle and quiet.

The lessons we learn and the skills and strategies we develop serve to broaden the scope of our lives and our art. We become more receptive to new possibilities, greater awareness of choices, and enhanced regard for ourselves and others.

Some of our lessons may involve pain as we learn to let go of old limitations, confining expectations, and self-defeating behaviors. The pain, many artists learn, is growing pain. Other lessons may bring joy and peace to our lives as we embrace our gifts and talents. We discover that we are becoming open to new levels of deserving, creating, and being. We are involved in the process of changing our perspective for the higher good.

❖ ❖ ❖

Today, I will consider whether any issues with which I am struggling may be part of the process of changes in the perspective of who I am and what my art may concern.

Self-Esteem

Our self-esteem is based on who we are to ourselves. It is not about our connection to others—families of origin or of our own making, teachers, authority figures, social groups, religious institutions, support groups, our art, or others.

Our connection to others has a role in our self-esteem. We can look to others as role models, but we have a choice to attain a certain quality on an individual basis. Our Higher Power can guide our healthful choices if we listen openly and follow where we feel healthfully guided.

We learn to respect ourselves by honestly examining and working toward acceptance of who we are, including our gifts and shortcomings. Our art serves as the projection of our creative choices. We put our choices out for the world to see. It is not, however, who we are. Many artists find the risk of exposing our choices through our art to be a meaningful expression.

❖ ❖ ❖

My self-esteem is not about anyone else or anything else but my relationship with myself. I can listen to and follow the guidance I hear from my Higher Power as I examine my relationship with myself.

Whatever You Can Do

"Whatever you can do, or think you can, begin it. Boldness has genius, power and magic in it." —GOETHE

Our creative dreams are a sacred trust, given to us by God, because God has faith in us to carry them out. No healthful goals are too small or too large for us. Many artists believe that we have been given, or will be given, everything we need to bring them to life in God's time, if we honestly believe we do.

Often, as artists, the hardest steps to take are the very first ones. Like a toddler learning to walk, we find it easier to resort to crawling because we may fear falling (failing). When we master those first few steps of beginning our creative endeavors, however, like a toddler finally walking, we, too, feel the power and magic inherent in creating our art.

Beginning requires boldness, courage, and faith. They are all waiting inside our souls for us to discover. When we learn to claim them as ours, we open our creative floodgates and create as only we can. The gifts are waiting for our willingness to claim them as our own.

❖ ❖ ❖

I am willing to claim the healthful artistic gifts I know are mine. I can begin today, by accepting that my creative goal is possible to achieve. I trust God's way and time for the unfolding of my art.

Savoring Our Accomplishments

Some artists may lead our creative lives by jumping from one endeavor directly into the next. As we grow spiritually, however, we find that it is more pleasurable to our artistic self-esteem to allow plenty of time to slow down and savor our accomplishments. Upon completing a project or endeavor, we may enjoy simply sitting in spirituality and gratitude with our works. We are not looking critically or for mistakes, but purely to enjoy the beauty of them.

Some of us perceive our artistic expressions as children of our souls, each with a spirit of its own. We have extended ourselves to nurture our works and give them attention and care, as we would a child. We learn to accept the spirit of our works before becoming willing to "let go" and turn them over to our Higher Power for their intended use. Our souls, it seems, then become freed up and open for the next endeavor.

We can learn to admire and enjoy our own art. We can savor the pleasure that is returned to enrich our lives and enliven our spirits. No matter how small or large our accomplishments, many artists believe they are all God-given gifts.

❖ ❖ ❖

I can slow down to appreciate the beauty of my art. I can manage my time, my relationships, and my art so that I encourage myself to value the joy that comes back to me through my artistic and creative expressions.

Enjoying Life

Before entering recovery, many artists may have used our energies denying ouselves, our feelings, and our artistic gifts and talents. We covered up our feelings by investing in others at the expense of healthfully investing in ourselves and our art. Some of us learned to use addictive behavior, generally giving away our personal and creative power. We felt only momentary glimpses of joy, if any.

The difficult times we faced have taught us lessons, some of them painful. In artistic recovery there are new positive and hopeful lessons of joy and peace available for us to learn and live.

We are learning to embrace the gifts we've been given by our Higher Power. We learn to seek peace by balancing significant areas of our lives. We learn to nurture ourselves and our talents and to use our gifts as an act of worship of our Higher Power.

We learn that we have a choice of perspectives in life. We are not helpless, powerless victims. Rather than seeing life as a series of problems to be solved, drudgeries to be endured, and injustices to be survived, we can choose to learn and use the skills and strategies available in recovery. Some of us learn to have faith that life will unfold on its own for the best according to God's will, without our obsessively worrying about it or trying to control its direction. We encourage ourselves to receive the gift of peace and joy. And we become grateful for it.

APRIL

❖ ❖ ❖

God, I am grateful for the joy you have given me. Though some of the lessons were painful along the way, I am grateful that my path is leading me or has led me to feeling joy. Thanks for caring.

Identifying Resources

Often, when faced with a problem or issue, we can bump into or trip over answers or resources without even recognizing them. We can become so busy in the process of searching for answers that our minds become closed to obvious solutions.

Some artists discover that sometimes the obvious is clearer to those who are not involved in a struggle. We learn to value the feedback others give to us that is so clear to them that we, in our struggle, have completely overlooked. When we feel confused, we learn to look to others whose opinions we value. Sometimes we cannot see things about ourselves that others see clearly.

Artist support groups can serve as a valuable resource to artists who are struggling to bring their creative ideas into the realm of reality. Solutions to artistic attempts, sources for inspiration, ways to take care of ourselves and our art, and support for our uniqueness are all available to us by participating in healthful support groups.

❖ ❖ ❖

I am grateful today, God, for the many ways you have guided me to learn to identify creative resources. I ask for your continued guidance as I travel the artist's pathway by carrying out your will as you reveal it to me. Thanks for caring.

Commitment to Our Art

To bring our art to full expression, there is much more involved than simply envisioning or imagining it. To imagine our art in its completed state is merely one of many, sometimes complex, steps, perhaps the beginning of which is becoming open to the idea.

Many artists find that in bringing our art to full expression, we need to become committed to its evolvement. We need to make necessary investments of time, energy, sometimes money, sometimes other things. We need to make spiritual commitments. We need to believe in our souls that we are capable. We become open to guidance by our Higher Power to complete our endeavors. We establish priorities that will encourage us to fulfill our commitment to our art.

We may also need to learn to be patient with the process of our artistic expression. Commitment does not imply that we rush to completion at the expense of doing our best work. We remember that our art evolves in God's time, not ours. When we learn to trust in God's timing, many artists learn, our work evolves peacefully.

❖ ❖ ❖

Today, I will consider whether I am willingly committed to my art. I will trust my Higher Power to guide me through the steps inherent in the unfolding of my creative endeavors.

A Recovery Riddle

It is said in math that the addition of a zero (0) does not change the outcome of a problem. A recovering person shared this little creative twist on the expression:

We begin with God.
O+God=O God. (We pray, asking openly for guidance.)
God+O in the middle = Good. (We are grateful for and accepting of God's creative gifts of goodness in our lives.)
God+O= Go Do (We show our gratitude to God by expressing our art using our gifts.)

❖ ❖ ❖

When I am faced with problems, I can use this recovery riddle to seek solutions.

Treating Ourselves Well

Some artists may need to learn the art of treating our-
selves well. Some of us have lived with deprivation or self-
neglecting attitudes for so long that we need to encourage
ourselves to indulge in luxuries as we can honestly afford
them.

Most of us can afford some luxuries or treats. We might
ask ourselves: How about that favorite soap or body lotion I
say I can't afford? Is it really true that I can't afford to go to
the movies occasionally? What about that new tool I'd like
for my woodworking project? Are drawing lessons really out
of my budget limits, or is that a handy excuse not to treat
myself well and perhaps feel better about myself?

If I can't get my hair done every week, how about once a
month? If I can't hire a cleaning person for every week, is
every other week a possibility? Is it possible to treat myself to
fresh flowers to inspire my creativity? Can I encourage my-
self to set aside some time to read that book or listen to that
music that soothes my soul?

There are any number of creative ways to healthfully
treat ourselves well. Sometimes we use our creative energy in
discouraging ways to look for excuses or rationalizations not
to treat ourselves well. The payoff for that behavior may be
that we can continue not to like ourselves and hold on to our
negative self-image rather than risk change.

Courage is required to change these old habits and atti-
tudes and learn new behaviors including treating ourselves
well. Many artists find that the work involved in this change
is worth the effort. We find that, in treating ourselves well,
we grow into respecting ourselves. Many of us happily dis-

cover that when we respect ourselves, others learn to respect us, too.

❖ ❖ ❖

God, teach me what I need to learn to treat myself well. Show me the ways I can be my most creative and respectful self. Thanks for caring.

Experimenting with New Behaviors

Sometimes we choose to experiment with new behaviors in recovery before we find those that feel right for us. For example, we may want to spend all our time with our art until we learn to balance our art with our other social, financial, physical, and spiritual needs. Sometimes we try a behavior only once and know that it is not for us. Other times we may allow more chances before letting go of it or adding it to our repertoire of healthful recovery skills and strategies.

If we choose to verbalize our experimental efforts in our therapy or support groups before trying them, we may discover others who have experience, strength, or hope to share with us on the subject. Sometimes our groups can serve as a place to try on a new behavior just to see how it feels. We may feel safe enough there to find the courage within ourselves to take a risk. In the process, we may be given awareness of a new God-given talent for taking the risk with our experimental efforts.

✦ ✦ ✦

It's possible for me to experiment with new, healthful behaviors in my artistic recovery. I may discover some things I want to change so I can feel better and more accepting of myself and my artistic expression.

New Levels of Deserving

Many of us have low levels of what we feel we deserve from life, from our art, and from others. We may feel that, because we behave in a certain way or hold a specific set of values, we don't deserve to have any more than we already have. We may mistakenly believe we don't deserve inspiration, a personal connection to God, compliments, money, art lessons, anything. This attitude of nondeserving controls and limits our thinking in our creativity, in our relationship with ourselves and with others, and in our spiritual relationship with God.

We can, if we choose, work toward new levels of deserving. We can reprogram our thinking by using prayer and meditation, daily positive affirmations, journaling our feelings, participating in support groups, and sometimes seeking therapy.

As we grow spiritually using these and other positive methods, seeking God's will for our lives and our art, many of us discover that God's will for goodness in our lives is much greater than our own. We learn to let go of our low levels of deserving and discover that they are replaced with higher levels than we imagined possible. With time and patience, we come to feel that we deserve all that we want that is healthful. Some of us believe we deserve to have all the desires of our hearts met in abundance.

❖ ❖ ❖

God, please guide my thinking and behavior so that I am directed toward the new level of deserving that is your higher will of goodness for me and my art. Thanks for caring.

Gifts and Shortcomings

Many of us have gone through life with little awareness of the unique gifts we possess. Some of us abuse ourselves with excessive use of drugs, alcohol, food, excessively caregiving others, or other addictions. For some discouraged artists, it is easier to lose our honest creative selves in these addictive behaviors than it is to uncover, accept, and use our creative gifts.

Some of us need to hit rock bottom, perhaps choosing life over suicide or other drastic measures, before we become ready or willing to uncover the gifts God has waiting inside us. Many recovering artists first need to become willing to let go of our self-destructive behaviors. We learn to get honest with ourselves and our feelings by looking inside ourselves at who we are. Often beginners in recovery focus on our defects of character. We concentrate on our shortcomings.

At some undefinable point, we become aware that the sum total of who we are includes our gifts as well. There are skills and talents we've developed, interests we have nurtured, things we'd like to pursue simply because they bring pleasure to our lives. These gifts and interests may have become discouraged by our unhealthy investment in our shortcomings. Our lives have become out of balance, discrediting our talents and gifts. We learn to examine our lives for all our qualities; not to judge, but to become aware of how we communicate, and to learn how to healthfully manage our lives.

As we continue our artistic recovery, many of us come to feel guided or inspired to use our gifts rather than invest in our addictions. We choose to encourage our inspirations and

open our creative channels. We learn to show gratitude to God by using our gifts.

❖ ❖ ❖

I can become willing to encourage my creative gifts. I may need to learn to let go of self-abusive behaviors or attitudes. I trust that my gifts will be worth the emotional and spiritual work I may need to do to bring them to light and life.

Waiting It Out

As we grow in our spirituality, we learn by experience that our lives and our art evolve exactly as they need to. We learn that waiting it out is often part of God's great plan of goodness for us.

Some artists discover that, if we have a plan in mind or an artistic inspiration, and we wait it out rather than painstakingly forging ahead, sometimes a better plan than we had imagined is provided. We find that if we become impatient with our creative efforts, we sometimes limit ourselves by the act of rushing into the process.

Some of us learn that the time we spend praying and meditating is just as valuable in the process of our creativity as the actual "hands-on" productivity of our work. By praying and meditating, we are able to quiet ourselves enough to listen for God's inspirations, which are often more expansive than our own. Only by quieting ourselves and our expectations can we open ourselves to receiving greater messages, it seems.

❖ ❖ ❖

I can become willing to try prayer and meditation as a means of opening my soul to receiving God's greater inspirations. I can discover that I have the patience to wait it out before making controlling attempts at my art.

Step-by-Step

Our lives and our art evolve step-by-step. Our artistic recovery happens over a long period of time, perhaps our whole lifetime. We make progress, sometimes by what feels like baby steps, and other times by letting go of large, self-defeating attitudes and behaviors all at once.

Our responsibility in the process is to trust that it all happens in God's own time and way. We take no step until we are ready for it. When we become controlling or manipulative we have lost our connection of trust in God. Any anxiety we feel is concerned with our becoming impatient with the process, ourselves and our art, and our faith in God as we understand God to be.

It is in learning to accept that we are exactly where we need to be, even though the reasons may not be clear, that we can work toward becoming peaceful with ourselves. We can learn to say, "Thank you for this step, even though it feels like a baby step in my life." Many artists discover, in retrospect, that an accumulation of baby steps adds up to a giant leap of faith. We become aware that each tiny step was necessary to the process of our artistic development. We become grateful for the courage we found within ourselves for each step we chose to take.

❖ ❖ ❖

I can trust that my life, my recovery, and my art are evolving step-by-step exactly as each is intended by my Higher Power.

Days of Special Remembrance

Days of Special Remembrance

MAY

Consciousness Raising

Because we artists often express innovative ideas in our creative efforts, others' responses to our work may be based on awareness we have inadvertently raised in those who view them. If we or others are less than secure with feelings and attitudes, then less-than-healthful methods may be used to soothe a raised consciousness.

Art may threaten the limitations that have become accepted as truths. The observers may have learned to look upon the world from their own internal limitations and impose those limitations on the world around them. Sometimes our breaking through others' preconceived limitations has a "backlash effect." The immediate response may be negative. Our art may be condemned or criticized. Others may assess our ideas in reference to the limitations they hold as possible. They may want to force their limitations on us so that they do not need to change their thinking. Only later, if and when others learn to let go of or readjust their limitations, do they see the intrinsic message our art may have brought to their souls.

Learning to set and maintain healthful boundaries can serve artists well when our art raises the consciousness of others. We trust that our art is a gift from our Higher Power. We learn to tolerate and even accept others' reactions and responses to our art as belonging to them, and not necessarily a truth we need to accept for ourselves. We may become inspired, as well, to reassess our own boundaries by awareness we view in others' artistic expressions. Our boundaries may become expanded by our own raised consciousness. Sometimes it is how we grow spiritually and creatively.

MAY

❖ ❖ ❖

Great Creator, I ask you to guide my spirit when I begin to feel insecure about my art. Remind me that there are healthful boundaries around me and my art that are protected by your spiritual presence. Guide my thinking, please, to trust that you are with me and are guiding me to the highest good, even if others may want to use me or my art for their own purposes. Thanks for caring.

Telling Others Who We Are

Others cannot know who we are if we never reveal our feelings. They may learn to guess what we feel and act upon that guess as if it were true of us. Their guess may not be true of our honest feelings.

We can learn to tell others who we are by talking about our feelings. If what someone says or does hurts us, we can learn to say, "That hurts my feelings when you say or do that to me." If we feel controlled, we might say, "I feel like you're trying to control me and I don't like it. I have choices."

We can express our joy and gratitude to others when something they say or do pleases us. "Thank you for being willing to help with my artwork" will tell them that we appreciate their efforts on our behalf. They will then know that what they did feels good to us. We will be telling them who we are and what we like.

By revealing ourselves to each other, we can learn to respect each other's boundaries. We can listen to the feelings of those around us; and knowing who they are by what they tell us, we can come to respect and accept each other.

❖ ❖ ❖

Help me, God, to tell others who I am by talking about my feelings. Help me, too, to respect others and their boundaries by listening to and accepting their feelings.

The God Box or Prayer Pouch

Some artists learn to utilize a spiritual concept they might call a "God Box" or "Prayer Pouch." These can be as simple or ornate, plain or elaborate as the owner chooses. Their purpose is to hold the things of which one wishes to let go. We trust turning them over to God's care.

The God Box or Prayer Pouch might be used as part of a spiritual ritual. The issue one is struggling with or praying about is written on a piece of paper in great detail. A new artistic inspiration or project may be sketched or described. Whatever one wants spiritual help with is defined, not to tell God how it should be but to ask for guidance on healthful, creative possibilities. Perhaps a prayer or meditation is said as the paper is placed into the God Box or Prayer Pouch. Many artists choose to then trust the outcome of the request to be up to God. We follow our feelings as we perceive healthful direction from our Higher Power.

The methods of choice for all aspects of this concept are open to the creativity of the individual. Some artists find that these rituals serve as a physical demonstration of the spiritual process of letting go. We discover peaceful results when utilizing these ideas, or others like them.

❖ ❖ ❖

I can experiment with the idea of using a "God Box" or "Prayer Pouch" for letting go of issues with which I struggle. I can give myself one as an artist's gift, choosing whether to buy, design, or create one that feels artistically right to me.

Learned Behaviors

Some of us may have learned behaviors and attitudes that helped us to cope with situations that were less than healthful for our well-being and our artistic expression. These behaviors served their purpose in their time and were necessary when we needed them.

Now that we have grown emotionally and/or spiritually, we may need to unlearn some of them. We learn to let go of them to make room for new and healthier behaviors and attitudes. We may need to examine the necessity of doing some of the things we do, in the light of who we are today.

To do this we need to become constantly aware of our feelings and actions. We need to consider whether our attitudes are based on choice, or if we feel we need to do something a certain way because that's how we've always done it, without any conscious awareness that we have choices. This requires that we pay strict attention to ourselves. It requires examination of our souls, and honesty with ourselves and our feelings.

❖ ❖ ❖

I can honestly examine behaviors and attitudes I have learned that are less than healthful for my well-being and my artistic expression. I am willing to unlearn them to make room for new and more healthful behaviors and attitudes that may enhance my creativity.

Healthful Choice Options

When we find ourselves in stressful or anxiety-producing situations, we may find it helpful to consider some of the skill and strategy options available in recovery to help us to make the most healthful choices among possibilities. Here are some to consider:

- detachment or semi-detachment
- setting and maintaining healthful boundaries
- setting limits
- keeping the faith
- choosing to use our gifts or art over giving our energy and resources to our shortcomings and addictions
- saying no to things we don't honestly want and yes to things we honestly do want
- letting go of things we cannot change
- trusting in the outcome or our Higher Power's plan of goodness for us and our art, even if we don't know what the plan is
- listening to our feelings
- prayer and meditation
- asking for what we want from others, ourselves, and God
- seeking balance by loving ourselves exactly as we are
- focusing on ourselves (what do I feel, think, and want?)
- talking about our fears
- looking for the good or the gift in any situation, no matter how small the good or gift may seem
- treating ourselves gently with acceptance as our goal

- examining our attitude for open-mindedness
- seeking creative solutions by brainstorming options
- practicing healthful self-care
- others

This list may serve as a beginning. You might add others here as you become aware of those that work for you:

Perspective and Focus

Visual artists know instinctively that an item in the foreground of an artwork is clearer and sharper than those in the background. Perspective is enhanced by giving clarity to things that appear closer to the viewer and blurring those in the distance, for that is how they appear to the eye.

We might observe that the same principle could apply to our lives as artists. The issues with which we struggle in our present reality are given focus in our present perspective. As we work through them, their intensity lessens, we let go of them, and they become only a part of the blurred background of the total picture of our lives. They become part of the perspective of the picture rather than the main focus.

When we learn to put problems in a more healthful perspective, we are able to free ourselves to live more creatively and to focus on expressing ourselves and our art in the moment. We solve one problem or challenge, let go of it, and move on to the next. It is how the perspective that is the picture of our lives is revealed.

✣ ✣ ✣

God, help me to see my life and my struggles in a more healthful and open-minded perspective, as part of the total picture of who I am. Please help me to trust that your plan for my life and my art is one of goodness, even if it may not feel good right now.

Quietly Stoking
Our Own Artistic Fires

Some artists learn the gentle gift of keeping our ideas to ourselves and nurturing them as a loving parent would do with a longed-for child. Patience is often the most necessary artistic skill we can cultivate as we encourage our inspirations to mature from the germ of an idea or fantasy in our imagination through the gestation process or production.

Some of us learn that the best ideas are often not the ones we make public and allow others to taint with their "shoulds" and "Why don't yous?" but the ones we keep inside until the time feels right for their emergence.

Like a gentle fire we don't want to proceed to a blaze and burn out, we learn to feed our art with just enough fuel so that it can burn gently, keeping the fires of our enthusiasm warm enough for our passion to remain balanced. Only when the time feels right to us do we offer our art for exhibition.

❖ ❖ ❖

I can quietly stoke my own artistic fires so that my passion can remain balanced. When I am ready, I can choose to share my art with others.

Availability

Many artists struggle with issues of learning to balance being available to others and being available to our art. Sometimes we balance it on a moment-to-moment basis. When we feel inspired and our art is flowing, we may choose not to be as available to meet others' needs. We may need to be alone to serve as a channel for our artistic interests as they arrive in our awareness.

Other times we may feel more open to being with others, to being available to hear their needs, and perhaps, if we choose, to meeting them. The choice is ours.

Often we learn as artists, if we are not available emotionally when our artistic juices are flowing, the idea or inspiration is lost and we cannot recapture it. So we learn to become available when we hear the artist's voice within us. We learn to listen to it, even if it means we need to become unavailable to others around us who are capable of taking care of themselves. For those who are not capable of taking care of themselves, we often find others who are willing to give the care that is necessary.

✦ ✦ ✦

I can learn to trust the artist's voice within me. I can develop the art of being available to it. I can serve as an available channel for God's gifts to me as I feel inspired.

A Prayer Idea

Fill In the Blank

Great Creator, Eternal Mystery, Gift Giver, Guide of My Path to Goodness,

I come to you humbly requesting your Divine Assistance. I ask you to use me as a channel for your goodness. I acknowledge that I am powerless over outcomes, people, places, and things, and that you are the loving source of all powers, without and within.

I ask for your help in the following areas of my life, my relationships, and my art:

I am willing to trust that you will reveal to me, in your own time and way, healthful answers for each of my concerns and opportunities. Please know that I trust the outcome as your way and your will for my life, my relationships, and my art. I will wait patiently until I recognize peaceful answers for what I have asked. I am grateful for your connection to me, and for each gift you entrust to my care. Thanks for caring about me.

Listening to Our Emotions

One of the difficult lessons in recovery is learning to listen to our emotions. We may have denied them for so long that it becomes like learning a new language—the language of our feelings. We need to work at it and practice it, just as we would if we were learning any language new to our awareness.

There are lots of books on the market on the subject of emotions, each with its own approach. Like any other language, reading the text is only the beginning of learning the skill. It is the application to our lives and practice of the skill that can lead to the benefits of learning it. Like any language, too, time and patience are often the best teachers.

Many support groups exist that can offer the skills to those who are willing to invest their time and emotional energy. The benefits of learning to listen to our emotions can be many. We may find ourselves saying yes more often to things we want; no to things we don't. We may find ourselves creating, from our honest healthful choices, the artistic life we only dreamed of but have yet to experience. Our emotions may lead us to being exactly who we are—full and feeling human beings living unique, creative lives as we feel guided by our Higher Power.

❖ ❖ ❖

I can learn to listen to my emotions. I am open to trusting that my feelings are a gift from my Higher Power. I can be patient with myself as I learn the new language of being honest about my feelings.

New Levels of Knowledge

Some of us remember the feelings involved in learning to drive a car. There was the longing for the freedom that would be ours when we could travel alone. There was the fear that we might hit another car if we didn't stop soon enough. There was the frustration of learning the coordination of our hands, feet, and eyes.

With courage, we kept working at it, learning new lessons each time we practiced, until now we can do it all without much thought. It feels natural and easy to us. Some of us can even drive a stick shift. With time, patience, and practice, we have broken through to a new level of knowledge and learned a new skill.

We might compare our artistic recovery lessons to learning to drive. We come in to recovery longing for the freedom to be who we are. Many of us are afraid to let go of our addictive behaviors because they are the only behaviors we know. They are what is familiar to us, even though we don't like the pain that accompanies the familiarity. We see others who are healthier and enjoying life. We admire and want the peace, joy, and serenity we see them model, just as we once wanted the freedom that learning to drive could bring to our lives.

We feel the frustrations as we try new recovery behaviors. With courage, we learn the maneuvers of setting and respecting boundaries, saying no and yes as we honestly feel them, letting go of attempts to control people, places, and things, and other skills and strategies. Sometimes we succeed and own our honest power. Sometimes we regress and need more time, patience, and practice. We can learn to accept that, too.

We're still learning lessons. We're working on the coordination, just as we did while learning to drive.

We keep working at our recovery, applying the skills and strategies to our everyday situations. We're learning the art of driving and maneuvering our own lives in health-enhancing ways. If we haven't reached the new levels of knowledge we want, we keep on practicing, just as we did in our driver's education situation.

As we master one level, there are always new lessons to learn—new levels to work toward. Just as in learning to drive a car there are new vehicular refinements to become familiar with—electronics, new driving patterns, new places to go—there are always new things to learn.

Similarly in artistic recovery, there are new levels of awareness, deserving, and understanding awaiting our exploration. We can examine a multitude of emotions and ideas. We can learn new and more effective ways to take care of ourselves and our art. We can experiment with new artistic endeavors. There are any number of new levels of awareness awaiting us if we choose to work toward them. Life is full of possibilities if we are willing to see them, just as when we learned to drive a car and broadened our horizons.

❖ ❖ ❖

God, please open my awareness to new levels of knowledge and understanding about my creative choices and my self-expression. Thanks for caring.

Making Space for Our Art

We may need to work through issues involving making space for our art that discourage our creative expression. We may need to rearrange furniture or get rid of some of it to set up that quilt frame or weaving loom that would bring us pleasure if it were put to creative use. We may want to transform a sunny window into a mini-greenhouse and try growing the orchids we adore.

Making space may refer to more than physical space set aside for our art. It may involve making time in a crowded schedule to do that which brings us pleasure. It might mean making space in a tight budget to allow for exploration of areas of artistic interest. It could mean encouraging oneself to go on a spirituality retreat if that might bring a more personal relationship with one's Higher Power.

When we learn to hold ourselves accountable for our lives and our art, we no longer blame others for discouraging our creative efforts. We find it more healthful to examine issues that stop us from expressing ourselves. We honestly and creatively consider the choices available to bring about the desired changes. And we take responsibility for making space in our lives for our art in many ways.

❖ ❖ ❖

I will meditate today on whether I need to make space for my art, including new art forms I might like to try. I will consider physical, time, budget, spirituality, and other needs as I become aware of them.

Mutuality in Relationships

Some artists find difficulty in learning to balance the healthful give-and-take that can nurture a meaningful relationship. Some of us may have become addicted to giving—trying to find love for ourselves by compulsively giving our time, energy, and attention to others. Many of us discover that our art is the victim when we give to everyone but ourselves.

Others of us may suffer because we have not learned how to receive in healthful ways. We discourage love from others, from our Higher Power, and ultimately from ourselves, because we have not learned to trust anyone, including ourselves. In the process, we also discourage our creative flow. We become closed to receiving inspiration, spiritual guidance for our creative endeavors, and help from others who are willing.

The lessons of artistic recovery can lead us to discover meaningful ways to open ourselves to mutuality in relationships. We can nurture the trust that is essential for a balanced feeling of give-and-take in our relationships. We can learn and use the skills and strategies of communication that serve to enhance our relationships with others, with our Higher Power, and with our creative selves.

❖ ❖ ❖

Today, I will consider the idea of mutuality in my relationships. I will meditate and pray for guidance to feeling a healthful give-and-take in all my relationships.

Our Recovery
May Threaten Others

When we begin to recover, to set boundaries and own our healthful, God-given power to be exactly who we are, others around us may try to sabotage our efforts. They may be uncomfortable with our new self-acceptant attitude and feel envious of our attention to our creative gifts and personal self-care.

They may describe our personal power to choose as being mean or selfish. They may try to use guilt or shame to control us and, perhaps, reclaim the unhealthy power they once may have had over us. We filled a need for them, possibly, and they now feel abandoned. What we now choose to claim for ourselves, they want. It is our freedom to be who we are.

We cannot afford to allow their feelings about who we should be for their benefit to reactivate our old self-doubt. We have fought too many courageous battles in our recovery thus far to permit influences outside ourselves to undermine us or our art.

We have come far enough to set boundaries that safeguard our valuable gifts from destructive forces that discourage our best interests. Retaining our power requires diligence on our part to not allow sabotage to undermine our artistic recovery. We can stand up to protect ourselves and our art.

MAY

❖ ❖ ❖

If there are people around me who want to sabotage my recovery efforts, I will diligently guard my boundaries. I will trust that their Higher Power is guiding their path to goodness, just as I trust that my Higher Power is keeping me safe.

Artistic Instincts

Many discouraged artists have learned not to trust our artistic instincts—those sacred natural feelings inside us that know what the perfect expression of our art is like. In our pasts, others may have judged us or our art according to their preferences or ideas, which may have differed from our own preferences and ideas. We learned to trust their judgments, rather than our own.

Some of us may have learned to honor the dictates of authority figures over our own judgment. We may have been shamed into thinking our art was not good enough. We may have adopted competitive attitudes that compare our art to others' art or standards, rather than accepting our art on its own merits.

We can learn to reclaim our artistic instincts in recovery. By learning to honestly own our God-given power in healthful ways, we reconnect with our instincts. We learn to trust our boundaries and choose to believe that our art is perfect as it is, in the moment. We examine and work through old feelings that may have devalued our artistic expression as we feel it. We cultivate skills and strategies that support our acceptance of our art and ourselves.

❖ ❖ ❖

I can learn healthful skills and strategies to reconnect with my artistic instincts. I will seek one way and concentrate on it just for today.

God and the Unexpected

Some of us may be quick to blame God for our troubles when things don't go as we had planned. We sometimes lose faith and say, "Oh, God, why did this have to happen to me?" We lose our spiritual balance until we become ready and willing to return to acceptance of reality.

We may not be as quick to give God credit for our unexpected gifts. Thinking it may take years to obtain something we desire, by unexpected positive circumstances we get it sooner than we had planned. Some artists see this as God giving us a gift. Perhaps we long for painting lessons, for instance. When we see an ad in the paper for painting classes at a nearby art organization, we might think of it as a coincidence. Some of us, however, choose to perceive acts like this as God giving us an unexpected gift.

Some of us learn to accept these unexpected gifts from God as a sign that powers greater than our own are guiding our lives and our art toward goodness. When we become open to God's will for our lives and our art, we become receptive to and accepting of the unexpected. We learn to express gratitude and to trust that life is good. We have faith that our needs are being and will be met, sometimes in unexpected ways that bring joy to our lives.

❖ ❖ ❖

I will consider, today, whether God has been working through me for my good without my acknowledging it. I will express my gratitude for each gift, spiritual and physical, as I perceive it, from my Higher Power.

We Do Not Have to Agree

Some of us may have learned that to have meaningful relationships, intimate or otherwise, we would have to agree on everything. We may have been told that we need similar interests, likes and dislikes, belief systems, etc., for any relationship to work. We may have negated meaningful relationships for this reason, thinking we need to be alike or agree on everything to relate to others.

Some artists discover that this is not true. As we learn to open our minds to God's infinite variety of people, we begin to see others as unique individuals who are the sum total of a huge variety of choices. Perhaps it is in the pulling together of our honest, healthful choices that each of us defines our uniqueness.

God did not merely create one flower or tree but a huge number of both, each with its own color, texture, shape, perhaps fragrance or fruit—an expansive number of choices. So it is with people—a huge variety of sizes, colors, preferences, combinations of gifts, and expressions of our personal styles and choices.

Each is unique. No one is any better or less than another. Each is merely different from the other, though there also may be similarities. We can learn to accept our differences and embrace the gifts each has to offer the other if we are open to them.

❖ ❖ ❖

Today, I will practice being open and accepting of God's infinite variety. I will see my own and others' uniquenesses as each person's gifts.

A New Approach

Sometimes a project or situation can benefit by our trying a new approach. Here's one recovering artist's story:

"My husband asked me to help remove a splinter he had been trying to remove with no success. He had pried at it, tried tweezers, and dug around for a while, but it would not budge.

"I used a new approach. I squeezed the area, and the splinter popped right out."

An issue that is weighing down communications can be let go of. A stressful situation can be borne by prayer. Humor can lighten a tense mood. We can rest when we are weary. We might take a break from each other, or the issue, or our art.

Our creative endeavors may grow in unexpected directions when we try a new approach. Maybe we need black instead of white. Perhaps pulling can work where pushing didn't. Maybe stopping where we are is a possibility. Perhaps we call the project completed when we don't know what to do next. Sometimes turning what we are struggling with over to our Higher Power brings unexpected positive insight.

By letting go of our limited and controlling thoughts and actions, we open our minds to a variety of options. Often a new approach is revealed when we get peaceful and calm enough to listen to our inner voice, our Higher Power.

❖ ❖ ❖

I might try a new approach with a project or relationship issue with which I am struggling.

Opening Ourselves to Learning

Artistic recovery provides many artists with opportunities to educate ourselves with effective skills and strategies for managing our lives and our art. Many of us are guided to recovery because of ineffective communication skills that have left us feeling powerless and uncreative.

Some of us may think we're too old, or too busy, or have other reservations about whether we are capable of change or spiritual growth. Many artists grow through these and many more fears. We discover the courage inside ourselves to face, feel, and resolve our feelings.

We go on to learn and practice a variety of skills and strategies that guide us to empowerment. We learn and practice healthful communication patterns that serve to manage our lives and our art to the highest good. We become open to continuous learning about what is possible, what we deserve, what choices are available to us, and who we honestly are.

❖ ❖ ❖

I can open myself to my personal education of skills and strategies that may lead me to increased creativity and positive self-acceptance. The degree that awaits me for my willingness to educate myself is the degree of peace, serenity, and open-mindedness my Higher Power wants for me.

Learning a New Song

We may have learned to sing a self-defeating, woeful, suffering, victimizing song by being around others who embraced these attitudes as the truth of the way life is. Most of them didn't know that change was a possibility, so they may have accepted their woeful fate without making any effort to change it.

It has been said that artists are often the agents of change. We are given imagination and audacity by our Higher Power to seek new ways of thinking, feeling, and being. We are gifted with the conception that something better may be possible if we experiment in healthful ways with reality, rather than always accepting it as unchangeable. Perhaps God grants to artists our prayer seeking the wisdom to know the difference between the things we cannot change and the things we can, if we are courageous enough to ask in faith.

We can learn to sing a new song of choices. Our new tune is bolstered with notes of taking care of ourselves and our art. We learn many ways to respect ourselves and others, and of trusting that God is guiding our paths. We let go of the self-defeating song we once knew and embrace a new melody of self-enhancement. We may need to hum the new tune first, as the notes feel unfamiliar. Over time we master phrase after phrase of the new song, until all phrases become joined, familiar, and comfortable. Then we sing our new song with confident self-acceptance.

We go on to serve as role models by singing our new song of who we are for those around us. We offer our experience as a gift to our Higher Power for entrusting it to us. We express

gratitude to our Higher Power for the message of the new song by being who we are.

❖ ❖ ❖

Thank you, God, for teaching me the new song of artistic recovery. Help me to sing the new song by being the creative person I honestly am.

P-A-I-N

An acronym:
Pay
Attention;
Inventory
Necessary

When we find ourselves in physical pain, we are quick to seek help. We go to great lengths sometimes to alleviate our discomfort as quickly as possible.

Some of us hold on to our emotional pain, however, for great lengths of time, sometimes denying that it exists at all. We may feel embarrassed to ask for help or admit that a problem exists . . . until the emotional pain becomes unmanageable. Then we may begin the work of recovering our unique, creative selves.

In artistic recovery, we can learn the necessity of paying attention in our lives. One of the strategies we learn is that of taking an inventory as a means toward greater management. Many times, we may find, we already possess the skills or gifts we need to move from pain to peace, but we have forgotten to put them to use. Other times we learn or develop them as a means of taking better care of ourselves and our art.

❖ ❖ ❖

If I am in emotional pain, I can pay attention to my self-care. I can take inventory as a way to begin the healing process and move toward creative growth.

Validating Myself and My Art

Some artists among us may have learned to validate ourselves and our art by looking to others. Others' opinions, values, needs, and expectations for us or our art, or their likes and dislikes, may have shaped the way we learned to accept ourselves. We may have learned that others' perceptions of us and our art are more valid than our own.

In recovery we learn to separate our validation of ourselves from external sources. We learn to set healthful boundaries that guide us to discover our own true nature or spirit as separate, possibly different, from those around us. We learn to detach from those who may want to influence us or our art for their own purposes, if they are different from our own. Many artists learn that we have a right to make our own healthful choices on a wide variety of issues and artistic expressions.

We learn to validate ourselves and our art by looking inside ourselves, not outside. If we like it and it is healthful, we trust that it is fine, even if others disapprove of it. If their values and opinions are different from ours, we accept that we are different by choice. Neither is right or wrong, better or worse. We are only different.

If others have needs and expectations for us that do not fit our needs and expectations for ourselves and our art, we might choose to do some clarification work to resolve our issues. We decide to whom the issues honestly belong. We each may discover that our healthful perceptions of ourselves and our art are valid. We can learn, with patience and practice, to validate ourselves and our art.

MAY

❖ ❖ ❖

I am grateful, God, that you are guiding me to healthful lessons that teach me to validate myself and my art. Thanks for caring.

Exploring Our Choices

Our lives can become enriched if we can learn to embrace an exploratory attitude about our choices and options. Choices are not written in stone with exacting outcomes, as some of us may have come to believe. The outcome of any of our choices, or combination of choices, is God's business, and not ours.

When we feel overwhelmed in making decisions and choices, there are skills we can use to manage our anxiety. Some artists find we can begin to quiet ourselves and our racing thoughts by taking a brief meditation break. We may begin by imagining a stop sign in great detail, focusing on the colors and shapes.

We might pray for guidance for the feelings that concern us. Some of us learn to write out our worries, perhaps making lists of the pros and cons of related issues that lead us to make a choice. We open ourselves to considering alternatives. We encourage healthful decision-making by examining our feelings and listening to what we feel guided. When the time feels right, we make a decision, trusting that we have been guided by our Higher Power through our feelings.

❖ ❖ ❖

Teach me please, God, an attitude of healthfully exploring my choices. Guide me to lessons of trusting my feelings as a gift from you. Thanks for caring.

Self-Sabotage

Just as others might try to sabotage us or our artistic efforts, we, too, can sabotage our own artistic recovery efforts. Unless we have achieved new healthful levels of awareness and deserving in our souls, we may unconsciously undermine our own recovery efforts by retreating to our old self-defeating ways of thinking and feeling.

Our art may be unfolding at a great pace, for example, when suddenly we lose interest or desire. It is possible that, on an unconscious level, we may have connected to an old message that says we don't deserve the goodness our potential success may bring to us. We are sabotaging ourselves.

Someone, or God, may be offering us just the supplies, guidance, or inspirations we need to fulfill a creative dream. How do we handle it? If we are in a self-sabotage mode, we say, "No, thank you," even to God's mysterious gifts to us.

When we get healthier and learn to recognize these self-sabotaging behaviors in ourselves, we choose to say, "Oh, yes, thank you." And to God, we offer our gratitude for the gifts and the goodness extended to us. Then we use our gifts to express our gratitude back to God.

It is a difficult lesson for some artists to learn to get out of God's way enough to accept goodness for our lives and our art. It is far easier for some to return to sabotaging ourselves by our old limiting negative behaviors and beliefs. Faith is asked of us to believe that we deserve God's goodness in our personal and creative lives. Though the lessons seem difficult, their messages can bring peace into our lives and our art if we become willing to learn them.

❖ ❖ ❖

God, teach me to get out of your way when my old self-defeating messages stop me from receiving your goodness and your gifts. Thanks for caring.

Cherishing Ourselves

Some artists may have learned, erroneously, that being hard on ourselves will make us strong. We may have become good at not expressing our emotions, thinking this will make us strong. It won't. It will discourage us creatively. In blocking our feelings, we block off valuable spiritual parts of ourselves. We become less than whole.

In recovery we may learn to replace the toughness we've given ourselves with gentleness and kindness. We learn to express our feelings as a way of sharing who we are. We learn to take care of ourselves emotionally as well as physically, financially, artistically, and many other ways. Many of us find that as we cherish ourselves, a circle begins in which we learn to express ourselves more creatively, using our own unique gifts. The gifts complete the circle as we embrace ourselves for our own creativity.

❖ ❖ ❖

Teach me, please, Great Creator, ways to cherish myself and my art.

The Continuing Lessons
of Recovery

Artistic recovery is not a short-term plan to repair a broken state of mind. It is a means of preparing us to learn that life is full of continuing lessons of creativity.

There are lessons concerning how and when to attach and detach; how much to invest emotionally in ourselves, our art, and others; how and when to recognize and set limits and boundaries; and how to make healthful choices that enhance the quality of our lives and our art. Each of us defines the skills and strategies that bring those lessons to healthful consequences for us.

By employing the skills and strategies that may be missing in our communications, we learn to move forward peacefully in our lives. We are not finished, however. Our Higher Power leads us inevitably to new lessons and potential for artistic and spiritual growth. Many artists learn to call the process life and choose to open ourselves to it to the fullest.

❖ ❖ ❖

I am grateful, God, for the perception that life is a series of continuing lessons to be learned. I am aware that recovery offers skills and strategies to help me to learn these lessons and to grow.

Cultivating an Attitude
of Gratitude

Just as a garden needs the attention of caring cultivation if it is to thrive and grow to maturity, so does our attitude need caring attention if we are to grow to feeling grateful for being who we are. Some of us may have accepted attitudes of self-abuse or self-neglect as reality by modeling ways we saw those around us behaving.

We may have learned to survive our situations by adopting the prevailing attitudes of suffering, denial of our gifts in favor of investing in our shortcomings, and neglect of our spiritual selves by lacking faith in a power greater than ourselves.

We can gradually change our self-defeating survival attitude into that of healthful gratitude for being uniquely who we are. We can cultivate a new attitude by honestly examining our feelings. Some of us find artist support groups to be encouraging of our artistic development. We learn to honor and use, rather than deny, our creative gifts. We reeducate ourselves to focus on the things that are positive in our lives and our art. We express our gratitude to our Higher Power for them, no matter how small or large they seem to us.

❖ ❖ ❖

I can begin to cultivate an attitude of gratitude right now by looking for one positive thing in my life and my art. When I dis-

cover it, even if it is as simple as knowing that I have choices in a situation in which I might not have seen them before, I can express my gratitude to my Higher Power for this gift. I can gradually begin to focus more often on positive things in my life and my art.

Opening Our Creative Channels

Many artists arrive in artistic recovery with only a vague idea of what our gifts are. We may have only a dim awareness of the possibility for our creative development. Our art may feel unmanageable and our ideas impossible to achieve because we might have unresolved issues from our previous development that have served to discourage our current creative efforts.

Much of the work of our creative evolution is spiritual. Some of us find that our willingness to bravely examine our expectations, limitations, and fears guides us to define more clearly who we are as creative individuals. We work to "clear away the wreckage of the past" as a means of viewing the present from a more open perspective. We courageously work through our old feelings to acceptance and learn to build upon the lessons our pasts have revealed to us.

We learn to "do the best we can with what we have where we are" and trust the rest to God's care. We work earnestly at establishing and nurturing our connection to God, as we under stand God to be. And we follow God's lead, as we feel it by our attention to our feelings, choices, and healthful desires. Many of us find that when we learn to be more honest about who we are, our art seems to express itself spontaneously. We serve as a channel for the spiritual energy that lies in waiting within our souls.

✦ ✦ ✦

God, please guide me as I examine any discouraging expectations, limitations, and fears that have become attached to my creativity. Help me to connect to the courage to change the things I can so that I can become a willing channel for your artistic gifts to me. Thanks for caring.

Judging Ourselves and Our Art

If we grew up in an atmosphere of judgment, criticism, or argumentation, we may have learned to judge ourselves and our art constantly. We may still cling to patterns of communication that criticize ourselves and our art and find a lack. We may argue with others to defend our beliefs. We may have been taught to strive for perfection rather than learning that we have choices.

These and other early lessons may have an impact on our lives, relationships, and art today. Unless we examine our feelings surrounding these early lessons, we may not be aware that we have choices in our approach to creative and relationship undertakings. We may unconsciously believe that unless things are done in a certain way, they are not right or good enough. We may believe that our way is the only way, unless we become willing to do the emotional work to resolve these old self-defeating feelings.

We can, if we choose, use these early lessons to our best good. We can work through our feelings of anger that resulted from the early lessons and arrive at acceptance and peace about our art, our relationships, and ourselves. We can learn that many choices exist as we approach our endeavors. We can define who we are by making honest and open choices based on our wants and needs now, not by the limited beliefs we may have learned in the atmosphere of our early development.

MAY

❖ ❖ ❖

Today, I will be open to and listen honestly for old messages that limit my choices. I will pray for the courage to work through the feelings surrounding these old lessons. I will express my gratitude that I am becoming open to choices that guide me to be who I am.

Hitting Rock Bottom

Some of us artists had to hit rock bottom before admitting that our lives were not as good as the appearance we worked hard to show on the outside. We may have hidden our true creative selves behind our addictions and compulsive behavior. Some of us didn't even know that there were mysterious gifts waiting for us when we got honest with ourselves. We were too busy trying to control people, places, and things . . . until our behaviors no longer worked for us to hide behind. Then we admitted to the unmanageability of our lives.

We found the courage deep within ourselves to take that first important step by admitting that we needed help in managing our lives and our art. Some of us got into therapy and support groups and met others just like ourselves who were struggling with issues of learning to manage our lives and art. We also met others who had previous experience with the struggle and had moved on to lead productive and creative lives. We listened to them and learned that there is hope for our creative development.

But first we needed to admit that we needed help so we could learn from the inside the lessons we needed about our own honest, creative expression.

❖ ❖ ❖

I am grateful, God, that after hitting rock bottom, I have been guided to the peaceful place that is my life and my art today. I ask you to guide other artists, who are seeking it, to the same peaceful place you have guided me. Thanks for caring.

STOP

Now I sit me down to rest
Because I know I've done my best.
If others expect me to work till I drop,
I let go of their expectations and tell myself to STOP.

"S" is for spirituality.
I listen till I hear my Higher Power
Guiding me quietly to a meditation hour.
"T" is for trusting the message I hear;
Following peacefully the feelings that are clear.

"O" is for options. I consider them all.
Then I listen for the healthful choice that sounds best of all.
"P" is for patience which comes from inside.
If I look for it, I find it. That cannot be denied.

Now that I've rested it's time for me to be
A channel for God's creativity.
As a token of my gratitude,
I can create my art with a fresh, tranquil attitude.

Days of Special Remembrance

JUNE

Healthful Giving

We can learn to give in healthful ways, without neglecting ourselves and our art, feeling victimized, or having feelings of guilt, obligation, or choice-denying duty, as part of the process of our giving. There is a healthful balance to strive for in giving, just as in everything else we explore in our artistic recovery. The challenge for each of us is to find the healthful balance that works in our best interests.

Our feelings can guide us as we work toward that balance. We might question ourselves: Do I feel controlled when someone asks for something that is mine? Do I know I have a choice to give it or to say no? Others may ask for money, food, our time as a volunteer, a donation of our art or artistic talent, or other things. We have a choice of saying no to any request that doesn't feel right in the moment.

If we honestly choose to give of ourselves, that is an okay choice, too. Our willingness to give can enhance our relationships and perhaps open opportunities for our art. We can enjoy the sense of sharing, of community effort, of nurturing others with our gifts. It is the feelings connected to the act of giving that will determine its impact on our lives and our sense of balance.

❖ ❖ ❖

God, please guide my path to the lessons of healthful giving. Teach me to listen to my feelings as I consider the issue of giving, so that I can be who I honestly am in my relationships.

Growing Experiences

Life is full of growing experiences. We can learn to be grateful for them and find the willingness to allow them to unfold in our lives.

But at first some of them may hurt. We may feel angry or resentful in a relationship or artistic undertaking until we work through our feelings to accept these situations as a part of the process of life, living, and creative development. Often we are feeling growing pains. If we can work through our pain, we can experience growth, personally and/or artistically.

An open and trusting attitude can ease our transition. If we resist the pain or the process, or deny our true feelings, we only increase our anxiety. We can learn to identify our feelings, express them, work through and resolve them, and eventually heal from our pain. Sometimes our feelings can be expressed creatively, perhaps verbally, by journaling. Other times we may put our emotional energy into our art. The choice of expression is ours. With time and experience, we become more open to growing experiences and welcome them as a part of life.

❖ ❖ ❖

I can learn to trust that the experiences I encounter are teaching me lessons for life. I can identify the lesson and find ways to use the lesson in my life and my art.

Gratitude Abuse

Gratitude can be an empowering feeling when we learn to use it healthfully. We learn to connect with our souls by feeling grateful to be exactly who we are. We can own our gifts and learn to use them. We can genuinely feel grateful that we are connected to our Higher Power and open to receiving our gifts. We can express our sincere gratitude to others for the gifts, compliments, help, support, and other things that enrich our lives, relationships, and our art. These gifts can serve as tangible evidence of the value and respect we feel in our connection to others.

Some of us, however, may compulsively feel we need to give to others because they have given to us. Gratitude is not about owing others or paying debts we feel we may have incurred. It is merely an expression of appreciation for something we have received. We have a choice about how we express our gratitude.

Some artists may take gratitude to an extreme. It is possible to become so grateful for small gifts and ideas that we blind ourselves to larger ones that await our owning them. We can learn to express our gratitude and move on, in God's way and time, to open our minds and souls to the next gift that awaits us. There is no need to become a gratitude martyr. We can learn to say "thank you" genuinely, and then open ourselves to the next gift.

❖ ❖ ❖

Today, I can examine whether I may be "martyring" my gratitude. If I say "thank you" once genuinely, even to my Higher Power, I can let go of it and open myself to receiving the next gift.

Owning Our Power to Be Who We Are

We may need to learn some difficult lessons about owning our power. Some of us have learned to give away our personal and creative power to people who may have intimidated us. We believed these people were stronger than we were or could make better decisions for our lives because of powerful messages we may have learned years earlier.

We may need to detach from these people, or the ideas and attitudes they have brought to our lives, at least until we learn that our power honestly belongs to us. Some of us learn that we can choose to be who we are even if others have different expectations for us or our art. We set healthful boundaries concerning what we are willing to do for and with others in order to take care of our personal and creative selves first.

The lessons take time and practice. We may try and fail. We can try again. We can try many times, if necessary. We will know when we have succeeded. We will be able to love and respect ourselves first. We will own our power. We will respond to others and our art by making healthful choices, not from fear or intimidation, but because we know we have a choice. We will know the freedom to be uniquely who we are.

❖ ❖ ❖

God, please guide my path to lessons of owning my God-given power. If I feel powerless, teach me to trust that you are already guiding me to the lessons, if I am open and willing to see and learn them. Thanks for caring.

The Courage to Change

When we pray earnestly for the courage to change the things we can, we may be opening ourselves to increased goodness in our lives and our art. The pathway to these changes may involve extensive willingness or diligent emotional, physical, or spiritual work on our part.

We may need to become courageous enough to examine and accept our shortcomings and understand the role they may play in undermining our God-given gifts and talents. We may need to become courageous enough to set and maintain boundaries, so that we learn to support the expression of our art, as we feel it. We may need to become courageous enough to trust that a loving and caring God wants the best life has to offer us and our art.

When we connect with the God-given courage that waits inside ourselves to change the things we can, many artists feel empowered to carry out God's will as we healthfully perceive God's will to be for us and our art. We may express our gratitude for the courage by using our gifts to our best ability.

❖ ❖ ❖

God, please grant me the courage to change the things I can. I will trust your way and your timing for what I perceive as your healthful will for my life and my art. Thanks for caring.

Recovering Gently

Our artistic recovery can unfold and progress gently, in its own time. Each person's recovery is different, everyone learning unique lessons that will lead to peace and security about ourselves and our art. Each lesson is revealed to us when we are ready to learn it.

We are not working toward a specific educational degree or striving for a perfect grade, or to recover better than others. We are living our recovery. We learn new lessons of taking care of ourselves. Then we put them to use in our lives and our art. We may learn lessons of setting and maintaining boundaries. We may go on in recovery to learn about new levels of deserving. We discover and work through ways we may have been discouraging ourselves from receiving the goodness God believes we deserve.

We define our unique gifts. We learn to put them in a healthful perspective in our lives, encouraging space for their growth. We learn to balance our lives and our art in an infinite number of ways.

Many artists find the courage to let go of the controlling behaviors that have served to discourage our spontaneity and spirituality. Gently, we learn to trust that God is guiding our lives and that to get out of God's way is to open ourselves to a fuller and more creative life than we knew to be possible.

We continue learning and discover the attitude of gratitude that guides us toward peace with ourselves, our art, others, and our Higher Power. Then we learn even more lessons and continue growing.

The Artist's Soul

❖ ❖ ❖

Please help me, God, to recognize the gentle path of my recovery and to choose to go where it leads. Help me to trust that it always leads to goodness.

Artistic Flow

Art is like many of nature's other functions. It has its own natural cycles. We may experience dry seasons when the ideas or work simply do not flow. We may experience bountiful seasons of seemingly nonstop projects or imaginative visions.

Like nature, we cannot control it. We can learn to accept it and go with it peacefully.

Sometimes our artistic expression will change with new relationships. We may become inspired by others' examples or points of view. Sometimes our art will change as we age, or develop specific interests, or work through illness, or for no apparent reason. We do not need to try to control the changes. They serve a purpose. We need to learn to trust that we are being guided, even if we don't know where that guidance is leading. We may need to let go of thinking we can control the outcome. In its place, we can have faith that we are being guided to a good place.

If we open our minds and souls to the cycles of our art, the results will often surprise us. Because our art grows and changes in God's own time and way if we can allow it to flow spontaneously, we can maintain the balance and peace we are working toward in recovery. Fighting or denying the flow will only lead to self-defeating behaviors and negative thinking about ourselves and our art. We can learn to embrace the flow and encourage it to guide us as it will.

❖ ❖ ❖

I can learn to recognize the flow of natural cycles in my life and my art. I will meditate on maintaining my balance and pray for guidance to the highest good.

Loving Myself and My Art

We may have learned to treat ourselves and our art less than lovingly and respectfully. We can let go of these old behaviors and learn to treat ourselves and our art with more respect and caring.

If we have learned to push hard and drive ourselves unmercifully, we can learn to slow down and have compassion for ourselves. We can discipline ourselves to have periods of rest. We can schedule periods of play or relaxation, or quiet prayer and meditation times. Our art will often become more spontaneous when we give ourselves the gift of gentleness.

If we have felt deprived, we can learn to stop depriving ourselves and encourage ourselves to receive. We can budget for the things we want or need. Often, when we ask in a spirit of trust, things come to us at bargain rates or sometimes free. God works in beautifully mysterious ways, some artists learn.

We can change our self-destructive behaviors by learning to love and respect ourselves. If we need to lose weight to feel better about ourselves, we can learn new healthful eating and exercise habits. If we have put our art and creative expression last in our lives, we can claim time and make it a priority. We can make choices that reflect positive and loving feelings for ourselves, just as we would treat someone else with respect. We can learn to give to ourselves and our art, as an expression of self-love.

JUNE

❖ ❖ ❖

Today, I will examine myself and my actions for behaviors that are less than respectful and loving toward myself and my art. I will meditate on ways I might change that behavior. I will practice self-love.

Change May Be Frightening

The process of change is a frightening place in which to be for some artists. Reality as we once knew it was a safe place, even if it was abusive or denying of our artistic development. At least we know what that reality feels like. We may fear the uncertainty that accompanies any significant change.

As we change, we feel the loss of letting go of the old familiar reality. Until we reach our new place and come to acceptance of it as reality, we are in the unfamiliar territory of the changing process. We truly do not know what the future will bring until it arrives. Until we reach the new level of awareness, spiritually and emotionally, we are in the process of becoming what the changes will bring about.

We can learn to accept the process of changes as a part of life. Though we may not enjoy the unsettled feeling of uncertainty, we do not need to allow it to disrupt the balance of peace in our lives. By applying basic principles of recovery to our lives, we can learn to live through even major changes one day at a time.

We can learn to have faith that changes are part of the process of the unfolding of our lives. We can choose to trust that changes will, in God's own time and way, lead us to the highest good. We can learn to "let go and let God" lead us through changes. We can face and walk through the fear of change with our Higher Power's healthful guidance.

❖ ❖ ❖

It is possible to trust that change may bring goodness to my life and my art, eventually, if not immediately. I can become open to the idea that change may be part of God's plan for my life and my artistic development.

Authority Issues

Some artists may have learned to give our honest God-given power blindly to others. We have learned to listen to and obey implicitly the dictates of family members, significant others, teachers, other artists, physicians, spiritual leaders, politicians, and others— sometimes without considering that we have choices about what we believe. We may then feel frustrated or angry because we have given our power to them, sometimes at the cost of our own healthful feelings. We may have denied our artistic instincts in favor of others' authority.

We may have been taught to live in fear of the dictates of authority. Some of us have been shamed, punished, abandoned, or neglected when we challenged authority figures earlier in our development. We may need to work through these old feelings to learn to claim our honest God-given power.

In artistic recovery we can learn to define our boundaries with everyone, including authority figures. We can respectfully listen to their ideas and opinions. We can also learn to weigh their opinions in the light of our own truths, experiences, and perceptions. As part of our growth we can develop our own capacity for healthful, independent judgment or decision making, perhaps offering alternatives to existing patterns.

We can build honest relationships that value and respect our creative options and ideas while we respect those of others, including authority figures.

❖ ❖ ❖

Today, I will examine my feelings about authority figures. If I have blindly given my power to them without respect for myself, I will pray for guidance to awareness of my choices. I will listen for my healthful instinctual responses when I am in the presence of authority figures.

Blaming Others

Artists in recovery strive toward the emotional space in which we stop blaming others for the development of our art. We learn that it is controlling and limiting to say or believe "I can't express my art because this person or system . . ." (Readers may want to fill in the blank.)

When we claim full responsibility, with our Higher Power's guidance, we are on the path toward healing. We accept our own creative power as belonging within ourselves. We open ourselves to God's infinite creative goodness.

This does not mean that we need to do every single step ourselves and cannot ask for help. It is certainly within our power to ask openly for what we need for our art and our relationships. And if the answer is no or noncommittal we are free to seek elsewhere. Blaming others for our artistic efforts will only lead us to anger, frustration, and depression about our artistic attempts.

We can turn over to our Higher Power our old response of blaming others. By letting go of it, we open ourselves to becoming responsible for seeking creative ways of getting our needs met. We can choose to express ourselves based on our own feelings. When we learn to keep the focus on ourselves as capable, competent, and creative artists, rather than envisioning ourselves as victims of others' whims, we open ourselves to God's mysterious ways.

❖ ❖ ❖

Today, I will meditate on whether I blame others for my artistic endeavors. I will turn my response of blaming others over to God and pray for God's will for my higher good to be revealed.

Delegating Responsibility

Some of us may have the mistaken impression that taking care of ourselves and becoming responsible for our art implies that we need to do everything ourselves. While we do not want to burden others, we do not need to assume a martyr role either. Perhaps striving for a middle-ground attitude works best for recovering our sense of ourselves as artists.

We may think that besides being a singer, for instance, our role as parent means that we meet each of our children's needs and keep our home spotless for our family. Some of us may need to learn as our children grow older to delegate more and more responsibility to them—teach them to clean their rooms, do their laundry, and do a fair share of household tasks. This will lighten our load and teach them lessons of re-sponsible self-care at the same time.

We can also ask our partners and those in significant re-lationships for help, support, or what we want and need. We do not need to carry our load single-handedly. Our Higher Power can guide us to learning healthful ways to delegate re-sponsibility.

This process may encourage us by providing more time for our art. By doing the healthful things that bring pleasure to our lives—our art—we can become more emotionally available to those around us. We will also be teaching those around us the valuable lessons of self-respect and respect for others and their art.

JUNE

❖ ❖ ❖

If there is a responsibility I have taken on that can be delegated to others who are capable, I will consider steps toward achieving this delegation. I will trust that this would free up time and energy for myself and my art.

God's Love

If we have learned to feel unlovable from discouraging experiences in our development, it is possible to grow into feeling that God's love is available all around us. We can learn to encourage ourselves to receive it and feel it. Sometimes we need to make ourselves consciously aware that there is love available to us from a source greater than ourselves.

Our imagination is one of God's great gifts to artists. Some artists might imagine that water symbolizes God showing us love. We might imagine a gentle waterfall. The calmly tumbling water becomes God's love pouring into our hearts and souls, filling us with creative energy and positive, healthful thoughts about ourselves, our art, and others. We envision ourselves as God's children and sense that God has an endless supply of water and love for each of us.

We might imagine that there is no shortage of water or love from God. We will not deprive someone else by taking all the love or water we need or want. There is plenty for everyone.

We can take a bath in it. We can encourage ourselves to be surrounded by God's love, using water as a creative symbol. We can open ourselves to gratitude for the feeling of being loved. It is okay to empty the bathtub when we're ready. There is lots more. God has an infinite supply waiting for us. Many artists find that it is possible to learn to trust in God's love.

JUNE

❖ ❖ ❖

Today, I will soak up God's love for me and my artistic endeavors. I will trust that there is plenty available to me and all who ask for it. I feel grateful for God's love.

Filtering Our Listening and Reading

Some of us may have learned to believe that every word we hear or read is a truth we must accept. We may have been taught to trust authority sources over our own instincts. If someone in a supposed position of power wrote it or spoke it, we may reason, it must be true for us as well.

We can learn the recovery skill of filtering others' words for what feels true for ourselves. We can question, at least in our minds, whether what is being said is true for us. We might imagine a flag being raised when we read or hear ideas with which we disagree. Our Higher Power can lead us to trust our instincts. We may or may not choose to take action on things with which we disagree, perhaps depending on the level of intimacy we seek.

Other artists may learn to creatively envision life as a buffet of ideas. Each speaker or writer presents a dish of thoughts and feelings on a table before us. We can learn that we have the God-given power to choose from that buffet the things we believe or want to believe. We simply leave the rest on the table.

We may learn to filter out old truths or truths that belong to others and not ourselves and our current level of awareness. Sometimes we feel guided to replace old truths with new truths. We allow others' truths to belong within their boundaries. This is part of the growth process and is healthful.

JUNE

A personal note from the author:

Some readers may disagree with some or many of my words in this book. That is a healthful sign. The words are, in truth, nothing more than a collection of my words and my ideas. They belong to me, as the writer. Some of them may offend some readers. I accept that no one person can speak or write for everyone. Each person can choose to define a collection of respectful truths that feels right. That is what makes each person unique. In recovery, that is known as defining boundaries.

I invite disagreement with my words. I invite filtering of my ideas to find the truths that will encourage each person's creativity. I encourage active filtering by listening and reading recovery information and experiences to discover the truths that define individual uniqueness. I believe, mysteriously, each of us, though distinct from the other, is at the same time connected to each other by the Great Spirit.

❖ ❖ ❖

I can learn and use the recovery skill of filtering my listening and reading to discover my own truths.

Artistic Shaming

Out of their insecurities, others may degrade our art or its importance. They may find fault or imperfection, or tell us how they would do it differently. If we can learn the art of allowing their opinions and ideas to belong to them, we shield our boundaries from the self-denigrating consequences of shame.

We can safeguard our boundaries by learning to trust our own and our Higher Power's opinion of our work. We can feel secure in the knowledge that no one artistic expression is right for everyone. It is impossible to be all things to all people. When we embrace this attitude, we let go of the potential for shaming.

By simply being who we are—without trying to impress, compare, or compete—we can build a secure foundation for ourselves and our art. We can give others' attempts to shame us no reception in our lives and art. We can give them back to whom they belong.

❖ ❖ ❖

I am grateful, God, for the lessons I have learned about shaming and the effects shame can have on my attempts at artistic expression.

How Important Is It?

In artistic recovery we learn many new slogans that serve to guide our thinking about ourselves and our art. A slogan some artists may find helpful in maintaining a peaceful balance is "How important is it?"

Perhaps in an effort to control people, places, and things, we assign emotional importance to the things we try to control. Our need to control may stem from strong, unresolved feelings from our pasts, which have an impact on our actions today. This expectation of importance can weigh on the reality of the current situation. We feel anxiety because the reality may be different from the emotional importance we have assigned to it in our minds. We may have set ourselves up for a fall, emotionally.

If we can learn to approach situations with an open mind—free of emotional importance and preconceived expectations—we may see that there are more options and possibilities than we might have thought. When a situation is freed of the weight of expectations and unnecessary emotional importance, its relevance becomes open to a healthier perspective grounded in reality.

❖ ❖ ❖

If I am involved in a situation with a person, place, or thing to which I have assigned more importance than is necessary, I can ask myself honestly, "How important is it?" I can become willing to let go of its importance so that I can see reality more clearly.

Creativity and Productivity

Creativity is not confined to producing a finished product or service and marketing it as our art. Some artists may do just that. But creative expression can be more than that. Creativity concerns opening our minds to healthful possibilities and choices, ideas, solutions, feelings, inspirations, and awareness.

We can apply our creativity to situations, relationships, endeavors of daily living, spirituality, and our lives. By creatively exploring options, keeping our minds open, and learning to trust our instincts, our lives can unfold as the creative expression of our many choices.

We can learn to listen to and value our feelings, wants, and needs. By paying attention to them and following where they lead us, many artists are guided to our gifts. Whether we produce a marketable product or service, or express ourselves through a personal choice in a relationship or endeavor, we are still being creative.

❖ ❖ ❖

I can consider whether I am using my healthful creativity to its fullest extent in my relationships and all my endeavors of daily living. One of the many ways I take care of myself can be by expressing my healthful creative choices throughout the day.

Looking for Credit

Some of us may have learned to look for and expect credit or recognition from others for our art or other things we do. In artistic recovery many of us learn, for the first time, that this is not in our best interests. We learn to do our art or tasks for the internal pleasure and rewards they provide to us in the process of engaging in and learning from them.

Looking for and expecting credit can set us up for a potential letdown. If we emotionally connect our self-esteem to our art and our art receives a bad review or doesn't sell, or is not accepted by others, we have set ourselves up for self-defeating feelings and perhaps depression.

If we learn to feel good about ourselves only because we produce or create art, we may begin the same cycle. We can learn that what we do is not the sum total of who we are. We are much more than our art. We serve as a channel for God's creative energy through us. Who we are includes our feelings and our spirits in addition to the outward manifestation of our art.

If we spiritually give credit to our Higher Power, rather than seeking it for ourselves, we can relieve the burden of our self-esteem being at stake with our artistic efforts. We learn to practice our art for the pleasure it brings to our souls, not for any external rewards or credit. We adopt an attitude of expressing our art as an act of worship to God for entrusting the gifts to us.

❖ ❖ ❖

I can learn to express my art for the pleasure it brings to my soul and my life. I can give any rewards or credit from my art to God.

Choosing Peaceful Attitudes

Some artists learn that it is possible to live and create in relative peacefulness. We choose attitudes that reflect harmonious decision-making. We choose to spend our time with others who respect us and themselves and encourage each of us to be who we are.

We find that our art unfolds gently as we learn and practice recovery skills that support our artistic expression. We do not need to control, strain, force, rush, or exhaust ourselves for the sake of our art or for anyone else. These attitudes may belong to others, but we can make a conscious decision and effort not to own them for ourselves.

In making a personal connection to and learning to trust our Higher Power as we come to understand our Higher Power, some of us find that our energy shifts toward more and more peaceful endeavors. We have faith that we are being guided toward continued goodness. Serenity is the reward for our investment in that sacred trust.

❖ ❖ ❖

I am grateful, God, for the lessons that have guided me to choose peaceful attitudes. I ask for your continued goodness to me and my art as I continue trusting more areas of my life to your will. Thanks for caring.

Making Healthful Choices

Some of us have learned to live our lives based strictly on external cues. We may have watched those around us, followed their example, accepted their limitations and expectations for who we should be, and become who everyone else wants us to be.

When we experienced feelings or ideas that differed from those around us, we learned to deny them, cover them up with addictive or compulsive behaviors, or perhaps vented them in conduct that is abusive to ourselves, our artistic expression, and our personal relationships.

Many of us learn in artistic recovery that we can become open and receptive to our own choices, no matter where we are in our development. We educate ourselves to listen to our feelings and to trust that they are gifts from God that serve to guide our self-expression. We learn to set and maintain boundaries that support our own spiritual and artistic growth, even if those around us choose to be different, or not accept our choices. We learn to make healthful choices that show respect and love for ourselves and our art and honestly express who we are.

Some artists find that the practice of scheduling quiet times in our lives for prayer and meditation encourages our connection of our feelings and our own healthful choices. We reflect on what we want, need, and enjoy. We may consider consequences of our actions. We mull over ideas before and during our creative undertakings. We foster inspirations and better ideas from our Higher Power.

❖ ❖ ❖

I can begin today to learn to make healthful choices for my life and my art. I can manage my time so that I allow for ample quiet time to examine and consider my choices in my relationships and my artistic expression.

God Has a Sense of Humor

A Personal Sharing by the Author, Linda Coons

The God of my understanding is not a totally serious spirit. There have been times when I have felt enlightened in funny and mysterious ways. For instance, there was the time when my sister, whom people sometimes confuse with me, told me of her need to get a new shower drain stopper. The next day, in sorting through some things, I found a shower drain stopper. I called her and told her that even God had confused us—she was the one who needed it, and I was the one who got it. I saw it as God's sense of humor.

I have become aware that God's light touch helps me to not take people and things so personally. By lightening up my intensity, I am often able to see things in a much more open perspective. Things do not wear me down emotionally when I am able to frame them with light or humorous insights about them. I am able to loosen my desire to control issues and turn them over to God much faster when I see them in a humorous or light frame of reference.

The gift of laughter is one of the great freebies God gives to those of us who are open to receiving it. If we encourage ourselves to receive this gift, our lives and our art can evolve more spontaneously and gently than if we absorb the same thing in only a serious manner.

❖ ❖ ❖

God, help me to lighten up my life and my art by seeing the humor and lightness that is available around me. Please guide my path to the lighter side of my creativity and my unique nature. Thanks for caring about the fun, too.

The Beauty of Today

In artistic recovery, we can learn to appreciate the beauty of where we are right now in our artistic and spiritual development. We may have spent much of our lives bemoaning the things we don't have, downgrading the things we do have, and lost in "what might have been."

It is far more healthful and beneficial to become grateful for what we do have, today, right where we are. We can look around ourselves, right now, and find something or someone beautiful in our surroundings. We can open our souls to feel the specialness and sense the unique positive qualities in what we behold. We might savor the uniqueness and beauty and look for qualities like it everywhere we are guided.

As artists, we are the carriers of the message that beauty lies in the eye of the beholder. When we learn to behold the beauty around and within us, we are able to project that spirit into our art, no matter what form our art may take.

When we are open to the beauty of now, we receive the gifts of which we could make the best use. We find the meaning and purpose of our lives in expressing our gifts.

✦ ✦ ✦

I can become open to the beauty of today. I am willing to let go of things that cloud my being open to the beauty that is within and surrounds me.

Balancing Act

Many artists become aware that recovery is a great balancing act. Our lives may have been out of balance in some ways. We discover the ways this unbalancing has served to discourage our creative efforts. In order to be our most creative selves, we educate ourselves to practice the delicate art of balancing many issues we face in our lives and our art.

We may need to balance giving and receiving, loving and feeling loved, listening for inspiration and using our gifts for creating, sharing and listening to others as they share with us, being quiet and making joyful noises, work and rest, grieving and laughter, deprivation and abundance, attachment and detachment, overwork and understimulation, life and death, breaking down and renewal, seeking and finding, black and white, day and night, despair and prayer, forgiving and feeling forgiven, discipline and spontaneity, hanging on to something and letting go of it, controlling and trusting God, denial and acceptance, complaining and expressing gratitude, expecting too much and expecting too little, willingness and resistance, giving away our power and owning it, wanting and having, feeling victimized and making choices, and many others.

❖ ❖ ❖

I can learn skills and strategies of artistic recovery that may serve to guide my creativity and my life to feeling more balanced. I am willing to learn about and practice one recovery skill today.

While You Wait, Meditate

Some artists creatively put times of waiting to effective use for their higher good. We use this time to connect with our Higher Power in quiet reflection.

We can pray for ourselves and others, if that is what we seek. We can meditate with a quiet, open attitude asking to be shown God's will for our lives and our art. When we discover God's will, we can ask for the power to carry it out.

We can express gratitude for gifts as we have seen and felt them in our lives. In feeling grateful we sometimes open ourselves to even more gifts, physical and spiritual. Time quietly spent in prayer and meditation may prove, over time, to be the wisest investment we can make in ourselves. It is a habit that can open our creative channels to receiving inspiration.

❖ ❖ ❖

I can remember that time is never wasted if I remember to pray and meditate, no matter where I am or what I am doing.

Early Development Issues

Each of us was raised in a system—family or other group—that held a certain set of values to be true. We participated in various social groups in the course of our earlier development. As artists, we sometimes find that we hold different values as individuals than those that the groups of our earlier development held to be true.

We can learn to separate our personal, individual values from the values of systems in which we have participated or currently share a role. This doesn't mean that we are wrong, or bad, or unloving, or uncaring. It simply means that we choose different beliefs. We may rightfully choose different values on any number of issues than others around us hold as truths.

The systems with which we differ, if less than healthful and open-minded, may feel threatened by our nonconformity. Some may try to persuade or shame us into thinking or behaving like others in the group. We may be branded as rebellious, uncooperative, or defiant. The truth may be that we are artists. We are able to be who we are, even if it means we lose the sense of community of the group with which we hold different values. We may have a strong need to be uniquely ourselves, within and/or without the group.

There may be painful lessons to learn as we detach from the expectations of these systems. We may feel abandoned or as if we have failed others. In working through our feelings, many of us grow to establish a more healthful relationship with our Higher Power. The emotional and spiritual work, most artists discover, is worth the effort.

Some of us go on to establish meaningful supportive

connections outside the system from which we detach. We find others who accept us and our values and encourage us to be who we honestly are. The possibilities are open to us if we see them and courageously choose to make the changes that can lead to creative and spiritual growth.

❖ ❖ ❖

God, help me to learn gently that it is okay if I have different values than others in systems in which I have participated or am currently involved. Please guide my path to find people who accept me exactly as I am. Thanks for caring.

Ways of Expressing
Ourselves Creatively

There are any number of ways we can express who we are. The more obvious ways may be by writing or speaking what we feel, believe, experience, or imagine.

We also express ourselves in other ways. Each of our choices is an expression of ourselves. Some of us become more keenly aware of expanding opportunities to choose as we explore our artistic recovery. We learn how our limited feelings and thinking have discouraged us from openly choosing among positive alternatives. We learn to let go of the rigid rules that have restricted our expression of ourselves and our choices.

Many artists learn to choose to express our God-given gifts and talents over investing our resources in our addictions. We joyfully discover that our Higher Power guides us to healthful choices that expand our awareness of what is possible in our lives and our art.

❖ ❖ ❖

I am grateful to learn that I can express myself creatively by the healthful, God-given gifts and talents that are mine to use.

Letting Go of Urgency

We can learn, in artistic recovery, to let go of the feelings of urgency. We may want a job, and we want it NOW. We need a car, and we need it NOW. We want serenity, and we want it NOW.

We can work toward serenity and peace much faster by letting go of the urgency of wanting anything on our own time schedule. We can, instead, choose to trust that God has a plan, even though we don't know what that plan is for us or our art. Often, artists find, God's plan for us is better than the one we so urgently struggle to hang on to. The trick is in learning to get out of God's way and allow the plan to unfold in its own way and time.

Each person's path of getting out of God's way is different. Some may need to follow a long-term dream with patience and faith in the outcome. Others may be given completely new visions and inspirations. Still others may discover that they've been on the path of their gifts all along, but not listening to the voice of inspiration that guided them along the way. They may now choose to actively listen to that voice.

Some of us practice letting go of urgency by using prayer and meditation. We may honestly examine the necessity to have things so urgently by talking or writing about our feelings surrounding that need. We might turn that need over to our Higher Power and seek a balanced attitude that is open to God's timing.

❖ ❖ ❖

Today, I will watch for signs of urgency and consider the discouraging effects it produces on my peace and serenity.

Budgeting Our Emotions

Imagine what might happen if we were to buy everything any salesman ever attempted to sell us because we were afraid to say no. How would we feel? What would be the condition of our financial budget? Many of us would feel powerless and become rapidly financially exhausted.

Most of us, however, learn budgeting skills that help us to manage our resources and live within our financial means. We learn to set financial boundaries by saying no to requests for our finances if we cannot or choose not to meet someone else's financial needs or requests. Similarly, artistic recovery offers skills and strategies we can learn to help to manage our emotional budgets. We set and maintain emotional boundaries that honestly define and express our personal and creative choices.

Some of us may have learned to give emotionally continuously in order to feel liked or accepted by others. This may eventually lead us to emotional bankruptcy—a condition in which we give to everyone else and find we have nothing left for ourselves and our art.

Or we may have learned never to give of ourselves, not to share emotionally with others. We rigidly hold on to every emotion, feeling that we won't have enough for ourselves if we share any feelings at all with others.

We can seek the balance of healthful sharing of our emotions. We might consider the question "Can I afford it emotionally?" when requests are made of us for time, money, art, or other things. We weigh the consequences a request may have on our lives and our art, including our feelings. We may discover that a request will offer opportunities for personal

growth or support of our artistic endeavors. Conversely, we may decide that some requests diminish our availability of meeting our own artistic needs. We may choose to say no to some requests so that we can remain emotionally open to our own creative needs.

❖ ❖ ❖

I can learn to budget my emotions so that I feel balanced enough to encourage my own artistic development.

Positive Thoughts

As our artistic recovery progresses, we may encounter instances of reverting to our old discouraging ways of thinking and behaving. Negative or self-defeating behaviors may spring back unexpectedly as we go about our daily endeavors. We may find that we have reverted to old, unhealthy patterns of thought about ourselves and our art.

We can learn to recognize these lapses and accept that they exist. Sometimes simply recognizing them as they come into our awareness is enough to instigate a positive change. We can, with awareness, choose positive, healthful attitudes over negative, self-defeating ones.

If we recognize that we have reverted to addictive or compulsive behavior, we may choose to trust that our Higher Power is available and willing to help us with whatever we need. We can pray for help. We can take care of ourselves spiritually by having faith that our Higher Power is with us. We do not have to face anything alone. God is with us, if we extend to ourselves the faith to believe.

We can turn to our positive affirmations for help. If we do not have a list of personal positive affirmations, we can make one to refer to in times of spiritual need. We can find them in many sources around us.

❖ ❖ ❖

Thank you, God, for guiding me to positive thoughts and attitudes today. Please remind me to ask you for them when I start to have discouraging feelings about myself or my art.

Moving Beyond Our Role Models

Those who, in our pasts, served as role models for us have done the best they could. If we feel that our lives have become limited by the behaviors we learned from them, in artistic recovery we can open ourselves to now own responsibility to work toward greater learning. We do not hold anyone else accountable for our own artistic development or spiritual growth.

The limits and expectations we learned and continue to learn from those around us are THEIRS. By setting our boundaries, we can learn to allow others' limited expectations to belong to them. We can choose to honor our own healthful limitations and/or expectations. We are free to be different from others and their expectations when we claim that choice for ourselves.

By becoming honest with our feelings, we may exhibit our choices in a way that is different from our role models. We can still respect others for their choices, even though we may no longer choose their choices for ourselves. The person we have become may have simply outgrown the expectations and/or limitations of our role model. We can each learn to respect the other and honor the differences as well as the similarities.

❖ ❖ ❖

I am grateful, today, that I accept the differences between my role models and myself. I am grateful, too, to be aware of my boundaries that encourage me to respect my own expectations and allow others' expectations of me to belong to them.

Days of Special Remembrance

Days of Special Remembrance

JULY

Expecting Too Little

Some artists may have been raised in an atmosphere that taught us to regard negative experiences as normal. If we were abused, we may have lived in fear and with little hope of goodness being something we deserved or expected. As a result, our low expectations of ourselves paint an unnecessarily bleak picture of what life can be for us.

In artistic recovery, if we choose to, we can examine our feelings on these issues. We can consciously choose to make healthful changes that may guide our thinking and attitude to new levels of deserving and possibilities. We can learn that abuse in relationships and of our art is not normal and discourages our highest good. We can detach from unsupportive situations and people. By seeking a supportive environment, we can learn new ways of taking care of ourselves and our artistic expression.

We can, with the help of our Higher Power, restore our expectations to a balanced, healthful level that will open our soul to the goodness life and God have to offer.

❖ ❖ ❖

Guide my path please, God, to getting out of the way of your goodness for me. Help me to feel in my soul, that as one of your valued children, I deserve and can expect you to guide my life and my art to your loving and kind will.

Expecting Too Much

We may experience negative reactions about ourselves if we expect too much of ourselves, others, our art, and our Higher Power. Our attitude may be that the world owes us a living and we need not extend ourselves to deserve it. We may also believe that we need to always produce great and perfect art in order to feel accepting of ourselves.

This thinking may be based on negative images of ourselves. We may not honestly trust that our Higher Power is there for us. When we do not get our unrealistic expectations met, we may feel we have proof that God does not exist for us. Then we have an excuse for our low self-image.

We may be in need of an attitude adjustment. With time and self-examination, we can explore the feelings connected in our souls with our unrealistically high expectations. We can learn to find a peaceful balance that is ours by our own respectful choices. We can make the connection to the God of our understanding and seek guidance to being our spiritual and creative best selves. Many of us find that the emotional work is worth the effort. We learn that it is possible to find the balance between expecting too much and expecting too little of ourselves, others, our art, and our Higher Power.

❖ ❖ ❖

God, please guide my path toward a healthful balance between expecting too much and expecting too little of myself and my art. Show me the way to be my best creative self. I am grateful for the awareness that this issue brings to my recovery. Thanks for caring.

Not Needing to "Fit In"

Much of the socialization process involves guiding us to being a part of a well-blended group, a team member and player, a homogenized ingredient in the melting pot in which we participate at the moment. Artists often feel that we do not or choose not to "fit in." Our uniqueness is a sacred part of our being. Perhaps our nonconformity is one of our gifts.

By being who we uniquely are, we often feel as if we do not fit into the systems in which we find ourselves. The ideas we hear or feel or sense in our instincts, when we choose to listen to them, are often at odds with those of the majority. The suggestions we pose to the groups in which we are involved are often shot down as radical. We may be told they will not work.

Many times we instinctively know differently. Sometimes we are certain they will work. Other times we feel they may be possibilities. If we have the courage to pursue them despite objections, and our ideas are carried out, we and our ideas are often ignored when the outcome is revealed as we felt it could.

To maintain a healthful balance, artists need to remain in touch with our feelings. We may need to mourn our losses, including artistic losses. Some artists envision artistic ideas as the children of our souls. We learn to recognize artistic envy: our own of others' work, as well as others' envy of our art. We maintain clean boundaries around ourselves and our art so we do not get entangled in others' expectations of who we or our art should be. We develop our own support system of people who have respectful expectations of us that do not include that we mold ourselves to fit in with being who they

want us to be. This is some of the emotional work involved in calling ourselves artists.

❖ ❖ ❖

Today, I will meditate on my need to "fit into" the groups in which I am involved. I will consider whether it is more important to be who I am—a unique, creative child of my Higher Power— than to mold myself to meet others' needs for who I should be.

"The Land of the Free and the Home of the Brave"

This line of America's National Anthem has an important recovery reminder for us. If we choose to let go of our help-less-victim thinking and discouraged attitudes, we become free to be who we uniquely are. We are free to express our lives and our art in the way that only we can.

"The home of the brave" reminds us of the great gift of courage. When we connect to the courage our Higher Power has gifted inside us, we can open our attitudes to mend and nurture relationships with ourselves and others. We can express our art and grow in many ways. We can courageously be who we are.

❖ ❖ ❖

God, I am grateful to live in "the land of the free and the home of the brave." I ask for your continuing guidance for my personal freedom to be who I am. I am grateful for the courage to accept myself as the creative person I am.

Denying Our Painful Feelings

We may have been taught early in our lives to deny our painful feelings. We may have been told that only babies or sissies cry, or that we are weak if we show our vulnerable feelings. There may not have been anyone to validate our early painful feelings of anger, loss, abuse, or loneliness. So we learned to deny their existence and buried them deep in our souls.

In therapy and recovery, many of us bravely examine these feelings and work through them. We encourage ourselves to feel the feelings. Many of us joyfully discover that we had buried positive feelings of self-love, deserving, peace, and self-acceptance along with our painful feelings. Some of us find that we had buried our artistic gifts as well.

The work we do with our emotions can lead to restoration of our unique, creative spirituality. We open ourselves and our art to expanded possibilities. We learn to get honest about our feelings, likes and dislikes, our creative dreams and ideas—we get honest about who we are.

❖ ❖ ❖

O Great Creator, I am ready to let go of the feelings I have denied for too long. I am ready to examine them honestly. I am willing to trust that you will stay with me so that I do not feel so alone and afraid. I trust, too, that in working through them you will guide me to peaceful and loving feelings about myself and my artistic gifts. Thanks for caring.

Dancing to Our Own Tune

A number of us may have learned to dance to a tune that denies our own uniqueness. We may have needed to dance to the tune of others who we believed held power over us and our lives, perhaps over our art. We may have denied our feelings, needs, gifts, and beliefs and given our power to the one or ones we believed held our power.

In time we come to admit to the very real feeling of powerlessness. Many artists go on to learn the painful lesson they had denied for so long—that we had been dancing to a tune not of our own choosing. We surrender ourselves to a spiritual power greater than ourselves—our Higher Power.

In turning our will and our lives over to God, we learn some new dance steps that patiently and gently guide us to our own feelings, needs, wants, likes and dislikes, and gifts. With time and patience we become guided to the courage within ourselves to step onto the dance floor of life and assert ourselves with our new dance steps—our own honest choices.

Some of us may trip in our early attempts and lose our balance. We dust ourselves off, learn some more lessons, and, with courage, try again. We practice naming our feelings and following where they lead. Sometimes we still trip, but we now know the lessons of regaining our balance.

We continue working on our dance routine by keeping the focus on ourselves and our art, respecting our own and others' boundaries, and getting out of the way of God's goodness. With practice, we fine-tune our routine until we learn to recognize and accept our own inner creative beauty—our dance. Then we begin dancing to our own tune gratefully, as an act of worship to our Higher Power.

JULY

❖ ❖ ❖

No matter where I am in recovery, I am grateful that a Higher Power exists to lead me to the unique dance of my art.

Letting Go of Guilt

Guilt is a healthful feeling when it guides us away from behaviors inappropriate to ourselves or others. Our Higher Power can guide us to making amends to ourselves and others we may have hurt in the past as a means of restoring respect in relationships. Many of us, however, become consumed by unearned guilt. We may have learned to feel guilty because we do not meet others' expectations or approval for who we or our art "should be."

We may have learned to feel loved by always doing what others ask of us, regardless of our honest choices, by giving generously or taking care of others' wants and needs at the expense of taking care of our own. We may have learned to do our art to get approval or acceptance from those around us, when expressing it for the pleasure it brings to us might offer us more peace.

We can let go of a lot of unearned guilt by learning to establish and maintain healthful boundaries. We learn to no longer own issues that belong to others who can take care of themselves. We allow them to be responsible for their expectations, wants, and needs, and encourage them to find their own creative ways of getting them met. And we take responsibility for defining and obtaining our own healthful expectations, wants, and needs. In this way we each establish our own values—our own sense of right and wrong.

We can seek to clear up old guilts from the past. We can journal our feelings and make connections to things we've felt as misdeeds in our history. We can explore our feelings in many respectful ways. We can turn our old guilts over to our

Higher Power. We can forgive ourselves and others and get on with our lives.

❖ ❖ ❖

I am grateful, God, that you have guided me to the lessons that will help me to let go of my undeserved guilt.

Three Ps of Artistic Recovery

There are three principles that begin with "P" that can offer help to us. They are patience, practice, and prayer. We all need to connect with patience in our relationships, our art, and with ourselves. It is perhaps a lifelong need to learn and live patience with the unfolding of our lives and our creativity. We may also need to learn to be patient with God and with God's way and timing for our lives and our art.

We can use the strategy of practice in many forms. Not only do we need to practice our art and the skills and expertise involved in bringing our art to life, but we also may need to practice recovery skills and strategies.

The skills we learn in artistic recovery need as much practice as our artistic skills so that we take care of ourselves spiritually and personally as well as artistically. By taking care of ourselves on many levels, many among us open ourselves to being the artists we truly are. Each of us has a unique set of God-given skills that need practice regularly so that our creative channels remain open for use by the creative spirit within each of us.

Prayer can help us to stay connected to our Higher Power. We can learn to ask openly for what we want and need in prayer. Then we listen and watch for the way our prayers are answered. We learn to stay open to God's better plan and get out of God's way so the plan can unfold for the highest good in our lives and our art. We learn to express gratitude for each gift we are given, no matter how small or large.

❖ ❖ ❖

Today, I will meditate on whether I am open to the Three Ps—patience, practice, and prayer.

Starting Where We Are

No matter where we are, we can work slowly toward more peaceful lives. The lessons we learn in recovery move us gently toward becoming our true and creative selves.

We learn to start with what we have and where we are in the moment. Many of us set flexible but attainable goals and work toward envisioning healthful expectations. We work on letting go of our discouraging beliefs by using positive affirmations, prayers, and meditations.

We work through the issues that have sabotaged our best interests by getting honest with our wants, needs, and gifts. We seek information on artistic recovery and inspirational materials from many sources.

By trial and error, sometimes it seems, we learn to balance many significant areas of our lives. All these things encourage us by providing the time, energy, and focus to do the thing(s) that gives us the greatest pleasure—our art. We learn to nurture our art as the valuable gift from God that it is. Spiritually, we create as an act of worship to our Higher Power.

We can begin today—right now—by being honest about our feelings. We can share ourselves emotionally with others who care about us and our art. If we are not in a caring place, we can pray for and become open to others who care about us and our art.

❖ ❖ ❖

I can start where I am by trusting that my life and my art are part of God's plan. Even if I don't know what the plan is, I can trust that a plan of goodness is in place just for me.

Saying Yes to
Positive Opportunities

We can learn to say yes to positive opportunities for our growth. Many of us courageously work through the fears that have stopped us from experiencing the expansion of our scope of opportunities. We learn to take healthful risks and trust our Higher Power for the outcome.

We release our old limited ideas of who we are and what we can be and create. We become open to exploring the many possibilities of ideas, feelings, relationships, etc., that once served to limit us and our art.

We learn to recognize the ways we may have previously sabotaged ourselves and our art. We make a conscious effort to change those ways for the good of our art by saying yes to positive opportunities.

By learning to trust God's lead, we become open to positive changes in our lives. By becoming grateful, we open ourselves to acceptance of our gifts.

❖ ❖ ❖

I can learn to say yes to positive opportunities for growth in my life and my art. There is no need for me to indulge in self-sabotaging behaviors.

Letting Go of Rigid Rules

Some of us may have grown up with rigid rules surrounding who we should be, how an artist should look or create, what or who a Higher Power should be, and many more. Without examining our own ideas surrounding these rules, we may have accepted them as unalterable truths.

In artistic recovery some artists discover that our feelings concerning many of these rigid rules have led us to feeling shame and/or guilt about who we are. We see how we have denied some of our own truths in order to honor others' truths. We have become unaccepting of who we really are to ourselves, and to God.

As we get honest with our own beliefs, we learn that rules are not "written in stone." We let go of the rigid rules in favor of choosing to be who we are on many issues. We choose to examine our feelings surrounding who we are and what we truly believe.

We define our unique and creative selves, not based on rules of others, but by making respectful choices that encourage what we believe. We learn to live our lives based on our healthful choices.

❖ ❖ ❖

I am grateful, today, to be aware that I have a choice to let go of the rigid rules I may have learned to follow without examining my own healthful choices. I can live my life based on being who I am—a unique and gifted child of the God of my understanding.

Regaining Our Balance

There are many situations in the endeavors of living that can threaten our security—our balance. The process of spiritual and artistic growth requires that we constantly monitor our feelings on the many issues we face as part of the experience of being fully human.

Sometimes we lose our balance. We may feel hurt, angry, confused, lost, alone, unloved, or other emotions. We may need to make changes—physically, spiritually, or artistically. We may need to set boundaries or respect the boundaries of others. We may need to trust that our Higher Power is available to us or to others who need care.

It is sometimes helpful to examine our attitude. Has someone said or done something that has affected how we feel about ourselves or our art? Is that our truth, or does it belong within the others' boundaries? Perhaps we've said or done something less than respectful to ourselves or to others. We can forgive ourselves, apologize to others, make amends, and remind ourselves not to be so hard on ourselves.

We can become grateful for each small step we take in our spiritual and artistic development. Gratitude can lead the way to peace and to regaining our balance.

❖ ❖ ❖

I can work toward regaining my balance by examining my feelings. I can initiate changes that guide me toward healthful self-respect and respect for others.

Asking Openly

Some of us may have learned to ask in manipulative and controlling ways designed to get the outcome we want, rather than allowing for the outcome to evolve as it will. We may feel frustrated when we don't get what we ask for if we ask with a fixed result in mind. The fault for the frustration lies not with the person who did not give us what we want. She or he, like us, has a choice to say yes or no to any request.

The shortcoming rests with our expectation that the other person needs to meet our needs, or meet them in our way and time. We actually set ourselves up for possible disrespect when we ask for things with fixed expectations or results in mind. This shortcoming can lead to continual feelings of rejection by others and to maintaining unnecessary negative feelings about ourselves.

When we learn to let go of our fixed expectations by asking openly—allowing the other person the option of saying yes or no, or to express feelings on the issue—we build respect into relationships. We nurture ourselves, too, because our expectations no longer suffer the frustrations that accompany the behavior of seeking a fixed outcome.

❖ ❖ ❖

Guide me, God, to learn the skill of asking you and others openly for what I want and need. Teach me, gently please, that in letting go of outcomes, I can let go of the frustrations I feel that are connected to fixed expectations.

Thou Wilt Shew Me . . .

Thou wilt shew me the path of life: in thy presence is fulness of joy; at thy right hand there are pleasures for evermore.

—PSALMS 16:11
KING JAMES VERSION

Sharing Artistic Support

We can all participate in supporting and encouraging each other's artistic and creative efforts and growth, regardless of our involvement in organized artist support groups. When we sincerely compliment another's expression of creative endeavors, we may encourage a sense of capability in the creator's attitude. We are actually supporting his or her choices. When we openly listen to others' ideas, we validate the worth of the idea.

Our sharing of positive feelings may serve as feedback to those who doubt their own assessment of their art. Sometimes we can build our own confidence from the feedback we receive from others.

It is important that we talk about our own feelings toward others' work, rather than judging or criticizing others' efforts or the artist. By talking about our feelings, we are really sharing our preferences. This may serve to build respect in relationships.

Unless an artist asks openly for a critique, it is usually more respectful to accept another's work as it is. Asking artists to share feelings about their creations with us can open a dialogue. We can learn and practice skills to respect our own and others' artistic boundaries.

❖ ❖ ❖

God, please guide my sharing to express honest supportive and encouraging messages regarding others' artistic efforts. Teach me to use healthful compliments that can build respect among creative people.

Recognizing Choices

Often, when we begin artistic recovery, it is not apparent to us that we have choices. Many times the choices are buried under our pain. Sometimes we need to do emotional work through the pain to understand how our pain has limited our lives and our choices. We've become limited by our pain.

Just as a physical injury, like a broken leg or arm, puts limits on what we can do physically, so does a spirit altered by pain limit what we can do emotionally and artistically. As competent medical intervention can encourage the mending process of a broken bone, professional aid may encourage the healing of the spirit. Support groups serve to continue the learning and recovery process.

As we work on our recovery, many artists recognize more and more choices emerging. As we make more personal choices, we define who we uniquely are. We are undertaking our greatest artistic effort—ourselves.

❖ ❖ ❖

I am beginning to see that my choices are ultimately creating who I am.

Asking Our Higher Power

When we learn to ask openly in relationships, we develop an asset that can enhance who we are spiritually and artistically. By asking our Higher Power for guidance, inspiration, supplies, lessons, etc., in an open-ended manner, we are participating by becoming willing to receive what we ask for. If our attitude is open to receiving, any gift is valued and accepted.

In our relationships with others, as well, we can build respect by asking openly and allowing the other person to express feelings about our current feelings. Some artists learn to trust that if one person chooses not to meet our needs, God may have a "backup plan" that will ultimately work in unforeseen ways, sometimes better than we expect. We can learn to have an open attitude to God's unforeseen and mysterious ways.

Our Higher Power may be guiding us in directions we cannot predict. We may be guided to meeting a need ourselves by learning a new artistic skill or expanding our creative awareness. Or we may be guided to new relationships of support, or new dimensions to existing relationships. We can learn to keep all our relationships open to God's greater possibilities, and ask openly of our Higher Power and others. We can also encourage ourselves to feel grateful for the response we get. We learn to trust that all our relationships are part of God's plan for our lives and our art.

❖ ❖ ❖

O Great Creator, teach me to ask you and others in an open manner that encourages your plan for my life to unfold peacefully according to your will. Please teach me to trust that in your way and in your time, all my needs and wants will be met. I am grateful for each lesson and each gift you reveal to me. Thanks for caring.

Following Our Feelings

Some artists may have creative ideas given to us during personal spiritual moments. Sometimes when we share our inspirations with others, even "experts"—other artists or professionals, or people whose opinions we generally hold in high regard—we are given negative feedback. We can learn that we have a choice about believing their opinions or trusting our own feelings. We respect our boundaries by not denying our own feelings.

Our unique feelings and instincts may be guiding us to a new approach, method, or insight others (even "experts") do not perceive. There are those who believe that our Higher Power knows exactly the person who has the right combination of attributes to entrust with a particular gift. One of our gifts may be the ability and willingness to follow our healthful feelings, no matter what others believe, when our inspiration feels right to us.

❖ ❖ ❖

I can become willing to follow my healthful feelings with my creative ideas. I can trust that I may have been given my gifts by my Higher Power because of my unique capability to use them to the highest good.

Being Available for Ourselves and Our Art

We may have learned to become available to meet others' needs and/or expectations, regardless of our own personal needs or wants. By various means we may have learned to feel good about ourselves because we were taking care of the needs of others. This caregiving is healthful to a certain extent in any relationship. We learn to love, nurture, and encourage each other's growth by being available to give and receive love.

Our caregiving can get out of balance, however. We can become addicted to taking care of others as an unhealthy method of feeling self-esteem. We can become so concerned with the welfare, needs, and expectations of others that we neglect taking care of ourselves, including our artistic selves. We deny our artistic gifts in favor of taking care of everyone else.

In artistic recovery, we can learn to recover our sense of availability to ourselves and our art. We learn to take time to express our artistic gifts as an act of nurturance to ourselves and gratitude to our Higher Power for our gifts. We learn to use our time, energy, and gifts in a balanced way that encourages availability for ourselves and our art in healthful proportion to our relationship with others.

Some of us, especially early in recovery, may swing to the opposite end of the scale and become totally self-absorbed for a while, not meeting anyone else's needs but our own. We need not shame ourselves if this happens. Gently, and with patience for ourselves, we can work toward the healthful bal-

ance of give and take with others that feels comfortable without neglecting ourselves and our art.

❖ ❖ ❖

Thank you, God, for guiding me to lessons of being available to myself and my art. I am grateful for the awareness that a balance is possible that will nurture me and my art in healthful proportion to my nurturance of others.

. . . *Accept the Things*
I Cannot Change . . .

This phrase of the beautiful Serenity Prayer may offer more encouragement to recovering artists than is obvious. We may believe it suggests only letting go of obvious things over which we feel powerless. We may not recognize our powerlessness over our creativity or be aware of the discouragement that inhibits our owning of our creativity.

In another interpretation, this phrase may be guiding us to learn to accept our gifts from God . . . that we are powerless to stop the flow of our creativity. Suppose our creative gifts from God are part of a grand plan of goodness that we cannot change. Suppose this phrase is guiding us to accept these gifts of goodness—compliments on our artistic efforts, creative insights, personal images and visions of what we believe we can accomplish, gains in our feelings of what we deserve, new positive awareness about ourselves and our art, and other gifts.

Perhaps this phrase . . . accept the things I cannot change . . . guides the artist toward acceptance of healthful goodness as part of the total picture of reality. Some of us may have denied our creative gifts for so long that we become grateful to accept that we cannot change them. We willingly learn to use and express them.

❖ ❖ ❖

God, grant me the serenity to accept the things I cannot change: especially the healthful, creative things about myself and my art that I may have felt discouraged from expressing. Thanks for caring.

Things We May Not Have Learned

There are some self-respect lessons we may not have learned in life for any number of reasons. The people we've been around may not have learned these lessons thoroughly themselves. They could not teach us what they didn't know. We can learn to accept that they did the best they could.

Some of us may have been discouraged from learning the lessons by investing ourselves in the addictive behaviors we did learn as a means of surviving in a difficult environment. Rather than blaming ourselves for not learning what we didn't know, it is far healthier and more self-respecting to simply choose to now become open and willing to learn the lessons we missed.

It is not too late. We are not too old. We can learn new and more peaceful ways to be who we are.

In artistic recovery, we can gain new awareness of attitudes, skills and strategies, and behaviors that may lead to self-respecting changes in our lives. We can learn and practice new life skills including, but not limited to: setting and respecting our own and others' boundaries, letting go of things over which we have no control, getting out of God's way, keeping the focus on ourselves and our art, and expressing ourselves and our art as only we uniquely can. We can learn to live our lives by the healthful choices we make as our lives unfold. We can learn to express our gratitude for our gifts by using them.

❖ ❖ ❖

I am grateful today, God, that you have guided me to lessons of self-respect I may not have learned so far in my life. I ask for your continued guidance in learning new and healthful life lessons that show me how to be the best I can become. Thanks for caring.

Fear Is the Darkroom
Where Negatives Are Developed

A Roadside Sign

When we live our lives based solely on the fears we have accumulated, we become limited in our perspectives. Our scope of opportunities becomes narrowed. We limit our choices. Our vision and image of ourselves become confined by the things we fear.

The negatives can spiral to limit our thinking, our feelings, and our attitudes. We may remain in the darkroom with our fears . . . until we courageously do our honesty work in recovery.

Then we begin to open the door. We connect with a Higher Power who shows us courage we didn't know we possessed. We open the darkroom door and confront our fears, facing them squarely, and exposing them and their effects on our lives and our creativity to the light of healing.

Our Higher Power guides us ever toward growth. Eventually, some of us discover that the darkroom was a necessary place for developing negatives into the colorful pictures that are the artistic selves we are recovering. It was all part of God's plan for us to go into the darkroom. We have come out of it with glorious full-color pictures of ourselves as creative people open to choices. God was with us the whole time.

❖ ❖ ❖

God, thank you for staying with me as I confront and work through my fears. I have faith that you will remain with me as I travel on my artistic journey.

How's Your Hope Quotient?

A Personal Sharing by the Author, Linda Coons

How great is your hope quotient? How much are you willing to believe in goodness, with no reservations, for your life and art?

I've come to believe that hope and faith in my Higher Power can provide fertile soil for my creativity. By owning these encouraging feelings, I open myself to miracles happening. By hanging on to self-doubt and negative thinking, I discourage the possibility of miracles and gifts.

I have seen miracles and felt their wondrous power. I know that if I had tried to control people, places, and things rather than letting go of them in hope and faith, they would not have occurred. I've learned to accept hope and faith as two of the great gifts from God. The quotient of my hope continues to increase as I practice letting go of controlling and make way for God to work the miracles as they are meant to unfold in my life and my art.

❖ ❖ ❖

I am willing to accept hope and faith as possible fertile soil for my creativity, knowing that I may need to let go of control to receive these gifts.

Keep the Focus on Ourselves

We may have been taught to always be considerate of others' feelings, needs, desires, and welfare. In learning these lessons of respect, some of us learned to always put ourselves last. We sold ourselves short by neglecting our own feelings and needs in favor of always giving way to others'. We learned to look for needs and the care of others as the way we could feel good about ourselves. By focusing on others, we may inadvertently have neglected and abused ourselves and our art.

In artistic recovery, we learn to put ourselves and our art in a healthful focus in our lives. We learn to use the lessons of respect we were taught about others for our own self-respect. We learn that the powerlessness many of us came to feel was the result of our self-neglect. We claim our God-given power by learning to listen to and respect our own feelings, instincts, artistic yearnings, and healthful desires of our hearts, as we once did solely for others.

We learn to claim time for our art as one means of healthful self-care. We encourage ourselves to feel the pleasure that expressing our art brings to our lives. We reduce stress by engaging in the creative activities we once neglected that make use of our gifts from God.

❖ ❖ ❖

Guide me, God, to the lessons I need of keeping the focus on myself. I want to use my creative gifts to express my gratitude to you for these gifts. Thanks for caring.

Learning to Trust

Many of us have learned not to trust. We have lost our faith in our instincts, God, our art, relationships, the goodness of life, and so forth. We may have trusted at one time and felt betrayed, abused, not validated, or not had our expectations for the trust met. So we learned to not trust anyone or anything. We may be afraid to try trusting again. Instead we may become controlling and manipulative, trying to force outcomes, putting our faith in our discouraged expectations alone.

Then when things don't turn out according to what we want and expect from our controlling behavior, we may feel hurt and used, betrayed by others, and abandoned by God.

We may need to examine our attitudes. We might ask ourselves: Am I encouraging my life and my art to unfold in God's way and God's time? Do I accept that any situation offers me choices, each choice with different possible outcomes and consequences?

Am I encouraging myself to see the choices available all around me? Do I see my creative gifts as opportunities for growth? Am I open to learning to connect my instincts and God's way and time with my gifts? Am I receptive to the idea that a God who cares about me personally is guiding my life and my art in ways I may not even imagine? Am I willing to believe that everything in my life could possibly eventually work out for the best?

✦ ✦ ✦

Today, I will consider whether my attitude is open to trusting my Higher Power.

Honoring Our Uniqueness

Some artists may have been brought up in an atmosphere in which differences were critically judged. Those who role-modeled for us may have used judgment and/or shame to control us to being who they wanted us to be. We may have learned to adapt to their expectations in order to feel included in the systems in which we were involved. Some of us, as a result of this early adaptation, have learned to deny our true feelings, wants, needs, and creative energies and choices in favor of adapting to the prevailing attitudes. We may have learned to deny our uniqueness.

In artistic recovery we learn to claim our uniqueness. As we examine our feelings on many issues and work toward accepting the reality of who we honestly are, we learn to honor the truth of our feelings. We discover that the differences between what we and others believe is what makes each of us unique. We learn that our personal choices belong within our boundaries, not to others. We trust that we need not berate ourselves for our feelings and choices, even if they differ from others'.

❖ ❖ ❖

I can learn to honor my uniqueness by examining my honest feelings on the many issues I face in my artistic recovery. I can trust the guidance I feel from the God of my understanding for my healthful choices for self-care and artistic expression.

Indulging Ourselves

One woman shared that her recovery is like eating a box of chocolates without feeling bad or guilty. "Sometimes," she said, "it feels so good to indulge in the things I once denied myself . . . my wants and needs, time for my art. Before recovery, I didn't feel I deserved to have what would feel good because I might look selfish. Now I don't worry about how I look to others. I do what feels good and right to me."

Sometimes indulging ourselves in healthful choices is therapeutic. When we have lived our lives denying our gifts and healthful self-care by our overinvestment in addictive or compulsive behaviors, it can be a treat to learn about the many facets of self-care.

Many recovering artists learn that our old self-abusive behaviors no longer work in our lives. We educate ourselves to the ways they worked against our healthful self-interests. We learn to choose to let go of our discouraging behaviors in favor of our personal and creative growth. We trust that our loving, caring Higher Power has been guiding us all along and will stay with us.

❖ ❖ ❖

Great Creator, if I am new to recovery, teach me to trust that the feelings I once denied can lead me to more peaceful feelings if I am willing to follow your lead. If I've been in recovery for a while, I am grateful for each lesson in healthful self-care I've been guided to learning and living. I am grateful to learn that healthful indulgences are a therapeutic part of the recovery process. Thanks for caring.

Learning to Ask

We may have learned in our earlier development not to ask for what we want and need: for help, for information, for guidance, for inspiration, for artistic gifts and ideas, for money, for food, for clothing. We may have become shamed in our thinking that if we asked for something, certain other things were true of us as well. Perhaps we felt we would look irresponsible, as if we were begging, or were not capable of obtaining what we want for ourselves. We may also have felt as if we didn't deserve what we want or need, were not good enough to meet someone else's expectations of who we are, or other shaming thoughts.

In not asking, we may close ourselves off from valuable resources that exist all around us. We limit what may be available to us when we lack the courage to ask for what we want and need. By learning to ask God for what we want through prayer and meditation, we can become guided to finding the courage to ask others for what we want from them.

This single courageous strategy can open possibilities for new relationships, and for new dimensions for existing relationships. It can open our minds and spirits artistically to finding new resources for expressing ourselves creatively.

❖ ❖ ❖

Today, I will meditate on whether my fears surrounding the strategy of asking might stop me from obtaining things I want or need.

What Controlling Does

In reality, controlling only limits our possibilities for out-
comes. Had we not manipulated what we may falsely believe
to be power over people, places, and things, the outcome may
have been much better. Our Higher Power often guides out-
comes to much greater results if we encourage our lives and
our art to unfold as they will according to God's plan.

Trying to control has the opposite effect of what we ex-
pect. We may work hard toward obtaining a particular result.
Our controlling efforts leave us feeling frustrated and angry
with the constant reminder of unmet needs, longed-for re-
sults, burnt-out energy levels, and low self-esteem.

By letting go of control and becoming peaceful, we open
our minds and spirits to outcomes of endless variety. We en-
courage our Higher Power to choose the highest good, rather
than the one specific, and often limiting, result our control-
ling efforts sought.

❖ ❖ ❖

*God, please teach me that controlling people, places, and
things works against my best interests. Guide me to learning to
get out of your way to encourage your will of goodness to unfold
for me and my art.*

People Who Want Our Time

There are lots of people around who want to claim our time. The self-care that healthful artistic recovery requires offers the lessons we need to claim our time so that we and our art are not left feeling like victims. Some of the time we once so easily gave to others now becomes available to ourselves and our art through our own recovery efforts.

The lessons may be painful at first. We may have been so good at being available to help others, at giving so generously of ourselves, and at putting ourselves last. We may, early in recovery, feel hurt when others call us selfish or frugal.

We are really only balancing ourselves. We are learning to balance giving our share of time to others and claiming for ourselves what we so richly deserve to claim for ourselves and our art.

When we find our balance, our time becomes manageable. We discover the joys of creating our art, without becoming so lost in everyone else's needs and wants or addictive behaviors. We are taking care of our artistic needs and wants.

We define our boundaries so that our own self-care is balanced with our need to share with others. We choose whether or not we want to share ourselves with the people who want our time. The lessons require patience, and we learn them when the time is right.

❖ ❖ ❖

Today, I will examine my boundaries concerning time. If I feel out of balance, I will pray and meditate for guidance on this issue.

Interruptions and Our Art

It is sometimes easier to allow ourselves to be distracted from expressing our art, which brings us pleasure, than it is to do it . . . until we learn to keep the focus on ourselves and our art. In artistic recovery many of us learn and practice the skills and strategies that encourage us toward balanced and positive thinking about ourselves and our art.

We learn to set boundaries and guard them against interruptions. We learn responsible self-care that guides us toward self-acceptance. We come to terms with the addictive behaviors that have discouraged us artistically.

We learn to recognize the many interruptions of our artistic process. We choose healthier responses that ensure that we and our art are given the respect we need to bring to life that which only we can create.

We might use interruptions in another creative way. When we become aware of a pattern of negative thinking about ourselves and our art, we can choose to interrupt that pattern by doing self-care. We can pause to pray and meditate, go for a walk, journal about our feelings, or do the things we discover that interrupt and reverse our negative thinking.

Some of us might stop our negative thinking patterns by turning to positive self-talk. We can use affirmations or contact supportive people. We can indulge in the healthful behaviors that guide us toward feeling balanced.

❖ ❖ ❖

I will meditate on how I manage interruptions in my life and my art.

Days of Special Remembrance

Days of Special Remembrance

AUGUST

Saying Encouraging Things to Ourselves

If we spent our earlier development around people who were less than accepting or supportive of our right to make personal choices, we may have heard negative assumptions of ourselves—messages that we were not capable, competent, or creative. We may have come to believe that the messages of others' assumptions were truths about who we are. If our boundaries were not clear, we relied only on information from others to show us who we were. Our souls may have become contaminated by the old limiting information we took in from those around us.

In artistic recovery we learn to clear the contamination in our souls. Our honest examination and working through of the feelings connected to our old discouraging messages break up the contamination in which our souls, and perhaps our art, exist. As we work through our feelings, the view of our true selves becomes clearer. Patiently we learn to set boundaries and discover the gifts we've been given that make us unique. The vision clears, and in the clarity we see a reflection of ourselves as capable, competent, and creative artists.

We have only begun when we receive the gift of clarity. Now we can learn the skills and strategies of saying encouraging things to ourselves. We learn to accept, not deny or discredit, our gifts, inspirations, guidance from our Higher Power, compliments on our creative endeavors and choices, etc. We affirm to ourselves who we are by thinking and talking with encouraging healthful messages.

AUGUST

We may need to begin by acting "as if" we believe the positive messages about ourselves and our art. Eventually the healthful messages to our souls become a spontaneous act of self-respect. We learn to feel and honor them as an integral part of the package that is ourselves.

❖ ❖ ❖

O Great Creator, please guide my path to learning to say encouraging things to myself about myself and my art. I trust that if my soul is contaminated, you will lead me safely to the lessons I need to learn to clear the perception of who I am. I am willing to believe that my gifts are waiting for me in the clarity of self-respect. Thanks for caring.

Cultural Norms

A culture is defined by the traditions, beliefs, and lifestyles of the majority of its group. If we, as individual members of a culture, accept these prevailing values as our own, we feel a part of the culture.

If, as individuals, we personally disagree with some or all of the generally accepted cultural values, we may feel stress or anxiety. The anxiety of not "fitting in" is a common theme among artists. Because our individuality is a sacred element of our nature, we may feel the pain of not being accepted because our values are different from some of the values of the culture in which we participate.

We can learn to validate our pain rather than denying it. We can choose to make changes that may lead us to feeling peaceful. We can learn to honestly share our feelings in ways that respect our own and others' boundaries. We can be who we are within any culture. We can also seek to participate in supportive groups or cultures who will accept us as we are, rather than being around those who want to mold us to their cultural specifications and needs.

By maintaining an accepting attitude about ourselves, we can guard our boundaries when we are around those who attempt to mold us to their cultural norms. With courage, we can say no to the things we don't want to do or believe. We can choose to be who we are.

AUGUST

❖ ❖ ❖

I can consider whether there are cultural norms that cause me to feel stress or anxiety in my life and my art. I can give attention to my feelings by journaling, talking to a trusted listener, or seeking a supportive source with whom I do not need to mold myself or deny my honest, healthful choices in order to "fit in."

Building on Small Successes

Some of us may expect instant recognition and acceptance from others for our art. Only a few will have that expectation met. Most of us will need to work diligently, one day at a time, sometimes for years, before we feel the level of achievement we seek.

If we can learn to feel gratitude for each small success, our lives may become more peaceful and satisfying than if we work obsessively toward our artistic goals. By building patiently on each small success, we develop a realistic foundation for our artistic growth.

One successful soprano shared that she began her career as a singing waitress in a resort. Through many years of additional work, study, and practice, her work became recognized.

Some artists refer to this process as "paying one's artistic dues." Often our small successes prepare us spiritually and emotionally for the next level of our artistic development. We regain our balance at each new level of success and begin work on the next, each success paving the way for what will unfold when it is time.

❖ ❖ ❖

God, help me to recognize and feel grateful for each small success with my art. Teach me that you are guiding my path with each small success, and that all is going according to your plan of goodness for me and my art.

Relaxation, Meditation, and Self-Hypnosis

There are many techniques available for us to learn that can engage our minds, bodies, and spirits in the healing process by expanding our awareness. Relaxation, meditation, and self-hypnosis are some of them. Books and tapes are available at bookstores. Seminars and classes are available through various agencies.

We may choose to experiment with a variety of these methods for learning to focus on ourselves and our art. Many recovering artists try several before we discover the one or combination of them that works for us. Some say these techniques provide mind-opening benefits that lead to greater inspiration and improved concentration. Some may find balance or use these methods to plant encouraging self-affirmations in our souls. Others find them useful for managing pain or relieving feelings of depression.

These methods might also be useful for getting in touch with or enhancing our personal spirituality. Some of us feel our first precious moments of serenity while experimenting with these health-enhancing techniques.

❖ ❖ ❖

Today, I will consider whether learning relaxation, meditation, or self-hypnosis techniques might offer healthful benefits to my life and my art.

Author's note: A meditation called "Turning It Over—A Visualization" is included at the back of the book for your consideration.

Balancing Teamwork and Individual Pursuits

As members of a society or group, we all serve a function as part of a team, be it family, work, or other social contacts. As artists, we often pursue our art on an individual basis. Our task, often, is to balance these two seemingly opposing concepts: our individuality and our role as a group member.

We can set respectful boundaries and seek a comfortable balance that encourages our self-actualization as an individual. We can strive to do this in a way that allows for our personal unfolding within and in addition to the group or groups in which we are involved. Making appropriate time and energy for each can be challenging. We can learn to make healthful choices that guide us to respect for ourselves and others with whom we interact.

There are numerous relationships and issues we may choose to examine on our way toward balance. Each relationship and issue can offer lessons for our creative growth if we are open to learning them. Each lesson we learn serves to enhance the delicate balance we each strive for between teamwork and individual pursuits.

❖ ❖ ❖

I can open my feelings to examine issues of balancing teamwork and individual pursuits as I become aware of them. I can work toward the peaceful balance that feels emotionally appropriate for myself and my art by making honest choices that reflect my needs and wants in a healthful proportion to respecting the needs and wants of others with whom I am involved.

Taking Healthful Risks

In our pasts, we may have taken risks with our art or in relationships and been shamed for our efforts. We may not have emotionally worked through the old feelings of shame and pain about ourselves or our art that may be spiritually connected with these risk-taking endeavors. It is possible that we may have generalized the taking of risks as a painful thing to undertake because of this unresolved connection we hold in our minds. We may be unaware that the connection even exists.

It is possible that we might become stagnant, hiding behind our fears that if we try again, we may fail again and feel the same painful and shameful feelings we felt before. Some of us learn that, with courage, we can reexamine those old feelings, work through our fears to self-acceptance, and emerge with a more open attitude about taking risks.

With patience and trust in our Higher Power, we learn to take small, healthful risks and gradually expand our efforts. Each positive accomplishment builds our trust for the next step. Along the way we may learn that what we once thought of as mistakes in our judgment are just lessons to be learned: nothing more, nothing less.

We establish healthful boundaries that do not include owning others' shameful or painful messages about who we are. We continue by taking more risks: sometimes for our art, sometimes in relationships. We learn to venture into the unknown with healthful faith that we are being guided. We choose to trust that all will be well, even if we feel unbalanced in the moment.

With time, we learn to discern which risks might under-

mine our recovery efforts, and we choose to detach from them. We learn to trust our instincts to guide us to risks that will expand our awareness of who we are and what is possible for our lives and our art. We learn that risk taking is part of the healthful process of growth.

❖ ❖ ❖

Today, I will meditate on whether I am avoiding healthful risk taking with my art or my relationships. I will ask for and listen to Divine Guidance if I feel I need it.

"Artistique Mystique"

Some of us may hold lofty ideals of who artists are, what they do, and how they go about creating. We may believe that their work is done magically, mysteriously, or with absolutely no effort or investment on their part. We may think we can't be an artist because we don't fit our own ideas of what an artist is supposed to be. We may have fallen for the "Artistique Mystique."

The truth is that artists are human beings. We eat human food and go to the bathroom like everyone else. We have relationships and deal with issues of growth like everyone else. We have feelings and feel pain. We manage budgets and time and sometimes households and families. We learn lessons of balance in our lives, too.

Many of us have learned to give our art a high priority in our lives. We may work on our spirituality sufficiently so that now we serve as a channel for the creative messages from our Higher Power. We learn to listen for the unique artist voice within our souls and trust that it is leading us to good things. We create our art as we feel led. We accept that we fit our own ideas of what an artist can be.

Some artists may view their art as hard work, others as creative play. Some of us come to see our art as gifts from God and feel grateful to willingly serve as a channel for the expression of our unique art. We choose to receive and honor our gifts and use them as an act of respect to our Higher Power for having been entrusted with them.

❖ ❖ ❖

I might examine my ideas of what it means to be an artist. I can consider whether I, too, might possibly consider myself an artist: if not today, perhaps one day soon.

Recovering Our Artistic Selves

We may have lived parts of our lives denying our creative gifts. Some of us may have lost our artistic selves to our addictions. Many of us had no idea that an artist was a possibility for who we could be. Others of us simply have not yet learned the skills and strategies that encourage the acceptance of ourselves as who we uniquely are.

Every human being, we might consider, is an artist when we connect with and use the gifts that express our creative selves. An elementary-school child can artistically express the grasping of the alphabet as a means of artistic expression in the moment. A store clerk can be an artist by genuinely expressing gratitude to a customer for a purchase. Suppose we were to believe that artistic expression is not limited to traditionally held boundaries of what art is but is a universal concept involving continual creation and/or recovery of our unique selves every moment. Suppose we believe that no artistic expression is any greater or lesser than any other, and that there is no need to compare any single artistic expression with any other.

We can express our creativity continually by the healthful choices we make as we engage in our endeavors of daily living. We can share our feelings on issues we encounter. We can choose healthful ways to express ourselves in relationships with ourselves, our Higher Power, and with others.

❖ ❖ ❖

In artistic recovery I can learn skills and strategies to make the best use of my honest gifts. I can become open to healthful choices that support my artistic development.

Accepting Individual Differences

We may have lived in an atmosphere in which individual differences were judged, shamed, or not accepted. This may have taught some of us to judge differences, which in reality are our uniqueness, in critical or negative terms. We may have learned to negate or deny our own differences in order to "fit in" with others around us.

In artistic recovery we can learn to accept, even celebrate, our individual differences. We can grow to embrace the gifts we once denied that are unique to ourselves. Our ideas, our inspirations, our choices, our unique connection to our Higher Power, our creative dreams—all are what makes each of us individual.

We can learn to trust that accepting our own individual differences can lead us to accepting others' differences. We can become open-minded by embracing differences and celebrating the diversity of choices available all around us.

❖ ❖ ❖

Today, I will meditate on whether I am accepting of individual differences—my own and others. I will become aware of any shaming, judgment, or nonacceptance I place on my own or others' choices.

Using Resources for
the Highest Good

Resources, like beauty, may be in the eye of the beholder. Some of us may be surrounded by resources but not recognize them as such. We may hold limited concepts of what resources are. We may be unwilling to change our limiting or restricting ideas about what constitutes our resources.

Some of us may be unintentionally discouraging the highest good for using our resources by hanging on to unresolved issues from our pasts. Rather than encouraging ourselves to grow by facing and working through our old feelings, we choose to cling to them and often, though inadvertently, discourage the goodness that might come to our lives when we let go of our limiting beliefs.

Many of us learn that willingness to surrender our old ideas opens our attitudes to more clearly identifying and using the resources, the creative gifts, and the spiritual guidance that have surrounded us all along.

❖ ❖ ❖

God, I am willing to surrender my old limiting concepts about resources. Please guide me to more clearly identify creative resources for my life and my art. Show me, too, how to use them to the highest good to your glory. Thanks for caring.

The Next Right Step

Sometimes in our creative recovery or our lives, we may not know what to do next. We may not have discovered a purpose, direction, or an answer that feels right to us. We may feel at a loss as to how to express ourselves, or where to turn. This is often a time when we can learn to trust God's lead.

Many times the quiet times in our lives and our art are being used to heal us from emotional wounds. Their purpose may be intended for spiritual renewal. We may need time to regain our balance from strenuous endeavors: sometimes physical, other times emotional or spiritual. Just as our muscles need time to rest after physical exertion, so, too, our spirits and emotions need time to rest in order to return to feeling balanced.

Many of us learn in artistic recovery that the next right step is revealed in God's own way and time. By praying and meditating, we become open to God's will for our lives and our art. By listening to our healthful feelings, we become guided on our paths. By trusting them and following our instincts, we become aware of the next right step and, when the time feels right, find the courage within ourselves to take it.

❖ ❖ ❖

God of my understanding, I am grateful that you continuously guide my life and my art to the next right step. I will endeavor to stay out of your way and listen for your healthful guidance by honoring my feelings. Thanks for caring.

Loving Ourselves

One of the ways we learn to love ourselves is to give ourselves permission to do things we enjoy. Life doesn't need to be all about drudgery, struggle, suffering, and negative feelings about ourselves and our art . . . unless we choose for it to be.

We have within each of us the God-given power to love ourselves. We can begin by exploring the endeavors about which we feel peaceful and centered when we are involved in them. They bring pleasure to us just by the involvement we allow ourselves with them. The process itself is enjoyable to us. This may be one of our avenues of artistic expression.

Our ideas of art do not necessarily need to be what is typically thought of as art—perhaps painting, music, dance, etc. It can be as unique as each of us defines art to ourselves. As long as it is healthful and does no harm, it can be called art. We encourage ourselves to express our art as a way of loving ourselves.

❖ ❖ ❖

I can find healthful endeavors that bring happiness to my life. I can learn to love myself enough to make the priorities for doing the things I honestly enjoy.

Focusing on Others

We may not be aware of how much we focus our time, energy, and interest on others until our lives reach a state of unmanageability. Some of us may have been taught to take care of others as a way to feel acceptance or to "fit in" a particular group's expectations.

In recovery, we learn that the price is high for our imbalance toward other-centeredness. The price is our spiritual and emotional peace, and the denial of our artistic expression. Some of the time and attention many of us have devoted to others' interests and care we might have better invested in our own self-care, including the expression of our art. Many of us didn't know that we had a choice.

As part of our artistic development, we may choose to take steps toward prioritizing the focus of our attention. We allow others who are capable to learn to be responsible for their own needs. We choose to give healthful amounts of time and attention to our own wants and needs. We set boundaries with ourselves and others that support our own need to express ourselves creatively.

In the process, we make changes that turn the focus of our attention from other-centeredness toward a balance that includes ourselves. We learn to pay attention to how we feel, what we need, and what our ideas and expectations are for ourselves and our art. We choose to take responsibility for seeing that our own needs and wants are met in healthful ways and allow others, who can, to do the same for themselves.

AUGUST

❖ ❖ ❖

If I have lost myself by focusing on others' needs at the expense of my own healthful self-care, I can examine my feelings. I can learn to focus on myself, including my artistic expression.

The Gentle Flow of Harmony

When we learn to trust ourselves, our art, and our Higher Power, we no longer feel the need to rush. We gently follow the path as it unfolds peacefully before us as we go about being who we are.

We listen to the flow of ideas, feelings, likes, and dislikes and follow those that appeal to that most healthful and unique part of ourselves—our souls. We let go of the rest. We no longer attempt to control people, places, or things or permit them to control us. We learn, sometimes after many attempts, to accept those we cannot change. Peacefully and creatively, we change those we can.

We seek a balance in many areas of our lives. We encourage management of our lives so that our art is not neglected, nor is our personal self-care neglected for the sake of our art. We seek meaningful relationships with open and growing people who nurture our creativity. Patiently we open ourselves to the harmony that is the reward for our emotional and spiritual efforts.

❖ ❖ ❖

God, please guide me to see the gentle flow of harmony that is available if I choose to do the emotional and spiritual work toward it. I am grateful for the awareness that the gentle flow of harmony is a possibility in my life and my art.

Bottoming Out

Many recovering artists may have had to reach an emotionally painful place in our lives before we opened ourselves to learn some valuable lessons about what life can be. Before we "bottomed out," we didn't trust ourselves or God, believe that life could be good, or perhaps conceive of ourselves as capable, competent, and creative. We believed that if we did things a certain way and controlled enough people, places, and things, life was okay. We were surviving.

Then some of us reached the painful realization that life was not okay, because our controlling didn't work anymore. We felt powerless. We came to seek help for our powerlessness.

In the course of our artistic recovery, we come to educate ourselves to new lessons that help us to let go of our old controlling ways of thinking, believing, and being. Our attitudes, over time, become open to trusting ourselves and our Higher Power, to accepting and using our gifts, to the variety of possibilities around us. We learn that we are capable of growth, no matter what our age or situation. We open ourselves to learning.

Some artists eventually come to accept our bottoming out as a necessary step in the process of our growth. We may perceive it as opening the door to a better reality where we learn to feel self-love, acceptance of our gifts, and peace with ourselves and our lives. We come to feel grateful for having been guided to that door. No longer living our lives in the old survival mode that limited us, many of us go on to thrive and enjoy life to the fullest.

❖ ❖ ❖

Today, I will consider whether bottoming out may be a mysterious spiritual gift intended to guide me to a fuller, more abundant life.

Youth

Anonymous

Youth is not a time of life—it is a state of mind. It is not a matter of ripe cheeks, red lips, and supple knees; it is a temper of the will, a quality of the imagination, a vigor of the emotions; it is a freshness of the deep springs of life.

Youth means a temperamental predominance of courage over timidity, of the appetite for adventure over love of ease. This often exists in a man of fifty more than a boy of twenty.

Nobody grows old merely living a number of years; people grow old only by deserting their ideals. Years wrinkle the skin, but to give up enthusiasm wrinkles the soul. Worry, doubt, self-distrust, fear, and despair—these are the long, long years that bow the head and turn the growing spirit back to dust.

Whether seventy or sixteen, there is in every being's heart the love of wonder, the sweet amazement at the stars and starlike things and thoughts, and undaunted challenge of events, the unfailing childlike appetite for what's next, and the joy and the game of life.

You are as young as your faith, as old as your doubt; as young as your self-confidence, as old as your fear; as young as your hope, as old as your despair.

In the central place of your heart there is a wireless station; so long as it receives messages of beauty, hope, cheer, courage, grandeur, and power from the earth, from men, and from the Infinite, so long are you young.

When the wires are all down and the central place of your heart is covered with the snows of pessimism and the ice of cynicism, then are you grown old indeed and may God have mercy on your soul.

Working with What We Are Given

Some of us may spend a lot of time worrying obsessively about the things we lack. We compare our talents to others and feel lacking. We look at our art and expect it to be like someone else's, or better than it is. We make mental lists of the things and conditions we need in order to do our art, and then get nowhere beyond the list. We berate ourselves for not measuring up to others' expectations of who we are and what our art is about.

We can learn to trust that our Higher Power has given and will provide everything we need. We can begin by becoming grateful for exactly what we have been given and creatively using that to our best ability.

To continue worrying about the things we don't have may be nothing more than a handy excuse that keeps us from growing creatively. It can keep us stuck in a "pity me" mode of thinking. To choose the grace to be grateful for what we do have and to creatively make the best use of it is an act of faith in God. Perhaps God requires a demonstration of our responsibility with the gifts we have been given before we are entrusted with more.

It is possible to learn to believe that each of our gifts is exactly right for us. We can express gratitude for them by using them to our highest good. We can trust that in God's own way and time, we will be given all that we need to express uniquely who we are.

❖ ❖ ❖

God, please teach me that exactly what I have is perfect for me right now. Guide me to creative uses of each of my gifts as a demonstration of my faith in you. Thanks for caring.

Growing Pains

When we are struggling with a difficult issue or beginning work on a new inspiration, we may sometimes find ourselves lost in small details. We might feel impatient or doubt our abilities. We may want to give up on the idea, the relationship, or the issue. We might be experiencing growing pains.

These are the times we need to learn to trust our Higher Power—when that seems the least likely thing to do. We can look inside ourselves, deep in our souls, for the healthful courage that is waiting for us. All we need to do is claim it.

We may be guided to courageously waiting patiently sometimes when our self-will insists that forging ahead would relieve the anxiety we are feeling. Sometimes we learn later that, while we waited, a better plan was being worked out for us—a fresh inspiration, perhaps, or a new dimension to a relationship, or other personal insights or gifts being revealed. We may learn new lessons about who we are.

Many times we only see the contribution that each small step revealed when we have completed the project or when the big picture of an issue or relationship is brought to our awareness. It was our faith and courage, our willingness to trust our Higher Power, some of us learn, that guided us through the small details to the completion. We have grown through our pain to a new reality.

❖ ❖ ❖

Guide me, please, God, through my struggle with small details. Help me to learn to trust that the big picture of my art and my relationships will emerge when the time is right. Help me to accept that my growing pains are leading me to expand my ideas of who I honestly am. Thanks for caring.

Respect for God's Boundaries

When we learn to respect boundaries, we engage in a process of clarification. We define to whom responsibilities belong and do not take on those that are honestly others' as our own. This strategy often leads to peace in relationships and endeavors.

Some of us may feel anger because we have not extended the courtesy of this respect to God. We may not trust that God has a plan for our lives. Or we may not like or accept the plan as it unfolds for us.

Sometimes our self-will is seeking to control God. We want to try to convince God that things should be done our way or in our time. We do this until we find the courage to surrender to God's will.

Many artists find that when we let go completely of expectations, fears, and limitations and honor God's boundaries, our lives and our art take on new creative dimensions. We become open to an abundance of gifts, peace, and respectful relationships. Many of us learn to place God, and respect for God's boundaries, at the top of our gratitude lists.

❖ ❖ ❖

I am grateful, God, for the awareness that honoring the boundaries of respect for what you are responsible for can guide me in my artistic development. Thanks for caring.

Choices, Courage, and Creativity

There are three "C" words that may serve to encourage our artistic development. Choices, courage, and creativity can guide our endeavors when we feel stuck or discouraged.

Our choices are a gift when we honor them and nurture their development. We set and maintain boundaries around our choices, so that they are given the respect they deserve in our lives and our art.

Courage is a spiritual gift that lies waiting in our souls for us to connect to and use. Many artists find that we need only ask God in faith for courage, and it is provided to us.

Our creativity is encouraged when we courageously honor our choices. Our lives and our art become manageable, and we become our creative selves.

❖ ❖ ❖

Today, when I feel the need of it, I will remember that the three "Cs"—choices, courage, and creativity—are available to me.

Recovery Gifts

We may not recognize them, but gifts are all around and inside us waiting to be claimed by us. We can discover our gifts by becoming open-minded and looking for them. Our creative gifts are often waiting just under our fears. When we break through or work through our fears by discovering the courage within ourselves to own our healthful power to choose, we often become open to seeing our gifts. Sometimes we gain new inspiration or insights into our creative attempts, or awareness of spiritual connections of faith in our Higher Power or ourselves as artists. Sometimes we uncover supportive gifts that guide our artistic expression. Some artists become open to receiving very physical gifts that await only our acceptance of them.

We may be guided to gifts as a result of our relationships—with others, with God, or our relationship with ourselves. A gift might be to learn a new behavior that will help us to feel more accepting of ourselves and our art. Someone else's behavior may teach us to set or maintain a boundary. We may discover new confidence in ourselves or our art. We may find that we can detach from unhealthy behaviors that serve to undermine our artistic recovery or our self-expression. All these and many more are gifts.

We may not always see the gifts or perceive them as gifts until later in our lives, but they are there if we become open-minded and trusting in our Higher Power. We can learn to see our gifts by looking for them. And we can learn to express our gratitude by using them.

❖ ❖ ❖

Teach me, God, to see the gifts around me, to claim them as mine, and to use them as my gift back to you. Thanks for caring.

Breaking Through Limitations

Each of us lives within certain limitations. These limitations are imaginary ideas of what we believe to be possible for our lives and our art. They are bound by our fears and restricted beliefs.

Some of our limitations may have been instilled in us by our ownership of the limitations of those around us. We chose to accept their limitations as our own, without examination or challenge. Some of them we choose because of our fears. For example, if we are afraid of water, we may choose not to swim or boat, etc. We may limit what is possible for ourselves by our fears.

Some artists discover that it is possible to break through our limitations. With courage, we honestly examine our feelings connected to our limitations. We come to see that our limitations are really illusions that can be changed. We choose to make healthful choices that guide us through the fears.

If we are afraid of water, for example, we may choose to seek professional help to work through that fear. Our reward for the work is an expanded sense of who we are and what is possible for us and our art. As we discover more courage inside ourselves, we break through more and more of our old limitations to new possibilities. That is how we grow: personally, artistically, spiritually, and in other ways.

❖ ❖ ❖

God, please grant me the courage to change the things I can, particularly the old limited and restricted beliefs and ideas about what is possible in my life and my art.

Feeling the Good

It is okay and healthful for us to feel and own our encouraging feelings like joy, peace, love, acceptance, appreciation of our artistic gifts, and others. As part of our artistic recovery, many artists may have learned to work through intense feelings of anger, pain, frustration, and change that are part of the healing process. We want to become whole by acknowledging and accepting all our feelings.

Our recovery needn't be all about serious work. We can learn to laugh at our blunders, rejoice in our triumphs, acknowledge the joy our art brings to our lives, feel gratitude for our gifts from God and others, and accept that God's will is being done. Sometimes we may go through stages to get to these feelings, but we can learn that they are a possibility.

We can feel the pleasure that is brought to us by engaging in our art. We can accept the compliments we are given for our artistic efforts and our choices. We do not need to deny ourselves any more of feeling the good in our lives. We deserve to feel good about ourselves and our art. Most of us have paid our dues.

❖ ❖ ❖

I will meditate, today, on whether I am encouraging myself to feel all the good in my life. I will consider whether I believe I deserve to feel good about myself and my artistic expression.

Competition As
a Learned Behavior

We may have grown up with defined messages and feelings about competition. If we were given attention only when we excelled at something—our art, for example—we may have developed a soul need to excel continually, to be better than those around us, to gain that continued attention. This is not discouraging in itself unless it is carried to extremes. Then this need can lead to emotional and physical distress, or neglect of our personal self-care for the sake of our art, as we drive ourselves to fill that competitive need to do more and more. We may be compulsively competitive.

Conversely, if we are given attention only if we "misbehave" according to others' expectations, we may hold on to a need to act out our misbehavior continually in order to keep getting that attention. We can learn healthful ways of gaining respectful attention in artistic recovery. We can ask openly for attention from safe people when we feel the need. We can take responsibility for getting our creative needs met in self-respecting, growth-enhancing ways.

In recovery we can learn new attitudes about competition. We can learn to express our art and interact with others for the pleasure it brings to our lives. We can seek to let go of competitive attitudes that work against our best self-interests. We can engage in endeavors that allow us to express who we are, rather than always compete with anyone or any system outside ourselves.

❖ ❖ ❖

I can learn behaviors and make choices that encourage me to express who I am rather than forcefully competing with others' ideas or the ideas of systems in which I am involved.

Accepting Nonacceptance

What do we do when others do not accept us as the people or artists we honestly are? We may expend our emotional energy trying to convince them of who we are for a variety of reasons. We may have learned to change ourselves to fit in with their expectations of who we should be. . . . Or we might choose to accept that they do not accept us as who we honestly are.

We can encourage ourselves to feel the pain of their nonacceptance. We can learn to let go of it by recognizing that those feelings and opinions belong to the other person. We do not have to own them simply because others choose to. We can turn over others' nonacceptance to our Higher Power and let go of it. We can respect our own and others' boundaries.

Then we can choose to focus on our own acceptance of ourselves as the artists we honestly believe we are. We can do positive affirmations or make lists of all our artistic gifts and accomplishments. We can make healthful changes and choose to be around those who accept us as we uniquely are. In the creative light of our positive self-image, many artists find, others' nonacceptance of us and our art loses it power in our lives.

❖ ❖ ❖

Today, I will meditate on the possibility of accepting others' nonacceptance.

Feeling Satisfaction

We can learn to feel the satisfaction that a peaceful, creative life has to offer. When we become open and receptive concerning our needs, expectations, and feelings for our lives and our art, that balanced feeling can be pleasurable to us.

When we feel unsatisfied or discouraged, we may want to clarify our feelings, needs, and expectations. It is possible that we may be looking to have our needs met in disrespectful ways, perhaps by controlling people, places, things, or outcomes. We can learn to look for healthful ways of getting our needs met. Sometimes by prayer and meditation, we are guided in unexpected ways of getting our needs met. Sometimes we are guided to remember to allow for God's time and God's way for our needs to be met.

Sometimes our expectations may leave us feeling less than content. We might ask ourselves, "Am I expecting too much or too little of myself and my art? Am I expecting my Higher Power to provide for me in a prescribed, specific way and time?"

We can learn to accept that God's plan for our lives and our art may be different from our own expectations. By getting out of God's way, perhaps by letting go of our expectations, we can learn to feel the satisfaction of living our lives according to God's will for us. Many artists discover that God's will for our lives is better than our own expectations. We gratefully get out of God's way and encourage God's will to evolve in our lives and our art.

AUGUST

❖ ❖ ❖

I can learn to encourage myself to feel the satisfaction of my life and my art exactly as it is. If I feel unsatisfied, I can become willing to honestly clarify my needs and expectations.

Willingness for Our Art

Our art does not merely happen to us. We open ourselves to it by our willingness in many areas. We become willing channels for God's creative energy by nurturing our spiritual connection to God as we understand God. By listening to our instincts, and giving attention to our feelings, we become guided to our honest creative expression.

We may need to learn to make time in our lives for our art. We need to discipline ourselves to the training and fostering of the skills for our particular art(s). We may need to practice, sometimes on a regular basis, to keep our skills in readiness.

We learn to establish and encourage focus on our art. We take care of ourselves by maintaining boundaries that protect and nourish our creative souls and our art. We feed our souls with inspirational gifts. We surround ourselves with people who support our artistic efforts.

We become willing to use our artistic gifts by surrendering to them rather than denying their existence. We become grateful that we've been given our gifts when we willingly use them for joyous creation.

❖ ❖ ❖

I am grateful to have been guided to the willingness inside myself to use my gifts for joyous creation. Thank you, God.

Making Peace with Ourselves

As our artistic recovery progresses, we become increasingly open to the acceptance of our honest reality. We honor our feelings on the many issues we face and learn healthful ways of thinking, creating, and being. We become more reassured about who we are and what is possible in our lives and our art. We strive toward becoming more accepting of ourselves.

We learn more and more to trust our Higher Power in all our endeavors and to trust that our lives and art are working toward the highest good. We learn to take healthful risks in an effort to grow artistically and in relationships.

We may have learned many lessons along the way of the personal discouragement of our own and others' behaviors. We now willingly choose to learn respectful alternatives to those behaviors. We choose to use our creative gifts to express ourselves in health-promoting ways. We accept our gifts as a loving, sacred trust from our Higher Power and use them accordingly.

We make peace with ourselves and our art by learning to become kinder, gentler, and more accepting of our wants, needs, and God-given gifts and talents.

❖ ❖ ❖

I am grateful, God, to have been guided to willingly choose to accept the peace of loving myself as a person and as an artist.

Try Waiting Patiently

When we feel frustrated or angry that our lives or our art may not be progressing as we expect, the hardest thing to do may be to wait patiently. We may want to react by manipulating, controlling, pushing harder, giving up, letting someone else do it for us, or other self-defeating behaviors. We may not know that we can choose to respond in peaceful ways.

Many artists discover that getting away from an endeavor, or detaching emotionally, provides a clearer perspective than when one is caught up in the intensity of a situation. Often the answers we seek are revealed to us when we have taken the time to calm ourselves, perhaps pray or meditate about possible solutions, and detach from the feelings of frustration or anger that serve to sabotage our peaceful balance.

Those of us who believe we lack the gift of patience can seek it by asking our Higher Power to grant us this gift. Some artists discover that in seeking it in our lives and art, we are pleasantly guided to finding it waiting within ourselves. It was available to us all along, waiting to be discovered by our growing beyond the feelings that discouraged it.

❖ ❖ ❖

If I am facing a frustrating situation or endeavor, I will choose to try waiting patiently. If I feel that I lack patience, I will begin today to ask my Higher Power to grant me this gift.

Enthusiasm Is Contagious

Some artists believe that, just as misery loves company, so does enthusiasm. If we choose to surround ourselves with people who are encouraging and hopeful and who have an honest passion for life, that spirit seems to travel from one person to the next.

Some of us may notice that, just by sharing who we honestly are by talking about our hopeful and trusting feelings, a group's attitude can be directed from a subject of shared misery toward a more peaceful and hopeful spirit. Often, it seems, some people feel so lost in their addictions or misery that the hope they see in others can provide a goal for them to connect with hopeful, creative feelings within themselves.

This does not imply that we need to try to fix other people's problems. That can lead us to frustration and anger. We learn to respect boundaries and allow others who are capable to solve their own problems. However, we do not need to get caught up in the web of others' misery either. We can encourage our own unique, honest, and healthful spirit to shine and provide a beacon by which others may or may not choose to travel toward healing and artistic development.

❖ ❖ ❖

I can choose to be around enthusiastic people whose spirit supports my most creative self-interest. I can seek to find those who demonstrate healthful boundaries in their lives and art so that I might learn by their example and practice to establish and maintain my own healthful boundaries.

Burnout

Many of us do not recognize the phenomenon of burnout even when we are in the midst of it. We may be feeling that we need to try harder, do more, give more, be perfect, be available to everyone else, push for the outcome we want. Or we may be unable to pinpoint our feelings.

Often burnout may look like we are very caring people. The truth is, we are caring people. We sometimes care too much about others and do not save enough love for ourselves and our own self-care. Some of us may neglect our art in favor of caregiving to others. We meet others' needs at the expense of ourselves and our own needs, including our need to express ourselves creatively.

Some of us continue to look externally for our needs to be met to the point of exhaustion. We may become physically and/or emotionally drained. We may feel unable to do or to give any more. For some of us, this marks the beginning of learning lessons of skills and strategies of healthful self-care and communications. We learn that we cannot possibly be all things to all people. Some of us may go into therapy and explore the issues that led us to exhaustion.

Many of us discover that our artistic gifts wait for us to regain a healthful balance when we let go of the behaviors that led us to feeling burned out. We go on to feeling grateful for the burnout that changed the direction of our lives for the better. We learn to choose communications that honestly express our choices rather than those that leave us feeling burned out and drained.

AUGUST

❖ ❖ ❖

If I feel constantly drained or exhausted, I will consider whether seeking help or therapy might guide me to a balance that will encourage me to feel peaceful in my life and my art.

Days of Special Remembrance

SEPTEMBER

Labor Can Be Joyful

When we are involved in our "right work" we feel satisfied and joyous. Work does not need to be about drudgery or living in fear or constant exhaustion. Our attitude can play a crucial role in our feelings about our labors.

Our creative endeavors may be our full-time job, or something we do in our spare time. We may punch a clock, or do our work as the spirit guides us. We may work with others or engage in solitary acts of creativity. No one way is better or more creative than any other. Each is merely what we make of it. If we can learn to feel grateful and accepting of our situation, we can feel peaceful with our labors.

When we feel unbalanced, we may need to examine the role our labor is playing in our lives. Perhaps we are being guided to change some aspects of our labor, or our relationships with those around us, or with our art, or our attitude. Often we are guided to new awareness about our labors and our art by unexpected events in our lives. Sometimes we feel pain before we are guided to peace. Many artists learn that, with time and patience, our Higher Power guides our lives to work out for good.

❖ ❖ ❖

Today, I'll consider my attitude about my labors and my art. If I discover things I feel I would like to change, I will meditate on this awareness and trust my Higher Power to guide me through changes.

Life Is A-Maze-Ing

One recovering artist shared this perspective:

I've learned to see my life as if I am traveling through a maze or puzzle. When I find myself at an impasse or discouragement, I no longer need to "kick and scream" because I don't know what to do. I don't need to resort to fear, because I have learned to trust that my Higher Power has a purpose for this, too. I may choose to be peaceful, because I've learned that anger is a choice, just as peace and acceptance are.

Increasingly, I am learning to rename what I once termed impasses. I now see them as "choosing points." When I begin to feel the anxiety that once clouded my perspective, I say to myself, "I can choose a peaceful alternative," or "This is not a life or death situation," or perhaps pray, "God, please show me what my options are here."

By reframing my perspective and seeing my life as a maze with many "choosing points," rather than blocks, my attitude has become more open. Just as in a maze there is a way out if one makes a series of turns, my life becomes more manageable by the turns, or healthful choices, I make to work through issues that discourage me or my artistic expression. I have come to see that my life is amazing! Or maybe another way to see it is that I feel amazement. Maybe it is meant to amaze me.

❖ ❖ ❖

I might imagine my life as a maze with many "choosing points." When I find myself at an impasse in a relationship or creative endeavor, I may choose to look for peaceful or creative alternatives.

Artistic Style

Our artistic style is ours to choose. We may look to others for role-modeling or suggestions, but ultimately we each define our own art in a way that only we each can by our choices.

Some artists may explore extremes of styles before becoming comfortable with those that feel balanced and peaceful. We may explore various possibilities on the way to choosing those that define our style. Many artists describe this process of exploration as being "in process."

Our artistic style does not need to fit into a particular mold or group unless we choose for it to. We may choose traditional styles, or we may blaze our own trail with a style unique to our personal expression. Some artists may become guided to change styles, mediums, or continue to explore other possibilities all our lives. Our choices may guide us in any number of directions.

❖ ❖ ❖

I can keep my attitude about my artistic style open to possibilities. There is no need for me to shame myself if I choose to explore a new, healthful medium or style of personal or artistic expression.

Projects in Process

Our artistic efforts generally evolve through a process involving many steps. Sometimes we proceed by using tested steps with which we have experience. Other times we feel guided in mysterious ways by our Higher Power. Sometimes we playfully let go and trust in the outcome.

With time and patience we learn to accept our art no matter where we are in the process. We can let go of a controlling attitude that may serve only to limit the outcome. We can open our minds to see various possibilities and to choose from those possibilities and trust the ones that feel right in the moment. And we can accept that choice as a gift from God.

We can learn to trust that our art, our relationships, and our lives are all projects in process—all evolving exactly as they need to. We can choose to accept that we are right where we need to be according to God's will for us and our art. We do not need to worry or overly concern ourselves with a particular outcome for any of them. We can learn that God's will for us is evolving in God's own way and time.

❖ ❖ ❖

I am grateful, today, for the awareness that my art, my relationships, and my life are all evolving according to God's will for me. I want to remember that all of them are projects in process.

Developing Our Resources

Some of us may be unaware of the resources available to us if we only claim them. We may have become discouraged from perceiving them as available to us by others who held strict boundaries concerning who we should be, how we should express ourselves, or what is possible in our lives and our art.

We each need to define and develop our resources and God-given gifts as we envision them. Our experiences, our inventiveness, our courage, our designs, our connection to our Higher Power, our boundaries, and many other factors are assets we can use to bring our art into the realm of reality.

In artistic recovery, many artists explore the feelings we have associated with our limitations and misconceptions. We resolve the feelings and reach new levels of understanding for what is possible in our lives and our art. Many of us discover resources that have been within our reach that require only our awareness of their existence. We come to accept and claim them as ours and learn to employ them to express ourselves creatively.

❖ ❖ ❖

Today, I will consider whether there are resources—ideas, help, inspiration, skills and strategies, assets, or others—available to me that I can become aware of, develop, and use for the highest good of my art.

Just Trust

We may have learned to respond to others and to situations in defensive, manipulative, or other unhealthy ways. If we were not taught that we had choices in our responses, we may not know of the peaceful alternatives.

Our artistic expression can become enhanced when we learn responses that respect our honest feelings in situations or relationships. If we were taught to respond to others so that they would like us, for example, we may respond to others' requests in ways that put our own needs or healthful self-care in disrespectful proportions to others' needs and wants. Our art may suffer because we do not trust that we will be liked by others if we say no to requests.

We can learn that our feelings are guided by our Higher Power and that to trust our feelings is to trust our connection to God. We learn that our choices are guided by our healthful feelings and that, as we learn to trust them, we grow toward becoming peaceful in our lives and our art.

❖ ❖ ❖

Today, I will just trust my healthful feelings, choices, art, and my Higher Power.

Self-Will

An acronym:
 Sabotaging
 Expectations
 Limitations, and
 Fears
 Which
 Inhibit
 Larger
 Living

As part of our spiritual development, many artists discover the role that our self-will has played in discouraging our honest expression. We may have denied ourselves by owning expectations, limitations, and fears that do not reflect our truest selves. We limit ourselves and our art by not working through these discouragements, or seeking the courage to change them.

We might imagine our expectations, limitations, and fears as an ELF. We might learn to understand ways in which the elf undermines our best and most creative efforts. We might open ourselves to mysterious outcomes.

Many of us learn to work through our discouraged feelings by letting go. We seek a spiritual connection with God that encourages us to express ourselves in ways much greater than our own small self-will. And we make way for God's will, which, many of us find, is much more encouraging.

SEPTEMBER

❖ ❖ ❖

I will consider ways my self-will may be limiting possibilities for better living or more honest self-expression.

God's Will

An acronym:
 Good
 Open
 Dialogue
 Showing
 Willingness to
 Investigate
 Larger
 Living

God's will for our lives and our art is greater than our own small self-will, many artists find. When we learn to let go of the expectations, limitations, and fears that discourage our thinking and our creative options, we willingly open ourselves to many more possibilities that we perceive as God's will.

Many recovering artists discover the advantages, gifts, and peace that accompany God's will for our lives and our art when we connect with it. We willingly choose to surrender to our Higher Power anything that does not feel peaceful. We listen to our feelings for guidance.

❖ ❖ ❖

Guide me, God, to your greater will for my life and my art. Show me the way to find peace and creativity in every endeavor of my daily life. Thanks for caring.

The Gift of Clarity

In the course of our lives and artistic recovery, we may face many issues we do not see clearly. Doubts and fears may discourage us about endeavors we can only imagine. Others' opinions may dampen our enthusiasm. Critics and consultants sometimes cloud our thinking and passion, if we permit them to.

Sometimes patience provides the pathway to clarity. At other times prayer and meditation bring light to our ideas and inspirations. Our Higher Power works in mysterious ways to provide what we truly need when the time is right. Clarity comes when we let go of controlling the outcome and open our minds to God's will—not a moment before. When we make honest commitments in our relationships, they work to our benefit. When we have the faith to remove the blinders of our discouragement, we learn to see with greater clarity.

❖ ❖ ❖

I am grateful, today, for the gift of clarity for my creative endeavors and relationships.

Write Your Own Daily Meditation

Today, I will be quiet and allow space to encourage you to write your own personal meditation and/or prayer on a subject of interest to you and your art:

Risking Public Exhibition
of Our Art

There may be many fears surrounding the idea of sharing our art with others. We may fear rejection (or, as some say, we fear acceptance that may be disguised as rejection). Old fears we have not come to terms with may resurface in our awareness. Perhaps during previous times of sharing, we felt shamed or were given unfavorable messages. We might possibly assume that those old messages are true of our current attempts at art exhibition. They may not be true at all. We may need to take the risk to find out for ourselves.

Courage is a requirement for all honest interactions. When we feel ready, our Higher Power can guide us to find the courage within ourselves to take the steps necessary to risk public exhibition of our art.

If we become willing to be guided, we can learn from each attempt at exhibition. We may learn new strategies or techniques, or perhaps things we don't want to try again. We may learn that we do have the courage we once doubted we had. We can listen to our instincts.

We can grow spiritually and artistically by extending to ourselves and our art the courage God gives to us. We can learn to trust that the Great Creator will guide us to lessons available in each situation in which we become involved, if we become open to seeing and learning the lessons.

❖ ❖ ❖

When I feel ready, I can seek the courage to risk a public exhibition or sharing of my art. I can trust that God will guide me to lessons of courage as I need them.

Returning to Old Patterns

Sometimes in the course of our recovery, no matter how long we've been working on it, our old self-defeating behaviors and attitudes creep back into our lives. We may return to discouraging patterns and habits, sometimes unaware that it's happening. Sometimes while proceeding with our lives, we notice a feeling of unease. Something just doesn't feel balanced.

We may have begun to neglect our self-care. Our focus may have shifted from ourselves and our art to someone or something else—perhaps to our old discouraging patterns.

We need not berate ourselves if this happens. When we recognize it, we can choose to take the steps back to healthful self-care. We can express our feelings, address our needs and wants, examine our boundaries, and guide ourselves back toward balance. Sometimes it is done easily; other times we may need to make amends or do emotional or spiritual work. All our efforts can lead to personal growth.

When we return to our healthier balance of recovery, many artists feel freer to create, the world around and inside us looks clearer and brighter, and we feel more fully alive.

❖ ❖ ❖

God, help me to be honest with myself when I find that I have returned to my old patterns and behaviors. Guide my path with the light that will show me the way to the balance of peace and creative expression. Thanks for caring.

Follow Through

An important part of our creative expression is the completion of our work. Some of us feel energetic and enthusiastic when we become aware of an inspiration. Like a new discovery, we are quick to begin our creative effort. Partway through, however, some of us may lose interest and give up.

We may be experiencing a form of self-sabotage. It is possible that, on an emotional level, we may fear the good feelings we might eventually have if we were to bring the endeavor to fruition. We sabotage ourselves and our possible good feelings by not extending the effort to complete the work. That way we can continue to hold on to a negative attitude about ourselves and our art, rather than letting go of our discouraging thinking and opening up to encouraging thinking and feelings.

If we find ourselves in a pattern of not following through with our creative efforts, we may be holding on to unexamined feelings concerning our possible success. We can journal or talk to someone we trust about our fears regarding success. Fear of failure, many artists believe, is often fear of success. We can talk or write about both fears.

We can pray and meditate on the subject, asking our Higher Power for the courage to change the things we can. Then we can watch and listen for instinctual answers, and make the healthful choices necessary to follow through with our artistic efforts as we feel guided.

❖ ❖ ❖

Today, I will pray and meditate about the issue of following through with my art. I will consider whether I need to make changes in my thinking and feelings about success.

Receptivity to Inspiration

Some artists believe that inspiration is not merely a random act. There is no good fairy who goes around dropping ideas, designs, and creative impulses haphazardly on unsuspecting people throughout the world. Our art simply doesn't happen that easily.

Many artists believe art is a spiritual process. Our human spirit becomes willing to receive inspirations, guidance, and gifts (spiritual and physical) by "getting out of God's way." By letting go of controlling our lives and our will, we become open channels for inspiration to occur. Our minds and spirits become free and open to allow our creative thoughts and ideas to play happily together, to become blended in the special ways only each of us can because of our unique combination of life experiences and personal choices.

In artistic recovery we grow beyond the limitations imposed by our old ideas about what is possible. We open ourselves to new possibilities, greater insights, and clearer awareness of what is feasible for our lives and our art. By developing and maintaining our spiritual connection to the God of our understanding, then, we serve as a channel for the expression of our art. With a healthful helping of courage from within, we risk bringing our art to life.

We learn to become grateful for each of our gifts and to express our gratitude by using the gifts that have been entrusted to us. And we practice the skills and strategies that keep us feeling open and receptive to our art.

❖ ❖ ❖

I am grateful, Great Creator, that you have guided me to become open to receiving inspirations from you. I want to learn to remain open to possibilities, ideas, and all your gifts to me. Thanks for caring.

The Art of Negotiating

Healthful interactions with others require skills and strategies that may be new to some of us. Negotiating with others requires, first of all, that we state our needs, wants, and expectations honestly, clearly, and gently. We respect our own and others' boundaries by keeping the focus on ourselves. Using "I" statements and naming our feelings and truths helps us to communicate on a personal level.

Next, we can learn to negotiate more openly by listening to the other person's response. We can respect their feelings, even if they differ from our expectations or our own feelings. We can learn to trust that if the first person we ask chooses not to meet our needs, wants, and expectations, our Higher Power may be guiding us to someone who will, or we may become guided to a different plan than the limited one we envision. When problems arise in our communications, our expectations may be the source of our frustrations, rather than the person or system with whom we are negotiating.

Our open attitude in all our negotiations can guide us toward more peaceful communications. Whether our dialogue is in personal relationships, with other artists, in business, or with our Higher Power, learning and practicing skills and strategies involved in the art of negotiating is a gift that can enhance our artistic recovery, our creative expression, and our lives.

❖ ❖ ❖

I can become open to learning more about the art of negotiating in my communications. I can seek sources from which I might learn more about and practice these healthful skills and strategies.

Everyday Choices

We may not be aware of it, but we are given choices all day long, perhaps from moment to moment. We choose when to get out of bed, whether to make the bed, what to eat and drink, and what to wear, whether or not to do personal self-care, and much more all day long.

We choose whether or not to participate in our addictions or to become involved in expression of our art. Early in recovery some of us may learn to make conscious, healthful decisions on a moment-to-moment basis. We choose healthful alternatives that reflect our honest choices in the moment to let go of our addictive behaviors. We can learn to work through these feelings toward more peaceful, encouraging feelings.

Each of our choices has consequences. If we choose to express our art rather than our addictions, we may eventually become guided to the encouraging feelings and pleasures that expressing our creative gifts can bring to our lives. We can connect with our Higher Power and feel the peace that is the eventual gift of our spiritual connection.

We can choose an attitude that is open to our gifts, our Higher Power, to loving ourselves and others, and to our healthful feelings. The consequences are often a more balanced creative life.

❖ ❖ ❖

God, please help me to become aware of my everyday choices. If I am struggling with an addiction, help me to see and choose the healthful creative alternatives on a moment-to-moment basis. Thanks for caring.

Experience

Experience can be a great teacher. We can listen to, read about, and observe others' experiences, ideas, art, methods, feelings, etc. But we cannot know or feel them intimately until we actually go through the emotions or experiences ourselves.

Experience brings instructions to our lives. We can learn lessons about what we like and don't like based on our feelings about our experiences. We can become guided in directions with our art and relationships by giving attention to the feelings we associate with our experiences. We can learn which things we may want to do again and which to detach from by seeking to understand and accept our experiences.

Our art and our relationships are based on a series of experiences, each built on those before, that have taught us many lessons about who we are and what is possible. If we maintain an open attitude, each experience can guide us to the next right step in our recovery as artists who have choices. We can learn to trust that God's will is being done by each of our experiences and that we are being guided to peaceful and creative lives.

❖ ❖ ❖

Guide my understanding, God, to accept that each experience in my life has a purpose. Teach me, please, that my open attitude can guide my path toward learning a lesson from each experience in which I participate. Thanks for caring.

Encouraging Ourselves to Make Room for Our Feelings

Some of us may have learned behaviors and attitudes that discourage or deny our honest feelings. We may have been taught not to express our views, opinions, ideas, or inspirations—especially if they differed from those around us. We may have learned, instead, to conform to those around us and deny who we are by negating our honest choices. We may have been taught to give away our God-given power to make healthful choices.

In artistic recovery we can learn skills and strategies that encourage us to make room for our feelings. We can set boundaries with others and ourselves that strengthen our expression of our healthful, creative selves. Our feelings can be expressed in creative ways that define who we are by their expression.

With time and practice, our expression of our feelings becomes a natural part of who we are. The skills and strategies we can learn in recovery serve to enhance our creative expression of ourselves. Our feelings guide us to being who we are.

❖ ❖ ❖

I can encourage myself to make room for my feelings. Learning and practicing healthful recovery skills and strategies can help me to express my creative self in more healthful ways.

Entrusted to Our Care

Our art is a gift that has been entrusted to us by our Higher Power. When we deny our creative gifts, or abuse them or ourselves with self-defeating behaviors and addictions, we do a disservice to God and to ourselves. When we use our gifts, it may be said that we are performing an act of worship to God, as we understand God to be.

By opening our minds and souls to artistic development, many artists learn to recognize and eventually use our gifts. We manage our time and our lives to give attention to the healthful things that appeal to us and bring pleasure to our lives. We learn to balance the significant areas of our lives by doing personal self-care, including giving attention to our artistic yearnings.

We learn to trust that the Great Creator is connected to us and has guided us to our gifts because we have demonstrated our willingness to receive and respect them. They have been entrusted to our care.

❖ ❖ ❖

I can become open to the idea that my creative gifts have been entrusted to my care by my Higher Power. I can best show my gratitude by using them.

Breaking the Rules

We learn to live in a society by following the rules that keep the status quo. Sometimes, it seems, it is the artist's job to test the rules and sometimes break them.

Suppose, for instance, the caveman accepted the rules as perfect when he did all his labors tediously by hand. We can assume, then, that the artist caveman who invented the wheel was not supported for his willingness to change from the reality that was accepted. We might imagine a group conscience shaming him by saying things like "Things are just fine the way they are," "That's a crazy idea," or "It'll never work."

Fortunately, the courageous artist caveman possessed the personal strength and faith to pursue his idea despite what others may have said or believed about it. Only later, when others saw the value of his invention, did they applaud his work. While it was in process, however, he may have endured shaming for his ideas and discouragement for his efforts.

When we become aware of it, we can see examples of healthful rule breaking for artistic expression all around us. Many artists believe that it is those who are in touch with our creative spirit who are given the strength to break the rules that would limit our self-expression. We choose to test the rules and sometimes break them in healthful ways, to move beyond previously held ideas of what is possible. In retrospect, this creative rule breaking is often revealed as progress.

SEPTEMBER

❖ ❖ ❖

Today, I will meditate on whether I am limiting my creative choices by obeying old rules that may no longer be true or apply to my current reality. I will examine the influence my holding on to discouraging rules might have on my ideas and possibilities for self-expression.

Finding God

Finding God is a personal, intimate experience. Some artists may look for and find God in traditional settings. Others may find God in nature or solitude. Some may find God in art—our own or someone else's. Still others may find God in other unique ways and methods.

Each of us may find God, as we understand God to be, in our own way by making personal spiritual choices. The process may involve letting go of controlling, accepting our own reality, and trusting in a source of healthful guidance that is greater than ourselves and our own self-will. Our search may involve learning to trust in goodness and opening our minds to healthful dialogue that includes our feelings.

We may find God by opening our minds to trusting that, when the time is right, we will know what or who God is and feels like to us. We can begin by meditating or praying to a Universal God and asking to be shown a personal God. Then we can listen, watch for, and accept answers that feel personally healthful and satisfying to us.

❖ ❖ ❖

God of the Universe, guide me to find the personal God of my understanding. I will open my mind to trusting that I will know and accept my personal understanding of God when the time is right. Thanks for caring.

Learning How to Share

We may have learned self-abuse lessons concerning the act of sharing. Some of us may have felt shamed into sharing what was honestly ours, when we actually felt angry or deprived because there wasn't enough to take care of ourselves and/or our art. We may have learned to give to others so that they would like, approve of, or accept us, or with unclear expectations that they would do something in return for us.

We may have felt compelled to share with others by customs or traditions with which we honestly may not agree. We may have learned to fear punishment or discouraging consequences if we didn't share in a certain way.

In artistic recovery, we can learn that we have a choice about how and with whom we share our feelings, our time, our finances, our gifts, our art, and other things that honestly belong to us. By listening to our feelings, we can learn to trust our instincts concerning with whom and how much to share so that we do not neglect or abuse ourselves or those in our care by sharing too much or too little. By learning to pay attention to and respect boundaries, our own and others', we can find the balance that will lead to peace in our efforts to share honestly.

❖ ❖ ❖

I can learn to trust my own ways of creatively sharing myself and my art that respect what I honestly choose. I can learn that a balance of healthful sharing is possible if I practice the recovery skills and strategies that guide me toward peace.

Letting Go of Naive Thinking

As children, each of us is naive in many respects. There is so much we learn simply through experience, through lessons of growing, by living, by paying attention to our instincts as they develop.

When we reach a certain level of learning (or not learning) important lessons, we are no longer naive. We become victims of ourselves and our own discouraging choices, though we may be unaware that we even have choices because of our naive assumptions about life. The pain, anger, and frustration we feel are not simply foisted on us at random. We may be choosing to allow them by hanging on to old, naive attitudes rather than choosing to learn new ones that open us up to our own healthful choices.

Some of us may naively need to experience pain repeatedly until we learn to ask for help to change our situation or our attitude. We might need to reach a state of powerlessness, or "bottom out," before becoming open to the lessons the pain is guiding us to learn.

Our art may suffer along with us. We cannot create freely when the pain of our naïveté discourages our awareness and creative growth. We may become ready to learn to make choices that encourage our art toward expression.

Some among us may choose to continue to suffer through the pain and hang on to our naive ideas of suffering and artistic denial as a way of life. Others of us courageously choose to let go of our naive thinking. We choose to learn more mature behaviors, skills, strategies, and possibilities, perhaps in therapy and support groups, or in other ways.

Many of us discover, joyfully, that we don't need to

blindly accept everything others want us to believe, do, or be. We learn that we can respect our own and others' boundaries, and respond to others based on our honest creative feelings and choices. We do not need to respond to others as if we lived in a concentration camp and have no choices in situations and relationships. We learn that we are not naively controlled by the dictates of others, when we connect to the God-given power to make choices waiting within us. We learn that we can boldly choose to express ourselves and our art as a means of experiencing life as fully aware adults who are free to be exactly who we are.

❖ ❖ ❖

God, I am willing to let go of my naïveté. I now choose to learn and practice the lessons of maturity that will guide me to be my most creative and expressive self. Thanks for caring.

Playfulness

When we encourage ourselves to play with our art and our lives, we open our spirits to many avenues of experience. As children, our play was often not goal oriented. We played freely, allowing results to evolve in their own time . . . or not at all. We did not judge our playful creations.

We may have experimented with a variety of things in our surroundings. A table could serve as a house. A blanket became a wall. We did not have rigid ideas and expectations. Our imagination transformed what was available into what we wanted or needed. We were accepting of our surroundings and our gifts.

We were experts at acting "as if." The gift of pretending entertained many of us as children—and may have laid a foundation for future careers or creative endeavors.

Some of us may have lost touch with these gifts of our childhoods. In reconnecting with them in artistic recovery, we can gain a valuable asset for our creative expression. The spontaneity contributed by a playful attitude may enhance our art or relationships in unexpected ways. Acting "as if" can give our endeavors creative and spiritual buoyancy. Our imagination can aid our healthful recovery reprogramming efforts.

If we've forgotten how to play, perhaps some of us can re-learn by mindfully observing or engaging in playful activities with children. They can teach us who we are by their examples of playfulness. We can learn to reconnect with our playful, spontaneous selves.

SEPTEMBER

❖ ❖ ❖

Reconnecting with the gift of playfulness might bring unexpected insights and pleasures to my life and my art. Today I can encourage myself, at least for a few moments, to play freely, without judgment, criticism, or expected results.

Times of Change

Throughout our lives we find ourselves in new situations. We may feel unsafe and afraid. Some of our fears may be based on not knowing the outcome of the specific situation in which we are currently involved. We may want to cling to the way things were or are because we know what that feels like, even if it may be painful in some aspects. We may lack faith that change may also include goodness.

These are the times we can learn to trust the Higher Power with whom we have established a personal relationship. The spiritual work we have done can provide a foundation for our trusting that the situation will be manageable and the outcome acceptable. Our faith that our lives and our art are evolving according to God's will can guide us to the balance of peace, even through the trying times of change.

Our belief that we are being guided by a loving source can serve to sustain our hope in troubled times. The emotional work of artistic recovery serves to establish and maintain the intimate connection of faith and trust with our Higher Power. We can come to rely on this source of spiritual strength, even when it seems like the least likely thing to do.

❖ ❖ ❖

God of my personal understanding, I will trust that you will stay with me, even through the times of change. Teach me to let go of worrying about the outcome and to trust that you will guide me to peaceful and creative outcomes if I remain open to trusting your will for my life and my art. Thanks for caring.

Taking Responsibility for Our Needs

Some of us may need to examine our ideas about our needs. We may have believed that one person could meet all our needs. We may have learned to expect a parent, spouse, child, teacher, or significant other to be responsible for seeing that our every want and need is met. This is discouraging codependent thinking that limits us creatively. It narrows sources available all around us.

In artistic recovery, we can learn to expand the sources of having our needs met. If we ask one person for what we need, and that person chooses not to meet that need, we respect that person's choice not to meet our need. Then we ask another, openly, with the responsibility for the need always belonging to ourselves. We continue asking until we find the person or source willing to be available to us, knowing that God works in mysterious ways to meet our needs. The source who ultimately meets our needs may or may not be who we expect it to be. Sometimes it is ourselves.

There is no need to deny or discourage our needs. We do not need to become martyrs or victims. We can identify our needs as we feel them and trust that they will be met in God's own time and way. Our job is to remain open-minded in seeking our sources, and willing and grateful to receive when the sources are revealed to us.

❖ ❖ ❖

I can encourage an open attitude about getting my needs met. I am willing to take responsibility for seeing that my needs are met in effective, open-minded ways.

On the Way Toward Balance

Many artists in recovery, especially in the beginning, identify many significant areas of our lives and our art to be out of balance. We recognize that we may have been devoting too much of our time, energy, resources, etc., to addictions or other people's causes at the expense of ourselves and our art.

In recovery many of us may initially swing to opposite extremes than the ones we held before. We may not be available to give anyone our precious time. We may hoard our gifts, refusing to share. We may isolate from others while we heal our wounds and learn effective lessons of self-care, setting boundaries, making and maintaining the connection with our Higher Power, and educating ourselves to other necessary skills and strategies of artistic recovery.

We do not need to shame ourselves for this period of readjustment. It is a necessary part of the process of our healing. When the time is right, we will reach out to others in healthful ways. Some artists find that we reach out in different ways and on different terms than previously because we have been through the process of our emotional and spiritual growth.

We accept that this stage, as others, is a necessary step for our creative growth. The quiet times, when we withdraw from others, may encourage spiritual moments when we are connecting with our Higher Power and our true creative selves. We become honest about our art, and learn to own and nurture our gifts and our God-given power to use them. We trust that God wants us to have them. And we learn to express our gratitude by using our gifts. All this spiritual investment in ourselves is necessary on the way to finding balance in our creative lives.

❖ ❖ ❖

God, if my life feels out of balance, please guide my path toward a creative balance. If I go to an extreme, remind me that I am on the way toward finding a healthful balance and that I need not shame myself for being who I am and where I am in my recovery efforts. Thanks for caring.

Forgiving Ourselves

Some artists arrive in recovery bringing many unresolved issues with us. It is as if we carry a suitcase full of dirty laundry that needs to be cleaned and prepared for our best future use. Some of our issues require that we open our minds toward forgiving and accepting others for their behavior toward us, and ours toward them.

But most of our emotional work involves our relationship with ourselves. We may have accepted the prevailing attitudes around us as the only way to be who we are, but in our souls we honestly held a different, perhaps more creative, truth of who we are.

Our artistic recovery work serves to search our souls for our own true creative selves. We learn to let go of feelings and ideas that no longer work for us. We learn to forgive ourselves for the wrongs we've done to ourselves, as well as to others, and open ourselves to making amends to ourselves and others.

In practicing self-forgiveness, we let go of discouraging behaviors and attitudes that work against our higher good. We learn to get out of God's way and encourage God's will for us and our art to evolve. In forgiving ourselves we are doing the groundwork toward self-acceptance. We prepare our proverbial suitcase of laundry for eventual better and more effective use. The journey toward a healthier, more peaceful life and artistic expression of ourselves awaits us.

❖ ❖ ❖

I can open myself to forgiving myself and making amends to myself and others as a means of encouraging my life toward a healthier and more peaceful journey.

Encouraging "Down Time"

As artists, we are not machines or computers. We are not designed to create endlessly, at the expense of having a personal life. There is no need to berate ourselves if we make decisions that prove to be less than perfect in our own or others' opinions.

We are human beings with personal lives that may or may not always involve our art. We maintain other connections that need our time and attention. We have other relationships in which we need to give and receive nurturance, in addition to our nurturance of our art.

Sometimes our "down time" is preparing us for change: possibly a new creative endeavor. Our souls often know timing better than our minds. Only in retrospect do we often see that we were being prepared for the things that unfolded later.

If we believe we need to produce or create every minute to feel okay about ourselves or our art, we will feel the frustration that not creating or producing brings to our lives. We may be in God's way with a discouraging need or attitude. By willingly letting go of the self-sabotaging need to create compulsively, we encourage "down time" or quiet time. We become open to peaceful creating and self-expression.

❖ ❖ ❖

I can encourage "down time" in my creative efforts. If I want to, I can let go of my needs to create compulsively and open myself to a more peaceful time and way of expressing myself and my art.

New Beginnings

New beginnings are often frightening experiences because we are unsure of our level of skills and talents and may have fears about the outcome. We may fear consequences or results or may become overwhelmed by the amount of work we see involved in the undertaking. We may lack experience in the new endeavors in which we become involved.

A strategy we can learn and use to ease our transition is that of breaking a task into workable stages. We can then concentrate our efforts on one stage until we are ready to move on to the next. Our perspective may become more focused, rather than scattered by the accompanying fears that the task is too big to accomplish.

We can also learn to pray and meditate before and while doing tasks. We can pray to be shown the way, for inspiration and guidance in the undertaking, and for our minds to be open to God's ideas. Many artists become amazed by the ways the Great Creator chooses to answer our prayers and work mysteriously through our spirits.

❖ ❖ ❖

I can learn to work through my fears surrounding new beginnings by using the strategy of breaking the task into stages or segments. By learning to stay focused, I can feel that my new beginnings and all my creative efforts are more manageable.

Days of Special Remembrance

OCTOBER

Learning to Trust God's Timing

There is an art to learning to trust in God's timing for our lives and our creative endeavors. We may have learned in our pasts to control feelings, events, or our art so that we could avoid a particular consequence or expect a specific outcome. Many of us have continued to use these controlling methods because we have become discouraged from thinking that it is possible for things to occur in other ways and with different timing than we expect.

In artistic recovery we learn that controlling can leave us feeling angry and powerless over our lives, our relationship with others, and our art. We learn to trust that God's timing is preferable to any other. We practice letting go of specific outcomes and limiting expectations. Some artists learn, mostly by experience, to accept that God's will and timing for outcomes is greater than our own. When we trust it, it is accompanied by peaceful efforts in all our endeavors.

We learn patience by turning over to God the things we honestly do not have the power to change. We accept that controlling does not work in our best interests—not with others, not with ourselves and our feelings, and not with our art. We learn, sometimes after many difficult lessons, that letting go of controlling opens us to creative choices that may have been discouraged by our need for a specific outcome or timing. We go on to let go of more and more and learn to replace any controlling efforts with faith in God's timing.

OCTOBER

❖ ❖ ❖

I can begin to trust God's timing for my life, my relationships, and my art. I can become open to learning patience by letting go of things I cannot change, and by trusting that God's timing is already in effect for my life, my relationships, and my art if I am willing to believe it is.

Trusting What We Know

Many of us know much more than we give ourselves or our Higher Power credit for. Our feelings and instincts guide us to healthful decisions and choices. Sometimes we sabotage our own efforts at creating, in relationships, and in making decisions of all kinds simply because we do not trust our feelings and instincts.

We may feel inspired in a creative effort but choose to discount the inspiration for any number of reasons. We may feel in our "gut," for no rational reason, that a certain healthful direction is the one to take, but we have learned to invalidate our gut level instincts. Or we may have learned to value others' decisions over our own, when ours are perfectly valid, if we will only trust them.

With patient effort, we can learn to listen to these instincts. We can learn to acknowledge and feel them as gifts from God that are leading us to our true selves and our creative expression.

It is difficult emotional work to learn to listen to our instinctual feelings when we have been taught to deny them. Most of us have. We can, however, make a conscious decision to do the work involved with trusting our feelings. We can begin by choosing one feeling and focusing on it, staying with it until we work through it to a peaceful resolution. Then we can pick another and work with it, building on what we learned from the previous one. Many artists soon discover that their feelings are guiding them, leading them to goodness. They were given to us by our Higher Power with the purpose of helping us to be who we honestly are. Many of us learn to reclaim our creative selves by beginning to trust what we know.

OCTOBER

❖ ❖ ❖

Today, I will focus on one feeling. I will listen to what it is guiding me to express or to be. I will work with it until I feel encouraged and peaceful. I will trust that I know what I know.

Passion and
Our Artistic Expression

We can learn to live healthfully and well by treating ourselves and our art with utmost respect. We can trust that we deserve goodness and peace in all our endeavors.

We can identify our unique spirit by finding and maintaining contact with the things and people who bring pleasure and contentment to our lives. The enthusiasm we feel for the things, people, and endeavors of our lives can ignite and sustain the fires of our passion.

By defining and choosing to do the things we like, and expressing ourselves honestly as we are, we can open ourselves to the things, people, and experiences that portray our soul-stirring excitement for life.

❖ ❖ ❖

I can encourage myself to feel passionate about my life and my art. I can open myself to choices and decisions I might make that may connect me with my passions.

Learning to
Balance Commitments

Some of us may need to learn to balance our commitments. We may have learned never or seldom to commit ourselves or our art in order to protect ourselves from others' comments. That may be one method toward feeling safe. But it also denies us the gift of sharing that holds the potential of bringing personal satisfaction and enrichment to our lives, relationships, and our artistic development.

The opposite extreme is overcommitment. We may have become afraid to say no to work or requests for our time or art. We may have learned to give of ourselves without allowing for the receiving that prepares us for the balance of the giving/receiving continuum. We may hold on to the attitude that we can be all things to all people. The truth is that we can't, unless we choose to be nothing to ourselves and our own art.

It is possible to work toward balancing our lives with enough involvement to feel satisfied, without overextending ourselves and feeling powerless over our lives and our art. We can become honest with ourselves about how much we need and want to do for others, so that we do not feel abused by our own choices. We can choose to set and respect our boundaries by saying no to others' requests for our time and our art when that feels right to us. We can learn and use the skills and strategies of healthful self-care that will guide us to the balance of a satisfying, creative life.

❖ ❖ ❖

I can learn to set and respect my healthful boundaries in making commitments. If I feel the need, I can begin self-care work on this issue so that I can feel more balanced in my commitments.

Taking a Vacation from Our Art

Our art does not need to consume our every waking moment. We do not need to control our art; nor does it need to control our lives. We have many choices about expressing ourselves creatively. As artists, we might choose to, and benefit from, taking a vacation from our art as we feel the need.

Our perspective often changes as we gain distance from situations, relationships, and issues. We may see some things more clearly as we move away from the intensity of familiar involvement. New awareness, ideas, and nuances are revealed that we may not have seen had we compulsively maintained the intense connection. The same is true in our relationship with our art.

One recovering artist shared this light perspective: "The only thing we get by keeping our noses to the grindstone is that we eventually have no nose. We also miss out on all that is going on around and within us while we grind away at our noses."

A vacation does not necessarily need to involve physical distancing. We can distance ourselves emotionally and spiritually by "letting go" of limiting expectations, by praying and meditating, by opening our minds to honestly considering possibilities and alternatives. Sometimes when we return to our art after these emotional vacations, the new peaceful attitude we bring with us serves to guide us in unexpected ways to revealing fresh insights and ideas.

❖ ❖ ❖

If I feel the need, I can encourage myself to take a vacation from my art. I can become willing to "let go" of any discouraging beliefs about my creativity in the trust that my Higher Power may be guiding me to new awareness and perspectives.

Creative Living Begins Now

Many people fall into the trap of believing that one day, in the distant future, when everything else is finished, and everyone else taken care of, or perhaps at retirement, or (fill in the blank), we will become able to devote time and attention to our art, our heart's desire.

It is easier to be passive about our art and berate ourselves for not doing the things that would bring us pleasure. It is much easier to make excuses and put off expressing our art than it is to become actively involved in creating it.

Each of us can begin the process of expressing our art now. Some may begin by doing sketches, identifying resources, journaling about our feelings connected to what we want to express, learning to make effective use of our time and resources so that we have time for our art, and being honest about who we creatively are.

Even if our work or professional lives do not include our art as we define it, we can find or make time to engage in healthful, pleasure-producing endeavors. Many of us happily discover that our self-esteem benefits and we feel more peaceful and balanced in our spirituality when we become involved in expressing our art.

❖ ❖ ❖

God, please teach me that I can own the power through acknowledging the courage within me to begin living creatively now. Show me the ways to claim the creative life that is your will for me. Thanks for caring.

Believing and Doubting

Belief and doubt are not black-and-white concepts that are easily recognized. We often doubt our Higher Power, our judgment, our choices, our goals, our sanity. Even when we are the most doubting, however, we may also possess some degree of hope.

As we work on our artistic recovery, the proportion of our belief in ourselves, our Higher Power, and our art increases and the doubt or discouraging feelings decrease. There may always be small areas of doubt for some of us. We can accept their existence. We may never eradicate them completely. We strive for progress in our artistic and spiritual development, not perfection.

We do not need to berate ourselves when doubting thoughts enter our minds. It is helpful to recognize and accept them, and then to let go of them. They are only thoughts. We do not need to allow them to control who we are or what our art is about.

We may need to work at believing encouraging things about ourselves as much as we once worked at doubting ourselves, our abilities, and our art. Positive affirmations can help us to tip the scales from doubting toward believing. An easy affirmation may be "I am capable, competent, and creative in the endeavors in which I choose to involve myself." We might try repeating this over and over when we feel discouraged about ourselves and our artistic endeavors. We can also pray and meditate for guidance toward believing positive affirmations about ourselves and our art.

OCTOBER

❖ ❖ ❖

I am grateful, today, for encouraging beliefs in my life and my art. When I doubt myself and my artistic abilities, I am able to look for and find the gifts my Higher Power has made available to me through my feelings.

Just Trust

When we start to worry and we think we just must,
There is another choice we can make.
We can learn to JUST TRUST.

When we hang on to our fears and deny our tears,
We can try letting go and look for courage within
and JUST TRUST.

When we feel weary and try to control,
There is a motto we might extol:
JUST TRUST.

If we've made a connection to a Higher Power,
There's no need to feel worried or fussed
(unless we want to).
The healthier choice is ours to make.
We can make a decision to JUST TRUST.

In Times of Stress

No one is immune to stress. How we respond to and deal with stress and crisis can determine our balance of peacefulness, even in stressful times. Some of us may have learned to answer every need we hear. We extend (or overextend) ourselves to others, sometimes at the expense of our own well-being and health or of our art. We may become exhausted and/or neglect our art. In recovery, we may learn that times of stress are when we most need to practice the healthful skills and strategies recovery has to offer.

Many artists may need to learn to encourage others who are capable to assume responsibility for seeing that their own needs are met in their own creative ways. We recognize and respect our own and others' boundaries. We allow others to ask for what they need. We own our power to choose whether we want to meet that need. We say no when we honestly do not want to do something we are asked. We listen to and trust our feelings.

We use prayer and meditation to maintain contact with our Higher Power. We ask for guidance, and learn to trust the guidance we receive. We have faith, too, that God will guide others to decisions that are right for their care and needs. We trust God's mysterious ways and work toward maintaining a peaceful attitude for ourselves. We let go of trying to control the outcome, even in a crisis.

❖ ❖ ❖

God, in times of stress or crisis, please remind me of the recovery skills and strategies that are available to me. Teach me to choose the healthful ones that will guide me toward peace, even when there are crises around me. Thanks for caring.

Problems, or Challenges?

Our attitude can determine a great deal about how we manage our lives. Do we see situations as problems to burden us, to get in our way and make us miserable and our lives difficult? If so, we will probably feel miserable most of our lives.

Do we perceive situations as challenges from which we can learn and grow; which can stimulate our creative processes; which may teach us new areas of capabilities? Do we know that we have a choice of what we accept as a challenge and how we go about creatively meeting that challenge? Then we may grow to feel capable, competent, and creative. We may feel effective in our lives.

These feelings come not from our minds but from deep within our souls. We can enhance our attitude by prayer and meditation, by choosing whether or not to accept challenges based on our honest feelings and interests, and by turning other situations over to the care of God. To believe that we can solve every situation we encounter by ourselves is a self-defeating behavior that will leave us exhausted and angry. With experience, we learn to choose challenges that encourage our growth. We willingly undertake them guided by our Higher Power and trust that the outcome will be good.

❖ ❖ ❖

God, please guide my attention to choosing challenges that will encourage my growth and learning. Help me to learn which situations are best turned over to your care. Thanks for caring.

Nurturing Our Art

Our attitude about our art may become strengthened if we learn to think of our art as we would a beloved child entrusted to our care. Our art needs to be nurtured, cherished, and shown love and respect from us. When we recognize a need or desire for our art, we can take responsibility to meet those wants and needs. When we feel inspired, we can give the time and attention to our art that it asks. When we need help, we can ask others who are safe and respect our art as we do. We can ask our Higher Power for inspiration, guidance, and direction. And we can listen openly, and willingly accept the answers as we perceive them.

It is often a challenge to balance the many significant areas of our endeavors. We have responsibilities including work, home, significant others, family, spiritual, community, and others. Often our art is given the spare time only. Some artists change our attitude about our art when we learn to consider it as a gift from God—a spiritual benevolence. This motivates us to give our art a greater priority in the balance of our responsibilities.

Like a gentle, loving parent, we nurture our art as a welcomed, beloved child. We can "be there" for our art.

❖ ❖ ❖

I can learn to nurture my art as I would a welcomed, beloved child—a gift from God entrusted to my personal care.

A-N-G-E-R

An acronym:
 Any
 Notion
 Generated
 Excluding
 Respect
Anger pertains to feeling disrespect. It is a healthful emotion that can guide us to ourselves when we become willing to recognize it and listen to the messages it is trying to teach us.

Many of us have been taught to deny our anger. We may have expressed our choices honestly, perhaps creatively. Others may have manipulated us into thinking our choices were wrong, rather than accepting them as we expressed them. We may have learned to change our choices in codependent ways to meet others' approval. In the process, we denied our own internal self-respect of our choices in favor of external respect or acceptance from others.

Others may have abused us in any number of ways. We may have felt rightfully angry but were taught to deny our anger. Others around us may have punished or threatened to punish us if we honestly expressed our anger. So we learned not to express it, and internalized it, at the expense of respecting our own honest feelings.

In artistic recovery, we learn healthful ways of resolving issues of anger. We seek to find respect for ourselves by expressing and honoring our own healthful feelings, including anger. We set and maintain healthful boundaries that include respect for our own and others' choices.

Often issues of anger may be seen as boundary disputes. We learn skills and strategies to clarify our boundaries as a means of gaining our own self-respect. If we feel abused because someone has violated our boundaries, we clarify, at least to ourselves, what we need to do to feel respected. We may or may not choose to express our opinions to that person, perhaps depending on the level of intimacy we seek. If that person continues not to honor what we ask for, we may choose to make changes ourselves so that our request feels honored. We may need to detach from that person to honor ourselves and take care of getting the need met. Sometimes our anger guides us to seek others who are open to meeting our needs respectfully, or perhaps we choose to trust that need to our Higher Power. There are peaceful ways to resolve anger issues.

Many artists find that the emotional work we do to clear up our boundaries and learn effective communication skills and strategies serves to open our channels of creativity. Because our channels are not discouraged by anger and resentments, we feel open and receptive to creative choices from many sources. We clarify and encourage our own identity. Some of us find that the results of our willingness to do the work on resolving our anger issues prove to be worth the efforts we invest in gaining our own self-respect.

❖ ❖ ❖

I can learn to listen to my anger. If I feel guided to make changes in order to respect myself and my honest, healthful choices, I will honor that guidance. I can learn peaceful ways of respecting myself and resolving issues of anger.

Expressing Anger

Many of us grew up with shaming messages surrounding our efforts at expressing our healthful anger. We may have been punished or threatened when we asserted our anger. Because we feared recriminations, some of us may have learned to stop expressing our anger altogether.

In our adult lives, our unexpressed anger can lead to misunderstandings in relationships, abuse of ourselves and others, unclear communications, and denial of our creative gifts. By denying our anger, we bottle up our feelings, reducing our sensitivity. Our honest feelings may become expressed in destructive ways, such as rage, depression, abuse of ourselves, or loss of a connection to our creative selves and our Higher Power.

We can learn to listen to our feelings, and trust that they are guiding our self-care. We can learn and use healthful ways of expressing our anger. We can say no to discouraging or self-defeating behaviors in ourselves and others. We can set and maintain boundaries that keep us feeling safe and secure. We can become open to expressing our feelings, including anger, in ways that enhance our honest self-image. We can choose to be around those who respect us and are concerned with our emotional and spiritual well-being.

When we feel angry, we can examine what has caused us to feel hurt, afraid, guilty, frustrated, or not respected. We can talk about our feelings and ask for what we need to regain respect. We can use "I feel" statements and keep the focus on ourselves. Some of us find journaling to be helpful. We can open ourselves to change. Our acknowledgment of and will-

ingness to work through our anger can guide us to the balance of peace.

❖ ❖ ❖

God, beginning today, I open my soul to lessons of dealing with my anger in healthful ways. Please show me how to use my anger for the highest good. Thanks for caring.

Giving God "Carte Blanche"

When we give people "carte blanche," we allow them full discretionary power. We trust that they will choose wisely for us that which is in our best interests.

In turning our will, our lives, and our art over to the care of the God of our understanding, we are actually giving God "carte blanche" status. We learn to trust that the choices to which we feel guided are best for us, even though we may see no recognizable reasons for believing in the validity of our choices. This is faith in action.

We can learn to trust that we are guided in our actions, in our artistic experiences and expressions, and in our relationships. When we let go of controlling, of discouraging or negative attitudes, expectations, and fears, we make room for God's mysterious ways. The scope of our choices expands, and we learn to seek greater levels of awareness and deserving. We grow spiritually.

❖ ❖ ❖

God, I trust you enough to give you "carte blanche" in my life and my art. I believe that you will choose wisely and well for me and guide me to being my most creative self.

Letting Go of Outcomes

Much of our early learning and artistic development is based on predictable outcomes for our efforts. For example, if we learn the alphabet, we will eventually be rewarded with the possible gift of reading and writing. If we learn musical concepts, we may become able to reproduce or create music. If we behave in a certain way, we can feel accepted in a certain setting. We have learned that there is a predictable outcome to many of our actions, and we may have learned to shape ourselves to generate that outcome.

In artistic recovery, many of us discover that the predictable outcome of our early learning is a limiting factor in some of our creative efforts. We find that our instincts often guide us to experimentation and exploration in which we are uncertain of the outcome. We trust following the unexplored path to which we feel guided, though we often do not know the destination.

We open our minds to creative possibilities when we connect to the courage within to let go and trust our Higher Power for outcomes. It is emotional and spiritual work involving learning to trust the unknown and untested. Sometimes our results are discouraging. But sometimes, they are far better than we might have expected. God's plan, we learn, is often better than our own, if we willingly let go of the outcome and get out of God's way. Many artists learn to take the risk and are often rewarded with joyous outcomes.

❖ ❖ ❖

I can trust my Higher Power enough to experiment with letting go of the outcome of a situation or creative effort that currently feels stressful to me.

Maybe Things Could Change

It is easier for some artists to become entangled in the web of our own expectations, limitations, and fears encompassing what we think our lives and our art "ought to be" than it is to trust our Higher Power for guidance. We hang on so tightly that we blind ourselves to the idea that anything else—even something better—is possible.

Many of us in recovery come to believe that it is the "hanging on"—the clinging to—that limits us, blinding us to choices, options, ideas, and inspirations. When we learn and use the strategy of "letting go" and begin to trust the Higher Power with whom we have established a personal connection, we open ourselves and our art to many more possibilities than we knew existed.

Some of us learn to let go of our skepticism gently by first considering that maybe things could change. Gradually we learn small lessons of trust that begin to open our minds and spirits to greater possibilities, ideas, inspirations, artistic gifts, and more.

❖ ❖ ❖

Today, I will watch for signs that I may be limiting myself and my art by "hanging on" to things that limit me or my artistic expression. I will open myself to trusting that "maybe things could change." Maybe they could even change for the better.

Choosing What We Will Be Responsible For

There are some recovery lessons and issues we can examine regarding responsibilities. Some of us may have lost our balance and taken on others' responsibilities as our own, when they honestly belong to others who are capable. We may have thought it our duty to take on others' self-care needs, financial burdens, creative goals, or other responsibilities. Perhaps we thought it was the loving thing to do. Sometimes it is.

Others may have learned to expect that our honest responsibilities belong to someone else. Perhaps we believe someone else should do self-care tasks of which we are capable. We may feel angry when that person chooses not to meet our needs, even though we could meet them ourselves.

Each of us needs to define the boundary where taking on others' responsibilities crosses over into self-abuse. If we neglect our self-care, our own wants and needs, our creative expression, or being who we honestly are by taking on others' responsibilities, we may violate our own boundaries. We are not loving ourselves. Some of us may have needed to reach a state of exhaustion—emotionally, financially, physically, or spiritually—before we learned to recognize and set boundaries concerning our honest responsibilities.

We can learn to honestly choose the things for which we will be responsible and the degree to which we choose to extend ourselves. It is in giving our artistic expression high priority in our choices of our responsibilities that many artists open ourselves to feel more balanced. By establishing, re-

specting, and trusting our boundaries, we can learn to make healthful choices for what we will be responsible.

❖ ❖ ❖

God, please help me to learn to make healthful choices for the things for which I am responsible. Teach me to recognize and respect effective boundaries that will honor my responsibilities to my creative gifts from you. Thanks for caring.

Attitude of Gratitude

In recovery we work toward an attitude of gratitude. We learn, as the Serenity Prayer reminds us, to "accept the things we cannot change." We become grateful for and accepting of them. We allow the things we cannot change to be exactly as they are, without expending our energy to try to change them.

We learn that the things we previously held on to, which we choose to let go of or turn over to our Higher Power, no longer have an emotional hold on us. The power we felt they had on our lives was all in our minds, and we have released that power by an attitudinal change. Even the painful lessons can teach us new options for behavior.

We go on to learn that our Higher Power has planned lessons for us all our lives so that we can grow as people and as artists. When we drift away from our attitude of gratitude, some artists find, we return to our discouraging behaviors, such as controlling, becoming involved in addictions, and not trusting our Higher Power. We may regress until we work back toward our balance and our feelings of gratitude.

By expressing our gratitude, we encourage ourselves and our art. We open ourselves and our attitude by recognizing and gratefully accepting our gifts and using them.

❖ ❖ ❖

I am grateful today for my attitude of gratitude. If I have lost it, I can seek healthful directions from my Higher Power to return to feeling the balance that accompanies gratitude.

Discovering Our Own Beauty

The process of recovery may be seen as the path toward self-acceptance. We learn to honor the things that bring joy to our lives and let go of those that discourage our creative energy. We focus on our unique gifts and develop and use them to the highest good.

Many of us find that we can take healthful risks for what we trust to be possible, even though we often do not know for certain what the outcome will be. We rely on instinctual messages and honor them as gifts from spiritual sources.

The result of the investment of positive energy we make in ourselves is that we become who we are intended to be. We live our lives by encouraging our creative inner light to shine brightly by using our gifts to honor our Higher Power.

❖ ❖ ❖

I can discover my own beauty by my artistic recovery investments. I can trust that who I creatively am will be revealed as I learn to trust that my Higher Power is guiding me in my art, my relationships, and my life.

Changes in Reality

Our concept of our own reality may change often during our lifetime. Our ideas of who we are, of our connection to others and to our Higher Power, of what we deserve, of what we are capable of creating and being, and many other images of our reality are all subject to alterations.

If we learn to maintain an open and trusting attitude, we can adjust and adapt to changes more readily. It is when we try to control and cling to a changing reality that we may feel powerless and overwhelmed. In the process of regaining our balance and accepting the new reality, we may struggle with many issues relating to change.

When we learn to trust that our Higher Power is guiding us and that the outcome of any situation will ultimately lead to a new reality, we can learn to "weather the storm" of changes with greater ease. Many of us find, when we do let go, that we are often guided to a better reality than the one we fought to hang on to.

❖ ❖ ❖

I can become open to changes in the reality with which I may sometimes struggle. I can learn to trust that God is guiding me and that my new reality will emerge when the time is right and in God's way.

Positive Feedback

We can all participate in the creative development of humanity. By sincerely complimenting others' honest efforts, encouraging healthful and creative choices, and honoring unique expressions of being ourselves, we encourage the development of the natural creative powers we each possess.

We can learn to compliment openly and honestly by sharing our feelings. We do it, not to gain anything from those with whom we share, but to share what is in our hearts—to share ourselves with others.

We may actually serve to enhance our own creative development when we compliment others. Perhaps we open a channel of possibility and store the information concerning that choice, effort, or expression in our souls. We may, in effect, remind ourselves that the possibility exists for ourselves to make the choice that the person made whom we complimented. Whether or not we ever act on that choice may be another issue.

When we learn to cultivate the gift of giving encouraging feedback, we actually support others' as well as our own artistic growth.

❖ ❖ ❖

I can discover the gift of giving encouraging, positive feedback to others.

Balancing Loyalty

Some of us may have learned to value loyalty as a prized quality. We invest our faithfulness and steadfastness in a specific cause or ideal. When it is balanced, loyalty can enhance a peaceful state of being.

Some of us may need to examine our boundaries concerning the investment of our loyalties. We may become overinvested in others' causes at the expense of fidelity to ourselves and our own art, causes, or ideals.

When we discover that we have become disloyal to ourselves and our art, we can peacefully make the adjustments that can return us to a balanced sense of loyalty. We can assertively return responsibilities to those people or organizations to whom they belong. We can say yes or no honestly in situations in which we find ourselves. We can make deliberate choices that keep the focus on ourselves and our art. We can become loyal to ourselves and our art as a means of balancing our lives.

❖ ❖ ❖

God, please teach me to honestly examine any issues I have concerning loyalty. If I have become overinvested in others' interests at the expense of myself and my art, please remind me of the skills and strategies that can return me to a healthful balance. Thanks for caring.

Clarifying Expectations

A great deal of the stress we feel in our lives involves unclear expectations. We may feel anxiety when we are unsure of what is expected of us in our art, our relationships, or of ourselves.

In artistic recovery, many artists examine our feelings and attitudes and work toward an understanding and acceptance of ourselves. We educate ourselves to skills and strategies that encourage us to examine our expectations of ourselves, our art, our Higher Power, and relationships with those around us. We learn to focus on ourselves to honestly express our feelings, wants and needs, our creative gifts, our boundaries, and other concerns. We begin to clear up who we uniquely are and what our expectations truly are.

Many of us learn to give effective messages to others about our own expectations and who we are. We learn to listen to others as they share their expectations with us. We examine both in regard to respect for boundaries. We respond to others' expectations based on our choices.

Clarifying expectations is some of the work involved in healthful communication. The effective expectations we learn to communicate can reduce stress and encourage more open and honest interactions in relationships and with our art.

❖ ❖ ❖

Today, I will meditate on whether I need to do emotional work on clarifying my expectations of myself, my Higher Power, my art, or other relationships.

Setting Priorities

A gift we may either uniquely possess or need to develop can be one of setting priorities. If our art and/or our self-expression is given low priority on our agenda, we may suffer from low self-worth.

We can examine our attitude toward our art. We might ask ourselves: How important is my self-expression to me? Would I like more time to engage in my art? Can I honestly budget time and finances for supplies, lessons, and practice? Am I willing to risk making the changes necessary to give my art a greater significance in my life?

We can learn to recognize and accept the importance of setting priorities for our art. We can ask for guidance from God for "courage to change the things I can" so that our art attains a healthful priority in our lives.

❖ ❖ ❖

I can become open to the idea that setting priorities for my art can be a healthful skill to cultivate. If I already have, I am grateful for this gift.

Examining Choices

To many of us, the scope of our choices is limited by our own limited experience and by the shared knowledge of the relationships in our close vicinity. We may be unaware that many more choices are available to us than we expect are possible.

Some artists find that our attitude can have an impact on our range of choices. If we maintain a controlling, strict attitude regarding our relationships, our art, and ourselves, we limit the choices available to us for our personal expression and growth.

If, however, we cultivate and nurture an attitude of openness and acceptance, we may expand the scope of choices in our awareness. We open ourselves to envision possibilities, ideas, and options that may serve to expand our healthful self-concept and our creative expression.

❖ ❖ ❖

God, please teach me the skill of examining my choices. When I feel limited and controlling in my thinking and my art, please help me to examine my attitude. Show me how to nurture an attitude of openness and acceptance for myself, my art, and others. Thanks for caring.

Control Is Limiting

Control is limiting. We might creatively envision control as the blinders a racehorse wears. Blinders are put on a horse to limit outside distractions and keep the horse's vision limited to the path in front of him. It is concerned with a narrow view and a single-purposed goal.

In artistic recovery, we may learn to remove the blinders that limit our creative paths. Many of us learn to step off the racetrack of external acceptance and onto the gentle path of spiritual guidance, which includes enjoying the pleasant view surrounding us as we travel.

In the process of our removing the blinders that have served to discourage and limit our attitudes, many of us nurture the development of our artistic interests and inclinations. We open ourselves to a new, expanded perspective that encourages us to explore a variety of options, possibilities, and perhaps goals. We let go of the blinders of the addictions and compulsions that have had a controlling influence on our resources and our ability to make effective choices and decisions. We learn, instead, to focus in more healthful ways that respect our creative selves and our art.

❖ ❖ ❖

I will consider, just for today, ways that control may limit my attitude, behavior, and resources for creatively expressing myself.

That Which Brings
Us the Most Joy

Many of us have been taught to deny pleasurable feelings. Some of us have learned to feel shameful about things that might honestly bring joy to our lives if we were not discouraged by our shame. We may substitute endeavors that we believe are more useful: like being who others want us to be, working tirelessly while denying ourselves joy, compulsively giving to others at the expense of ever giving to ourselves that which might enrich our own lives in the form of our artistic expression.

Some artists may have been brought to recovery through painful experiences. In artistic recovery, we might learn that our Higher Power wants to balance our spirits and our lives by bringing us joy. Some of our most difficult lessons may involve encouraging ourselves to receive and feel the joy our Higher Power offers to us.

We learn to become willing and open channels for God's gifts to us. We listen to and honor the feelings that guide us to the creative gifts that are waiting for each of us.

❖ ❖ ❖

God, please help me to open my eyes and my soul to the healthful things and feelings that bring me the most joy. Teach me to trust that I deserve joyfully and peacefully to be my creative self as an act of worship to you. Thanks for caring.

Taking Care of
Ourselves Creatively

We do not need to limit our ideas of art or creative expression to traditional values or ideas of what art may be to others. We can learn to encourage creative thinking and open attitudes in all our endeavors of daily living.

In business, we might explore new ways to perceive opportunities and open our thinking to consider suggestions, options, and alternatives. We are not limited to the current patterns, methods, or expressions. We can learn more effective ways to manage resources and personnel. Experimenting often leads to innovation.

In relationships we can express who we are in creative ways. We might learn about spirituality on recovery issues by considering involvement in new, more healthful situations and relationships. We may choose to expand our concept of who we are and how we relate to others and to God, if we are willing to do the emotional work involved.

Our art may involve living in a creative manner by the combination of healthful choices we make as we live each day guided by our feelings and our Higher Power.

✣ ✣ ✣

I will consider, today, expanding my perception of art to include every facet of self-care in my life. I will consciously look for creative ways to improve my life by considering my healthful choices.

A Job Well Done

If we grew up around people who were critical, judgmental, or demanding, we may not have learned to feel accepting of ourselves and our expressions. As others did to us, we may be continuing to criticize, judge, and demand that we or our art be more, better, or something other than it is.

We may choose to examine some of our old, unresolved feelings concerning these old messages. We can learn how to get to the balanced feelings of acceptance. Many artists find that the emotional work we do toward acceptance is worth the effort we invest. We become grateful for having extended ourselves to learn the necessary lessons toward peace. They guide us to being able to examine our lives and our art in any stage and honestly say, "A job well done."

❖ ❖ ❖

I can learn the lessons toward accepting myself and my art. I can look at my art as it is in each stage of the process and accept it exactly as it is.

The Gift of Curiosity

One of the gifts of our childhood we may have lost connection to is our curiosity. It is said that curiosity killed the cat. If that is so, perhaps the cat died peacefully for having had the courage to follow where his instincts guided him.

The things we want to know more about may provide spiritual clues given by the Great Creator who directs the unfolding of our lives. Our gifts lie along the paths we are guided to follow by spiritual clues. By listening to our healthful, instinctive feelings, including our curiosity, and trusting the direction of the Great Creator, we can learn to accept the nature of our gifts.

It is when we want to become the director and the star of our lives that our lives and our art can become unmanageable. When we try to control the show and determine the outcome, we are left feeling frustrated and angry. By learning to trust our Higher Power with the job as director of our unfolding reality, we can become open to the script of our lives as it is revealed to us.

❖ ❖ ❖

Guide my steps, God, to reclaim my gift of curiosity. Teach me to listen to your emotional clues and to trust that you are guiding me to the higher good in any endeavor.

The When and How
of Creative Recovery

Creative or artistic recovery does not occur on a time schedule or in a recognizable or measurable way or pattern. The Great Creator exercises freedom to teach each of us the lessons and skills we need for our creative and spiritual growth. We learn in mysterious ways and on a time schedule over which we have no control.

Each of us, by learning to focus on ourselves, by making the personal spiritual connection to our Higher Power, by listening to the healthful messages of our feelings and our souls, by trusting those messages and following where they lead, can grow spiritually and creatively into who we uniquely are.

The pathway for each of us is different. There are many similarities to which many of us can relate, however. By sharing with others we can learn to use our similarities, our unique gifts, and recovery skills and strategies in ways that promote the healthful, creative spirit each of us possesses.

❖ ❖ ❖

God, help me to surrender to your timing and method for my creative or artistic recovery. Please grant me the gift of patience as you work your mysterious ways in my life and my art. Thanks for caring.

Days of Special Remembrance

NOVEMBER

As We Grow and Change

Many facets of ourselves and our art may become transformed as we grow and change. Our ideas may expand, lose importance, or take on new dimensions as we work through the feelings we identify.

Our relationships with others may change as we clarify our boundaries, identify and seek to meet new needs, and evolve spiritually. Some connections we may choose to let go of in order to move on with our lives. With others we may feel guided toward more honest and intimate sharing. Still others may fall in the areas between intimacy and letting go.

Our expectations and limitations may change as we work through our fears to new levels of awareness, deserving, and creating. Many artists learn to cultivate open attitudes that encourage new and expanded concepts of ourselves, our art, and our relationships. We learn to accept change as part of creative and spiritual growth. We learn to trust—sometimes painfully, other times joyfully—that our Higher Power has a plan of goodness for us that includes every change we courageously face.

❖ ❖ ❖

God, please stay with me and guide me as I grow and change. Help me to trust that changes to which I feel healthfully guided can encourage me to grow creatively. Thanks for caring.

Investing in Ourselves
and Our Art

Many of us are taught strategies for investing and managing our money wisely so that we are able to claim the maximum yield from our investments. Some of us may need to use this strategy with our emotions and spiritual energy as well.

We may have learned to deny things that might bring healthful rewards and pleasure to our lives—for example, expressing our art.

We may have been taught to "keep our noses to the grindstone" when what we would honestly like to do might bring more pleasure than the financial rewards we work tirelessly to earn bring to our lives. Some of us may need to learn to encourage ourselves to enjoy our lives as they unfold. In getting honest with our feelings, some of us learn to choose to express our art over doing some of the things we had previously felt it was our duty to do.

We learn that investing in our spirits by being honest with what we like to do, create, and express proves to be worth the effort. Some of us find that we are able to turn an avocation or special-interest hobby into a successful vocation when we learn to invest wisely in ourselves and our art.

❖ ❖ ❖

Today, I will meditate on whether I am willing to make the spiritual investment in myself and my art that might possibly bring benefits of balance and peace to my life.

Becoming Willing Recipients
of God's Gifts

Some of us are possible recipients of God's gifts and are simply not aware of it. We may need to educate ourselves to listen for and tune in to the channel that only we can hear for ideas and inspirations for our art.

Artistic recovery may bring gifts to us in unique ways. Some of the ways may be difficult to describe or understand. We may hear an idea in our minds and dismiss it as crazy. Others around us may discourage our ideas as we share them, when the truth is that they are perfectly valid ideas. Some of us may choose to invest our energy and resources in our addictions rather than choose to honor and follow the ideas in our minds. Our addictions are, perhaps, the easier path to follow. They don't require that we discover our individual courage. Nor do they encourage us to grow spiritually or creatively. That path, many artists discover, also eventually leads us to feeling powerless over our lives and our creativity.

Some artists learn to choose to receive and honor the ideas in our minds, no matter how bizarre or different they are from the things with which we are familiar, or how others may try to discourage us. With time and experience, we learn to recognize them as the healthful channel of our Higher Power speaking to us. We learn to listen to them and follow with faith and courage.

Many of us learn to make time when we recognize this instinctual artist voice within, even if we are busy or occupied with other of life's requests. We keep a pen and pad or recording device handy for acknowledging the ideas as we hear

them. Some of us even hear them in the middle of our sleep cycles. We learn to arouse ourselves, listen to and record them, and, when the time is right, follow where they lead us. Many artists discover that they lead us to joyous and peaceful places.

❖ ❖ ❖

God, please open my mind and my life to become a willing recipient for your creative gifts to me. Teach me to recognize and make time for the healthful voice that is your channel to me. Show me how to listen to and trust that artist voice within me. Thanks for caring.

The Good Stuff

Many of us are guided to artistic recovery because of painful issues in our lives. We have come to accept our powerlessness over a situation or character defect. We learn to feel and work through our pain, anger, and shortcomings to acceptance. That is the beginning of our recovery.

At some mysterious point, we each choose to begin to feel and honor the nurturing feelings about ourselves, too. We encourage ourselves to feel joy, peace, contentment, and happiness. We learn to recognize our gifts from God—spiritual, creative, sometimes physical, too. We have reached a welcome turning point in our acceptance of ourselves, our honest choices, and our art.

That turning point often centers on gratitude. We give ourselves permission to talk about our lives and ourselves in terms of feeling grateful. We open our minds and our souls to the abundance available to us in relationships, from our Higher Power, and in our art. We have reached the sacred terrain of balance for which we have worked very hard.

❖ ❖ ❖

I am grateful, God, to have learned to encourage myself to feel the good stuff in my life. I am enjoying the balanced feelings of peace, joy, contentment, and happiness you have guided me to feel.

If I have not progressed in my recovery to these feelings, I will be aware that it is possible for me to work toward feeling them. I will trust that they are waiting for me and that I can grow toward feeling them in God's way and God's time. Thanks for caring.

Art Is an Attitude

Art is not a confined or narrowly defined concept. It is a wide-open range of possibilities each of us defines as we uniquely feel it and express it. In giving art our own definition and form, we demonstrate our choices by our expression.

To come to know in our souls that we always have a choice about our attitude is powerful spiritual medicine. To honestly believe that our healthful expression of choice is acceptable can heal our wounded spirits and connect us with creative spiritual energy sources.

When we feel stymied or discouraged, then, it is helpful to examine our attitude. We can choose an attitude that is positive, supportive of our own healthful choices, and empowering of our gifts. We can choose to believe that our creative choices are valuable and valued by our Higher Power. We can choose to honestly examine the possibilities that are open to us. All we need to do to express our art is to be who we uniquely are by expressing our healthful choices.

❖ ❖ ❖

Today, I will examine my attitude. I will consider the spiritual connection my attitude may have on my artistic expression.

Feeling the Flow

Some artists might need to learn to get out of God's way enough to encourage the natural flow of creativity in our lives and our art. Some of us learn, with time and experience, to recognize the quiet voice of the Great Creator within us. We maintain and nurture that connection by prayer and meditation, journaling, encouraging quiet times in our schedules, and perhaps other ways.

We may feel frightened by the voice or the peaceful feeling that accompanies this flow. We may have become more accustomed to the stress of working hard to achieve the results we want. We might have learned the discouraging behavior of trying to control our lives, our art, and our relationships, rather than allowing them to flow.

The natural flow of creativity is gentle. It happens through our spirits effortlessly, mysteriously, and peacefully. We, as artists, do the spiritual work to connect to, listen to, and trust God enough to become willing channels for the creative flow as we feel it. We learn to trust the process and encourage our lives and our art to unfold as they will, in God's way and in God's time.

❖ ❖ ❖

God, I am grateful to have made my personal connection to you. If I am new to recovery, I will trust that in time I will learn to have faith in your will and your way to connect to me and my art. Thanks for caring.

Spheres of Concern

Many artists lose their creative balance by investing inordinate amounts of energy, effort, attention, and perhaps money in concerns that honestly belong to others who are capable. We extend ourselves for a variety of reasons, sometimes without considering the cost to ourselves or our own artistic expression.

In artistic recovery many artists learn skills and strategies that help us to balance our lives by honestly examining our spheres of concern. We learn to return the healthful focus of our attention to ourselves and our art by examining our feelings, listening to them, and finding the courage within ourselves to make changes that lead us to the areas of our own creative domain. This is often called boundary work.

Many of us find that we feel more peaceful and creatively balanced when we learn to examine and respect the boundaries separating concerns that truly belong to others and those that honestly belong to ourselves.

❖ ❖ ❖

Today, I willingly choose to examine my spheres of concern. If I feel overextended by taking on concerns that belong to others who are capable, I will trust my Higher Power to guide me to consider healthful changes.

Opening Ourselves to Sharing

Recovering artists can learn and grow as individuals by pooling our spiritual resources. When we share our experience, strength, and hope with each other, no matter to what degree we have developed artistically, we can all benefit.

By listening to someone with more experience, beginners in recovery may become aware of an option or a new, more healthful attitude, choose to experiment with it, and grow spiritually for the willingness to take the risk.

By sharing our insecurities and doubts honestly, newcomers to artistic recovery may remind the more spiritually advanced artists of progress made—of how much courage and faith have been invested to arrive at the current level of awareness. The more advanced artists may continually express gratitude that serves to strengthen the bonds with the God of their understanding.

By listening, others might choose to mirror this trust and seek their unique gifts and connectedness to a power greater than themselves. They may become aware of their own feelings of gratitude and gifts, and learn to trust and use them.

Everyone benefits when we open ourselves to honest sharing. The courage we demonstrate when we share ourselves openly can serve to benefit those around us as well as enhance our own artistic and spiritual expression.

❖ ❖ ❖

God, please teach me that my honest sharing is of benefit to myself and those around me. Show me the ways my art might benefit by my becoming open to honest sharing.

Enemies of Our Art

It may not be apparent to us, but we may have internal foes at war with us for our artistic expression. We may need to do a "soul search" for the old, self-defeating feelings, attitudes, and behaviors that inhibit our free and creative expression of ourselves and our art.

Some of us uncover these villains in artistic recovery. We may have been shamed or denied choices as we made early attempts at expressing ourselves creatively. At one time, some of us may have been experimenting with new or unique ideas and become discouraged by someone's negative feedback. We may have accepted someone else's limitations when we honestly believed we had a workable creative effort. We may have denied ourselves and our choices in favor of the other person's expectations.

In recovery, we can learn that the enemies of our art are not necessarily the people involved, but the feelings we have held on to that now limit our unique self-expression. We can learn that it is never too late to work through these old feelings and reach a balance of acceptance of ourselves and our art.

As we work through and let go of the old limiting and discouraging feelings and attitudes, we become open to new possibilities. We learn to define our boundaries by our own and our Higher Power's healthful expectations. We come to trust our Higher Power as the ultimate authority for our artistic expression. We let go of the enemies of our art—those old, limiting feelings—and make room for new supportive and encouraging friends of our art: positive and encouraging attitudes and affirmations.

❖ ❖ ❖

God, teach me to recognize enemies of my art. Guide me to work through the old feelings I may hold onto that discourage my honest creative expression. Help me to define my boundaries so that I discourage enemies of my art from entering my personal and creative space. Guide me, please, to the friends of my art for the encouragement I need. Thanks for caring.

Dealing with Resistance

Artistic recovery can be marked by major and minor battles for our personal growth and creative development. Sometimes, it seems, we grow by leaps and bounds. Just as suddenly, we may become stopped in our tracks, feeling helpless to give any more energy to our creative endeavors.

We may be dealing with resistance. One of the internal enemies of our recovery is a life-depriving force that opposes our recovery. The payoff for resisting our positive recovery efforts is that we remain emotionally and spiritually stuck where we are, or return to old familiar self-defeating attitudes and behaviors that discourage our creative expression. We may be replaying an old, discouraging theme that says we don't deserve to think of ourselves as artists or to reap the rewards that accompany our possible success.

In recovery, we can learn to recognize resistance. Often it feels like fear. We may be afraid to go on, or to take the next risk, or to trust what we honestly imagine as a possibility.

We can pray and meditate for guidance on this issue. We might try turning our resistance over to our Higher Power, or work through our fears by journaling or talking to someone we trust. With time and patience, many artists learn that we can grow through the resistance to the balance of peace with ourselves and our creative growth.

❖ ❖ ❖

God, I am grateful for the awareness that resistance may be an issue I face in my artistic recovery. Please teach me to recognize it and to remember that there are recovery skills and strategies available for me to use when resistance comes to my awareness. Thanks for caring.

Consulting the Artist Within

There is a resource available to many of us that can guide us when we feel lost or out of balance. It is our feelings.

Many artists believe that our creative gifts are channeled from God to us through our feelings. It is by listening to them, honoring them, and following them that we are guided to our creative expression.

It is essential, as artists, that we learn to recognize and accept our emotions. They lead us to effective choices for our exploration and expression. We can consult our feelings and work through them to acceptance and balance when we feel discouraged in our art, in our relationships, and in all our endeavors.

❖ ❖ ❖

I will remember, today, to consult the artist within me when I feel discouraged or unbalanced in my relationships, my artistic expression, or any endeavor. I will listen for and honor my healthful, God-given feelings.

God's Rhythm for Our Art

Some of us may have learned to march to the beat of everyone else's drum but our own. We may have learned to deny our timing of our feelings, instincts, talents, and gifts in favor of a pace that those around us expect us to follow.

In artistic recovery, we can learn to set boundaries that define our uniqueness of timing. We can learn to allow others' expectations concerning timing to belong to them, not us, unless we choose to own the rhythm as our own.

The footwork of our recovery may involve learning to say no to timing we do not honestly choose to live by. It may involve learning to say yes to healthful things we do want for our creative lives when opportunities present themselves. We learn to establish a cadence that reflects our honest, creative choices, as we are guided by our feelings and the spiritual direction of our Higher Power.

By establishing and maintaining a personal relationship with the God of our understanding, we can learn to listen to our internal rhythm for our creative efforts. Some of us may feel inspired to slow down or focus our efforts and/or savor our accomplishments. Others may become guided to pick up the pace or seek new and higher levels of expression. In God's time and way, we are each guided to find the rhythm for our art that expresses who we uniquely are.

❖ ❖ ❖

Today, I will pay attention to rhythm. I will consider whether it is my own by my choices. If it is not, I will seek guidance to find my own rhythm and listen to it.

Small Successes

The small successes of our artistic recovery are not to be overlooked. A series of small successes can move us forward in our creative growth as surely as a single large success might. We can learn to be as grateful to our Higher Power for each small success or gift as we are for larger ones.

If we pray for inspiration or guidance and receive an answer, even a small one, we can express gratitude for the response. We can recognize unexpected sources of encouraging support for its value. When we become aware of and break through our resistance to new creative insights, we can be grateful. Many artists choose to express our gratitude by using our gifts to the highest good.

There is no need to judge our successes or gifts by size or to compare them with others'. Sometimes the small gift of a genuine compliment or smile can bring light to an otherwise dreary day or provide incentive to continue our efforts. We can learn to accept that we are making progress in our recovery, even if it evolves slowly.

❖ ❖ ❖

Today, I will recognize and be grateful for the small successes of my artistic recovery. I will not discount a gift or success because of its size.

Stretching Our Spiritual Muscles

Experts in physical fitness remind us to use and stretch our muscles often for greater fitness. Perhaps we need to be reminded also to stretch our spiritual muscles for greater efficiency.

We can do this by establishing habits that include some quiet time to pray and meditate. Some artists journal daily to keep in touch with our feelings and listen to answers to our prayers.

We can also stretch our spiritual muscles by trying new things, experimenting with new techniques or methods for our art and our relationships, and opening our spirits to expanded possibilities. We can learn to ask God and others for help as we feel the need for our art. We can try trusting our Higher Power for outcomes for our art, our relationships, and other endeavors, rather than investing our energy in worrying or trying to control things to be a certain way.

We can look inside ourselves for our God-given gift of courage when we face situations that feel threatening. We can extend the limits of our patience by turning over to God those things over which we have no honest power. We can listen to and honor our healthful feelings and creative instincts.

We can maintain our spiritual connection with God by expressing our gratitude for being who we are. We can learn to perceive gifts everywhere and offer gratitude for each gift, no matter how large or small it seems to us.

NOVEMBER

❖ ❖ ❖

Today, I will consider whether I need to do some emotional exercises to stretch my spiritual muscles. I might try trusting my spiritual source for guidance when I feel discouraged.

Opinions

If our boundaries are unclear, we may have learned always to mold ourselves to conform to others' opinions of who we are and what our art "should be." If we conform often enough, we become not who we honestly are but who everyone around us expects us to be.

We can learn to respect our own and others' boundaries regarding opinions. We can listen openly to others as they express their opinions, perhaps regarding our art or creative ideas. Then we can trust that we have a choice to agree or disagree with that opinion as a truth for ourselves and our art.

Even when we ask for opinions from others, we can filter the information we receive. We can weigh this information on the honest scales of our perceptions and choices. Then we can choose from this information the things that work for us and let go of the rest.

We can learn to detach from the behavior of compulsively conforming to others' opinions of who we are and what our art might involve. Some of us may have learned this discouraging behavior hoping that others would like or accept us if we changed ourselves to meet their needs. In artistic recovery, many of us learn that respect for our own and others' boundaries serves to guide us to find those who accept us and our art exactly as we are.

❖ ❖ ❖

I can learn to trust my opinions about my healthful choices, my art, and my relationships. If I am unclear about my feelings, I can ask my Higher Power for clarity on the issue in which I am involved.

Continually Making Adjustments

Some of us may have adopted the limiting attitude that we were working toward some magical time or great accomplishment that would signify that we "have arrived" and we'd not have to make a single change for the rest of our lives. We may have believed that when we reached that magical moment, things would be perfect with no effort again on our part.

In artistic recovery, we learn that investing in that way of thinking can limit our lives and our art. We learn that we express ourselves to the fullest when our attitude remains open to possibilities, choices, inspirations, and change. When we honestly embrace change as an option and allow for making adjustments on a continual basis as we feel the need, our creative expression is given full opportunity.

We learn to maintain honesty with ourselves, our art, and others by communicating our feelings, wants, and needs. Some of us do this in our daily conversations, some in support groups, others by journaling, prayer, and meditation. Still others may find healthful expression in creating our art or in other ways.

❖ ❖ ❖

God, please teach me that life is a process of continually making adjustments. Show me the ways that my life and my art may have become limited by my limited attitude. Teach me, also, that with deliberate effort, I can make adjustments that will benefit my life and my art. Thanks for caring.

Each of Us Is an Artist

Art is not limited only to traditional ideas of painting, sculpture, music, dance, or other endeavors. It is an unlimited field of personal expression. Each of us has a choice of defining art in ways that work for us as individuals.

Art could be defined as an expression attained by investing creative attention in a specific skill or skills. In this perspective, art might include any expression of ourselves at any given moment defined only by our healthful choices.

We might perceive our artistic recovery as an artistic expression if we choose. The skills we learn by giving attention to them in recovery can enhance our lives in many ways by opening our minds and souls to choices, possibilities, and personal expressions of ourselves, even in recovery.

When we discover the God-given gifts that are the highest expression of ourselves at any moment, and we choose to be who we are by expressing those gifts, we are creating art in the most open-minded sense.

❖ ◆ ❖

I will meditate, today, on the idea that artistic and creative expression is not limited to a restricted definition. I will consider the many healthful things I do that involve my giving creative attention to skills. I will express gratitude for my unique expression of these God-given gifts.

Honoring the Gifts We Value

As we grow in spirituality, our lives become more authentically our own. We become more open to being who we are and creating from our unique spiritual guidance. Our personal connection to our Higher Power can lead us to more honest choices about our art. We become more balanced and disciplined with our gifts.

We learn to listen quietly for the familiar voice of inspiration that guides our choices, teaches us timing, and leads us gently to the next step in our creative endeavors. Since we value that inspiration, we learn to act on it to honor its presence in our lives.

We learn patiently to accept and honor our creative gifts as sacred and valued treasures from God. We come to believe that in using our gifts we honor our Higher Power for having entrusted the gifts to us.

❖ ❖ ❖

Teach me, God, to honor the gifts I value from you. Guide me, please, to use my gifts to honor you for giving them to me. Thanks for caring.

Feelings As Gifts

Our feelings may not be recognized or appreciated as gifts from God. We may have learned to think only of our artistic talents and skills as gifts from God.

Some artists learn to identify our feelings by listening to others who openly and honestly share their own feelings. Some may journal regularly or participate in artist or other support groups to learn to listen to and accept feelings as an inner guide. Others may learn by reading specific books on the subject or participating in therapy, workshops, or seminars.

When we learn to identify, listen to, and trust our feelings, many of us discover an unexpected and encouraging dimension to our artistic efforts. We find that we create peacefully and more efficiently. Our art evolves gently when we listen to our feelings and begin to trust God's way and God's time for our lives and our art.

❖ ❖ ❖

God, I am grateful for my gift of feelings. Please teach me to listen to and trust my feelings and to follow the healthful guidance they offer me for my life and my art. Thanks for caring.

Waiting Is a Choice

Some of us may have been programmed always to respond to communications from others by taking action. We want to fix problems, offer caregiving to others, even though they may be capable of taking care of themselves, or perhaps we want to tell them how they should resolve their insecurities even if they don't ask for advice.

Some artists learn the lesson that waiting is a choice. We can listen as others share without responding at all, if that is how we feel guided.

It is said that patience is a virtue. In our spiritual aware-ness, some of us discover that patience is a valuable asset. We find that by combining waiting and trusting in our Higher Power, we encourage mysterious outcomes that our compul-sive action-taking would have limited.

As we learn to allow more and more responsibilities to belong to those to whom they honestly belong, we free up more time to invest in our art. Choosing waiting, as we con-sider our options in situations, relationships, and with our art, many of us find, can bring rewards of peace and balance to our lives.

❖ ❖ ❖

Just for today, I will remember that waiting is a choice avail-able to me. When I feel as if I have to respond to someone, I will consider the choice to simply wait. I will trust my Higher Power for guidance in my responses to others.

Living Our Own Lives

Some of us may have chosen to put off living our own lives to nurture and care for others around us. We may be performing a valuable service to others in the process. Others of us might have learned to give of ourselves to everyone else in an addictive effort to feel good about ourselves. We may have crossed over the line from healthful caring to addictive and compulsive caregiving.

We do not need to shame ourselves if we become aware that we may have abused our own self-care or the care of our personal creative gifts in this way. We can begin the journey of learning the art of living our own lives, right where we are, as we feel guided by our Higher Power.

In recovery, many artists may come to learn the freeing lesson that we are okay simply because we exist; that being a child of the universe is enough reason for us to learn to like and love ourselves. We do not need to validate ourselves by addictive attitudes or behaviors. We learn that to start living our lives as we choose, we can nurture and validate ourselves by taking care of ourselves in many ways. We can assert ourselves by saying no to things we don't want or want to do and by saying yes to healthful things we honestly do want and want to do.

Many of us learn to change the focus of some of the patience and attention we once lavished exclusively on others. We healthfully redirect it to ourselves and our art as we grow and change. We find and nurture our connection to God, as we understand God to be. We begin the journey toward living our own lives as whole and creative beings connected to our Higher Power.

NOVEMBER

❖ ❖ ❖

God, please guide my path to living my own life in the creative, healthful ways you will for me as one of your beloved connections. I am grateful to feel that I am spiritually connected to you.

Learning to Trust in God's Ways

Some of our recovery lessons are revealed only by experience. We may try a particular method for our art or style of expression in our relationships and find ourselves feeling powerless. It just isn't working for us. So we try another and another until we find those that provide us with healthful empowerment. Our experience has guided us to God's highest good.

Over time we gain confidence in our instincts. We trust our feelings to reveal the path we need to take. We learn to listen to our feelings for the information that moves us along the path toward healthful relationships and for our most creative artistic expression.

The work many of us do in prayer and meditation helps us to maintain the connection of trusting in God's ways. We pray for what we need. We meditate for guidance and direction. Then we open our minds and souls for the answers to be revealed to us. Sometimes the answers are revealed in joyful ways we like; other times, in different ways that may require that we grow to appreciate or understand them. We learn to wait patiently for God's time and way to be revealed, and express gratitude for any results we receive.

❖ ❖ ❖

God, please teach me to be patient as I learn the lessons of trusting in your ways. Show me, by experience, the ways to healthful empowerment for my relationships and for the expression of my artistic self.

Encourging One-Word Affirmations

Some artists choose encouraging one-word affirmations and meditate on how that quality or feeling may apply to ourselves and our art. Here are some possibilities:

thoroughness	tolerance	peace
flexibility	calmness	practicality
enjoyment	surrender	communication
common sense	dependability	imagination
intuition	attentiveness	discovery
responsibility	celebration	mystery
service	friendship	assertiveness
ideas	enthusiasm	sharing
change	desire	optimism
patience	healing	empathy
opportunity	love	curiosity
harmony	open-mindedness	humility
knowledge	understanding	commitment
truth	strength	efficiency
passion	powerfulness	faith
growth	abundance	wisdom
generosity	resourcefulness	motivation
maturity	confidence	receptivity
rejoicing	forthrightness	versatility
hope	appreciation	availability
cooperation	style	play
solutions	revelation	readiness
cheerfulness	beauty	excitement
options	risk taking	surprise
humor	spontaneity	perceptiveness
perspective	courage	laughter
intelligence	progress	will
simplicity	uniqueness	spirit
kindness	observation	
gentleness	education	

Finding Facts, Not Faults

Some artists may have spent our early development sur-
rounded by authority figures or role models who spent their
time pointing out our faults and failures, and gave undue at-
tention to our insufficiencies and shortcomings. If they
neglected or gave little attention to our positive qualities or
creative initiatives, we may have learned to deny our gifts. We
may have learned from others' examples to give attention
only to fault finding in ourselves, our art, and others.

Some of us discover that our gifts have remained dor-
mant under the stifling attitude that discourages our giving
attention and expression to our gifts. If we have been taught
by others' examples to strive only for perfection and pay no
attention to our feelings, we may have an attitude that over-
looks many of our God-given gifts.

In artistic recovery, we can seek the balance that identi-
fies and accepts our shortcomings without giving excessive
attention to them. In the same process, we can learn to nur-
ture our gifts by investing in them the energy we previously
may have invested in seeking faults. We can turn our fault-
finding energy into fact-finding efforts that support our artis-
tic expression.

❖ ❖ ❖

*Today, I will meditate on how I invest my time and energy.
If I have learned to give my energy to finding faults, I will seek
guidance to learn to find encouraging facts that support my
healthful artistic expression.*

Thinking Clearly

In artistic recovery, we identify the discouragement that clouds our healthful thinking and feelings about ourselves and our art. We let go of denial and recognize the impact our addictions and compulsions have had on our making the best use of our creative gifts from God.

We work through the old feelings that dissuade our true expression of ourselves. We strive to keep our lives free of things that block us from expressing ourselves creatively. This requires that we become constantly vigilant of ourselves and our feelings and own responsibility for our lives and our art.

Many artists find journaling to be helpful in keeping our thinking clear. We often spot trends of artistic neglect while writing about our happenings. Sometimes we need to work toward making an amend to ourselves or others. We make changes that guide us back to being respectful of our artistic expression.

Other artists may find prayer and meditation, support groups, reading and researching recovery literature, or other ways to clarify our thoughts. Many of us find that when we invest honestly in ourselves and our feelings, we become channels for God's creative gifts to us.

❖ ❖ ❖

I can discover skills and strategies that work toward keeping myself thinking clearly. I can become willing to make amends to whomever, myself included, to clear my thinking and be who I am.

One Lesson at a Time

Recovery is a process of patient evolvement. We become aware of a gift and learn over a period of time how we can use that gift for good in our lives and our art. We learn one skill at a time. It may be a creative skill that enhances our self-expression through our art. Or it may be a recovery skill or strategy that guides us toward self-acceptance, improved relationships, and increased spirituality.

Some of us may become guided to learn lessons through painful experiences. We may feel angry, frustrated, or depressed about an issue with which we struggle. We learn to ask for help. We open our attitudes and spirits to embrace the lessons our feelings are guiding us to learn.

Sometimes our lessons are joyful. We discover that we are capable of mastering that skill we previously admired only in others. We own our power in a situation or solve a problem in a creative way that is new to our awareness. We grow by using the skills and strategies recovery has to offer.

We grow spiritually by increasing our levels of trust and letting go of worry, control, fear, and limited expectations. We turn to prayer and meditation rather than clinging to doubt and discouragement. We remember to seek the lessons our Higher Power is teaching us in each situation we face. We express our gratitude more and more often. One lesson at a time, we become who we are.

NOVEMBER

❖ ❖ ❖

I will remember, today, that my recovery is a process that evolves one lesson at a time. If I begin to feel overwhelmed by all there is to learn, I will stop and focus on one recovery skill or strategy. I will trust that the other lessons I need to learn will be presented and learned in their own time.

Encouraging Time for
Prayer and Meditation

Prayer and meditation are gifts we can give to ourselves. The payoff, many artists who practice these spiritual disciplines realize, can be a peaceful atmosphere in which we foster the emergence of our art.

Some artists may learn to support these disciplines by scheduling time regularly just for prayer and meditation. There are those who set aside a corner of a room as their personal spiritual space. This area may include candles or flowers, art objects, or special trinkets of spiritual significance to us. We may play music in the background or enjoy the quiet.

Others may have a space on a table, desk, or other place that addresses our spiritual needs. One recovering person shared that the bathroom served for this purpose. "Bathrooms are available everywhere we go," this person suggested. "When I use the bathroom for its intended purpose, I can get extra value in the quiet space by praying and meditating. If I feel stressed by a situation, I excuse myself to go to the bathroom. The time away from the stressful situation I use to pray and meditate, asking for guidance and direction. Often I find that I am able to return to situations with a clearer focus."

❖ ❖ ❖

I can encourage myself to schedule time for prayer and meditation. If I do not schedule it, I will remember that prayer and meditation can serve as a resource to me as I feel the need.

GOD = Good Open Dialogue

In artistic recovery, we can become open to learning health-ful skills of communication. We can apply these skills to our-selves and our art, in all our relationships and endeavors, and especially in our relationship with God.

We can learn to express our feelings in our prayers and meditations. We can learn to turn over things we cannot change to God and trust that God will know what to do with them. We can learn to accept God's will and trust that it will lead us to good, even if it may not feel good in the moment.

We can learn to ask God for what we need. We can be specific. Do we need help with a relationship? Do we need in-spiration, direction, supplies, lessons, etc., for our current creative endeavor? We can ask God.

When we ask openly, we do not have a specific limited outcome in mind. We ask to become guided in God's way and God's time to the highest good. We keep our minds open to possibilities. Sometimes, many artists find, God's highest good is greater than our specific limited ideas might have been.

Another part of GOOD OPEN DIALOGUE involves listening. We listen openly for answers. We learn to trust that God works in mysterious ways. We keep our minds and souls open to receiving the answers to our prayers, not denying them. We trust that the answers to our requests are God's will for us and our art.

We go on to express our gratitude for the gifts we have received from God by making the best use of them. And the cycle continues: asking openly, receiving openly, expressing gratitude by using our gifts. This is G-O-D in action.

❖ ❖ ❖

God, please teach me the communication skills I need for good open dialogue in all my relationships, and particularly my relationship with you. I am grateful for the awareness that I can learn and use these skills. Thanks for caring.

Integrating New Learning

As creative beings, we are continually learning. Each new lesson we learn about our lives, our relationships with each other and our Higher Power, and our art serves to help us to grow.

We learn new skills by trusting our feelings of curiosity and willingness to expand our sense of who we are. We employ the skills and strategies of our learning by combining our personal choices and expressing ourselves and our art in unique ways.

Sometimes when we choose to learn new lessons in life, we need to let go of, and perhaps mourn the loss of, old lessons or relationships that no longer serve our best interests. Old, self-sabotaging feelings are replaced by new, healthful feelings of capability, competence, and creativity. We combine the new lessons and skills into our current reference of who we are. We grow spiritually and artistically by integrating our new learning.

❖ ❖ ❖

God, please teach me to see that I am continually learning. Help me to let go of self-sabotaging attitudes and behaviors and replace them with new, encouraging feelings of capability, competence, and creativity in myself and my art. Thanks for caring.

Holiday Feelings

The holidays may engender a variety of feelings in us. Some of us may connect with unresolved losses or needs from our pasts. We may feel sad or depressed and not be able to pinpoint the reason. It may lie in our memories of the past or our expectations of how things "should be."

Some of us may have undergone changes in our lives and recoveries that have distanced us emotionally, physically, or in other ways from our families of origin or significant others. We may need to work toward adjustments of accepting our new or current reality to feel peaceful.

Many of us may connect with joyful feelings. We may feel positive about our creative expressions and contributions in preparing for and celebrating holiday traditions and observances. Our self-esteem may become enhanced by our holiday efforts. We may be able to assert and enjoy our choices and the consequences of honoring them.

Others may feel exhausted. Our efforts may be out of balance for discouraging reasons. We may not be respectful of boundaries and try so hard to please everyone else that we neglect our own self-care and end up exhausted—emotionally, financially, physically, spiritually, or any combination of these. We may overextend ourselves and feel like victims.

We can all work toward finding a healthful balance. We can discover ways to feel positive about ourselves during the holidays, without becoming overwhelmed by our feelings. We may need to put some of our recovery skills and strategies to work for us, consciously, with deliberate effort, during the holidays. We learn them so we can use them when we need them.

NOVEMBER

❖ ❖ ❖

I can find ways to keep the focus on myself, my feelings, and my creativity during the holidays. I can work toward feeling accepting and peaceful with myself and others. I can trust my Higher Power for guidance. If necessary, I can create my own joy, perhaps by designing new traditions or holiday artistic expressions.

Days of Special Remembrance

DECEMBER

Discouragement and Encouragement

Some of us may have revealed our artistic efforts, at one time, to others who discouraged us by judging, criticizing, or shaming us. If we attributed more value to that person's opinion of our efforts than to our own, we may have become thwarted from further attempts at creating. We may have learned to deny our feelings of frustration or anger by accepting others' opinions at the expense of our own opinions, when ours may be valid.

We might find a word game to be helpful when we recognize the feeling of discouragement in ourselves. Perhaps if we imagine the word *discouraged* as meaning "disconnected from courage," we may be guided to finding the courage within ourselves to feel encouraged. We might pray and meditate to be connected to the courage we need for self-acceptance and our own acceptance of our art.

This strategy may help us to nourish our souls. If we choose to, we may consider sharing our feelings with the person who discourages us and our creative endeavors. We can allow the other person to have an opinion on the subject. We can also learn to respect our boundaries as well as others', by valuing our own healthful feelings about our artistic efforts.

❖ ❖ ❖

I will meditate on whether I have felt discouraged in a healthful artistic effort. I will pray for connection to courage so that I can encourage myself to express my art as I feel it.

Dealing with Success

The idea of success may feel threatening to some of us. If we feel less than secure in our belief that we deserve goodness from our Higher Power and life, a success may feel fraudulent to us. In our souls, we may not honestly believe we deserve the goodness a success might bring to our lives, whether that success is in our art, our relationships, or other areas of our lives.

We may feel envious or jealous of others' successes and use those feelings against ourselves. Some of us may have learned attitudes that judge ourselves negatively based on comparing ourselves to those around us. In our souls, we come up short because of others' achievements or accomplishments.

It is possible to change our perspectives about success. Rather than seeing our own or others' achievements in judgmental or comparative terms, we might envision them as gifts. Our own achievements might be seen as gifts from the loving and caring God of our understanding who wants the best for us and our art.

Others' successes might be seen as gifts as well. We can express happiness that the other person has been given a gift. If we have an interest in achieving the same accomplishment for ourselves, we might ask that person for guidance on how he or she achieved that success. Or we might choose to quietly observe their attitudes and behaviors for lessons we might learn for ourselves. We might also view their success as a possibility for what we might accomplish if we focus our energy and attention toward a specific healthful endeavor.

Many artists in recovery happily discover that if we be-

come open to learning and growing spiritually, personally, and creatively, we, too, may achieve the success we once only observed, and perhaps envied, in others. From this perspective, others' successes, as well as our own, encourage our creative growth rather than denying or stifling it.

❖ ❖ ❖

Today, I will open myself to examining my ideas about success. If my old ideas are working against my most creative interests, I will strive toward letting go of them and replacing them with more healthful attitudes that encourage my artistic expression in my relationships, my art, and my life.

Holiday Preparations

Many of us experience stressful feelings during the holidays because we have not learned healthful management strategies to prepare for them. We can learn strategies that might include scheduling adequate time for preparations and activities, setting and maintaining boundaries for responsibilities, and consciously choosing the endeavors that are personally meaningful to us and giving attention to them, and letting go of the others, if they feel stressful to us.

We can learn to budget our time, money, and resources so that we do not deplete any of them for our own self-care and consequently feel victimized. We can use the recovery skill of saying no to things we don't want or want to do, and yes to healthful things we do want or want to do.

If we feel discouraged, we might examine our attitude. We might consider the things we enjoy and express our gratitude to our Higher Power for them. When we practice our recovery skills and strategies, our holidays can be a time of joyful sharing and balanced giving and receiving.

❖ ❖ ❖

Throughout the holidays, I will be aware of the many recovery skills and strategies that can guide me to feeling balanced and peaceful.

Acknowledging Our Creative Gifts

For many reasons, we may choose to deny our gifts. We may hold attitudes that discourage our acceptance of ourselves as creative people with God-given power to choose how we express ourselves. We may participate in groups or belief systems that downplay individual or unique views on issues that are honestly significant to us creatively or spiritually.

Many artists struggle with these and other issues as we work toward recovering our honest sense of ourselves and learn to acknowledge and use our creative gifts. We examine the discouraging feelings that limit our belief that we deserve to receive gifts of creative value. We work through these feelings to acceptance and gratitude for the gifts that have been entrusted to us.

We continue to grow after we learn to acknowledge and accept our gifts. Many of us learn to use our creative gifts and talents to the highest good as a spiritual act of gratitude for having been entrusted with them.

❖ ❖ ❖

If I am new to recovery, I will trust in the will of my Higher Power toward acknowledging my creative gifts. If I have experience in artistic recovery, I will express my gratitude by using my gifts for what I trust is the highest good.

Embracing the Mystery
of a Higher Power

Upon arrival in recovery, many of us have fixed ideas of what our lives "should" be, of how our relationships with others "should" be, of what "should" be possible for us and our artistic expression. The spiritual work we do to connect to our personal Higher Power can open our minds and spirits to new perspectives and possibilities. We learn to let go of our "shoulds" and limiting expectations.

Some of us come to understand that God does not operate by "shoulds" but in mysterious, unexplainable ways that do not follow known patterns or rules. We learn to trust that we and our art are guided by our willingly, and sometimes courageously, going where our healthful feelings and choices honestly lead us, in God's own mysterious ways and times.

As we continue our spiritual practices, many artists come to embrace the mystery that is our Higher Power. We openly ask to become guided in God's mysterious ways, not by our own limiting "shoulds" and expectations. By our empowering experiences in life and with our art, we learn to trust that our Higher Power is leading us to the highest good.

❖ ❖ ❖

Just for today, I will trust embracing the mystery of my Higher Power by letting go of my discouraging "shoulds" and listening for God's will for my life and my art to be revealed to me.

The Benefits of Practice

Some of us may feel overwhelmed when we discover that artistic recovery offers many skills and strategies we can learn that might offer peace to our frantic lives. Our emotional pain may be so great that we compulsively work toward seeking immediate relief and balance.

The bad news is that recovery is not about quick relief or instant cures for our pain. It is a lifelong process. The good news, however, is that the rewards of peace and balance many of us come to enjoy in our lives and our art are worth all the time and effort we invest in our artistic recovery.

Like any other skill we learn in life, it is through the practice of recovery skills and strategies that we find the benefits we seek. For example, if we practice setting and maintaining healthful boundaries for ourselves and our art, the benefit will be that we have the time and resources we need to carry out the expression of our art. If we do not continue to practice the skill of boundary setting, we soon feel the frustration and anger that are the discouraging result of our not taking care of ourselves and our art by our boundary work.

The gentle pace of recovery is purposeful. It represents the gradual healing of our spirits by the practice of new, healthful skills and strategies that guide us to self-love and confident expression of our creative selves.

DECEMBER

❖ ❖ ❖

I am grateful for the awareness that there is a purpose to the gentle pace of my artistic recovery. I will trust that the benefits of my practicing recovery skills and strategies are worth the investment of my time and energy in learning and continuously practicing them.

ART = Attitude + Responsibility + Trust

Our attitude plays a guiding role in our lives and our art. If we feel unworthy, our art will suffer the consequences of our discouraged thinking. If we feel open and receptive, however, our art will reflect our encouraged position.

We can learn to establish and maintain healthful boundaries by honestly defining and respecting responsibilities. We can learn to clearly define the things for which we are honestly accountable, including our gifts, and give our time and attention to them. We learn to examine our lives and relationships for issues that honestly belong to others who are capable. We learn and practice skills and strategies that respect others' boundaries as well as our own.

Trust is an issue many artists face. We may want our art to be done in our own way and time. God's way and time may be different from our own. Many artists learn that letting go of our own way and time for our lives and our art, and learning to trust God's way and time is the path to peaceful, creative lives and endeavors.

❖ ❖ ❖

God, when I feel discouraged in my creative efforts, please help me to examine whether I may be denying my feelings about my attitude, my honest responsibilities, and trusting that you are guiding my life and my art.

Keep the Focus on Myself and My Art

A number of us may have learned earlier in our development always to focus our attention on pleasing others, meeting their wants and needs, or being who others wanted us to be. We may have carried those lessons with us to adulthood, some of us to extremes that neglected our own self-care, including the expression of our art.

In artistic recovery, we learn to shift a healthful proportion of the focus of our attention back to ourselves. By learning about feelings and their role in our creative lives, we begin to give the consideration and respect to ourselves and our art that we previously may have lavished on others, perhaps at the expense of ourselves and/or our art.

Some may accuse us of being mean or selfish when we choose to take care of ourselves and our art over always taking care of others. We can accept that they have a right to their opinion. We can also accept our own right to take care of our own needs, including our needs to express ourselves creatively.

Keeping the focus on ourselves and our art requires emotional effort. It does not happen automatically, at least at first. We learn patiently to honestly listen to our feelings and choices. We live our lives according to what feels respectful for ourselves and our creative expression. We trust that God will guide others to having their needs met that we choose to let go of so that we can use our own God-given gifts to the best purpose.

❖ ❖ ❖

Teach me, God, the lessons I need to learn to keep a healthful proportion of the focus of my attention on myself and my art. I am grateful to know that there are skills and strategies available in artistic recovery that can guide my healthful artistic expression to the best use.

Staying Balanced
Through the Holidays

The level of our recovery skills and strategies may become tested through the intensity of the holiday season. Our self-care may become neglected as we extend ourselves to holiday celebrations, family and social gatherings, and the hustle and bustle of activities many associate with the season.

Some of us may lose our focus and get caught up in trying the discouraging behavior of controlling. Others of us may lose ourselves by denying our feelings and becoming what or who others want us to be, and disregard what or who we honestly want to be. Still others will choose to own our healthful, God-given power to be exactly who we are, by respecting our own and others' boundaries.

Staying balanced and being who we are is possible. This is not to suggest that it is always easy. The effort we extend to ourselves to stay focused on our feelings, wants, and needs can reap the benefit of peaceful and joyous holidays.

We can do healthful self-care by maintaining our boundaries and nurturing our spirituality, including our creative capacity to make choices, throughout the holiday season. Many artists find that our attitude is more open, our lives and art more manageable, and our stress level reduced, when we maintain our self-care.

❖ ❖ ❖

God, if I find myself feeling discouraged during the holidays, please guide me to the healthful self-care skills and strategies that will bring me to the balance I seek. Thanks for caring . . . and happy holidays.

Giving Ourselves Permission

Some of us may have grown up in surroundings that required us to obtain permission from others for our actions. We may have felt or experienced consequences or the threat of consequences if we did not follow the rules of obtaining permission. We may have learned always to give our power to make healthful choices to others or authority figures.

In our adult lives, some artists may still be waiting for permission from others to be who we are. The child inside us still clings to the old rules under which we need permission to express ourselves differently from others or to stray from the expectations of authority figures, or to become someone of our own healthful choosing, perhaps an artist.

In artistic recovery, we can examine our feelings related to the need to obtain permission from others. Some of us courageously and patiently explore our old feelings about our need to give away our God-given power to choose. We work through our feelings to acceptance by letting go of the idea of others being authority figures who have power over us. We learn to trust our Higher Power as our ultimate authority. In time we give ourselves permission to become who we creatively are.

❖ ❖ ❖

I am grateful for the awareness that I have a choice about giving myself healthful permission to be who I honestly am.

Clarifying Our Perceptions

Our feelings provide a basis for our perceptions. If we honestly feel hurt, angry, deprived, neglected, or otherwise wounded, our perception of life may be that it is about suffering.

As we work through our feelings to understanding and acceptance of them, our perceptions of what life is or can be change. We can change the focus of our lives and our art by learning to listen to our feelings. We can become willing to work through them and trust that they have a guiding purpose in our lives. When we learn healthful communications skills and strategies, our feelings may direct us to our art and to self-acceptance.

In doing the emotional work to clarify our feelings and perceptions, many artists discover that our gifts have been neglected. Our art has not been given the attention it deserves. We learn to place greater emphasis on our gifts and let go of the addictions and compulsions that were in the way of a clear perception of ourselves as creative beings. We learn to encourage ourselves to feel the joy that using our gifts can bring to our lives.

❖ ❖ ❖

As I work on my artistic recovery, I can learn to place greater emphasis on the expression of my art and less on the addictions and compulsions that divert my energy from my creativity. I am grateful for the gift of clarifying my perceptions of who I am and what my art is about.

Empowering Our Art

Some of us may invest lots of energy in wishing we had the time, the patience, and the knowledge and skills to create a cherished art or pursue an idea we envision. We mistakenly believe that only others have magically been given the secret ingredients to create the things we only long to express. We may feel envious or jealous of them. We may believe we were not born in the right family, or had the right teachers or experiences, or that some other circumstances outside ourselves was wrong.

In artistic recovery, many artists learn that the secret ingredients for each of our artistic expressions lie dormant in our souls. We learn that we each can choose to give power either to our addictions and compulsions, or invest the same power in our art. With focused effort, we learn the formula for empowering our art by courageously and faithfully practicing the recovery skills and strategies available for us to learn when we become willing.

Often by trial and error, we learn to stop giving away our power to choose. We practice the recovery skills of owning and trusting our feelings, setting and maintaining our boundaries, and detaching from people and things that discourage or depower our art. We choose to say yes to people and things that encourage, support, and empower our art. Each of us can learn to take responsibility for empowering our art by the application of creative skills and strategies available to us in artistic recovery.

❖ ❖ ❖

Today, I will consider the ways I might empower my art by choosing to practice skills that value my art over my addictions and compulsions. I will invest my God-given resources healthfully in my art.

Getting to Gratitude

Some artists discover that the road to gratitude is a difficult one filled with struggles. We initially may not be aware of or see goodness anywhere. We may be oblivious to our creative gifts that others see clearly. We let go of an issue, then return to trying to control it, only to feel the powerlessness again that accompanies controlling. So we may let go and trust God once more.

This is a common pattern in recovery as we work toward the balance of accepting reality as it honestly is. Letting go is not an easy process, nor is it accomplished in a particular way and time by everyone. We each choose to do it when we are honestly ready and in the way that brings peace to our lives.

Some of us work toward gratitude by becoming receptive to lessons we can learn from any situation in which we become involved. Though some of our lessons may be painful, we might see the pain as a consequence of a discouraging choice. We may learn to try a different or more healthful choice or attitude when we are in a similar situation the next time. Patiently we become grateful for lessons that teach us to grow.

Most of us find that when we reach feelings of gratitude in our recovery, our art benefits. We learn to see goodness, gifts, and opportunities to grow spiritually and creatively all around us. We become grateful for the emotional work we have done to let go of issues and systems that discourage our creative choices. We willingly become grateful channels for the expression of the gifts God has entrusted to us.

❖ ❖ ❖

Please teach me patience, God, as I work toward gratitude for being who I am and for each of my creative gifts. Help me to become aware of the goodness that surrounds me and my art. Please show me how to express my gratitude for all of it. Thanks for caring.

Asking for Support

In recovery, some artists learn for the first time that it is all right to ask for the support we need. Some of us may need encouragement to take a risk in a relationship or endeavor. Some may need information or advice, or perhaps therapy.

Most of us find that when we ask openly and clearly of our Higher Power and others, and listen patiently, when the time is right, we get what it is we need. Sometimes assistance comes from those around us. Sometimes we discover that our needs are met from within ourselves. Other times, we find happily, help arrives in the most unexpected ways and from the people we least expect. It happens in God's mysterious time and ways.

❖ ❖ ❖

I will meditate, today, on whether I need to ask for support in dealing with an issue, a relationship, or an artistic endeavor. When I feel ready, I will openly and clearly take the risk to ask someone I trust for support for my artistic needs.

Defining Our Art for Ourselves

Our art is not necessarily something that can always be pinpointed or identified exactly according to specific frames of reference. Because our personal choices help to determine our art and what it means to our lives, many of us have difficulty discovering what our art involves.

Our art may sometimes be an in-the-moment experience that may or may not be continuous or relevant to the rest of our lives. Sometimes we see only a glimpse of what may be possible for our lives. We do not need to discourage ourselves if our art is less than definable. We can accept it as it is whenever we recognize it as our art or our creative gifts.

Nobody else can define for us the healthful things that bring us the most joy. We can learn to identify them ourselves and nurture them to fruition by our own creative choices. We can learn and practice the healthful skills and strategies that support our artistic expression and enrich our lives.

❖ ❖ ❖

I can learn to define my art by my own healthful choices. I can learn not to discourage myself for my artistic efforts, no matter how small or large.

I Want to Thrive, Not Merely Survive

By Linda Coons

In the midst of all my struggles, my worries, and my griefs,
Just next to my awareness, my hurries, and my beliefs,
I hear a calm expression that keeps my soul alive:
I want to thrive, not merely survive.
Sometimes it lies there quietly, not making much ado.
Other times it shouts to the world,
 "Stand back. I'm coming through."
Its voice is ever changing. Sometimes it speaks in jive:
I want to thrive, not merely survive.
In its most joyous form it sings to me its song.
When I feel full of gratitude, sometimes I sing along.
Taking poetic liberty, I feel so creaTIVE.
I WANT TO THRIVE, NOT MERELY SURVIVE.

Guidance for Our Choices

Many of us have learned not to trust our feelings. We feel an inspiration, then may set out to discount it or abuse ourselves by making choices that discourage us from the opportunity to risk what we envision. We do anything but listen to the guidance we have been given by our feelings for our art.

The skill of learning to trust our feelings is one we can acquire if we work at it patiently. Gradually we take risks that support our inspired choices. Some artists may make and maintain the connection with God by valuing the healthful feelings, inspirations, and choices that come to us from what or whom we perceive as God. We trust that our feelings serve as a form of Divine Guidance, and that we can safely follow where our choices lead us.

❖ ❖ ❖

God, please guide me to learn to trust my feelings. Teach me that my inspirations are spiritual gifts from you, and that I am worthy of receiving and using these gifts. Thanks for caring.

Working Through Discouragement

Sometimes as we work on an artistic effort, we may reach a point in which we are suddenly halted and feel we can't proceed. We may feel foolish for having believed that we could do what we initially envisioned as possible. We may want to give up on the whole idea, disregarding the effort and resources we have already invested.

This is a dangerous place for creative people. Some artists refer to this feeling as self-sabotage. Others call it fear of failure or fear of success. Still others call it a block. We may be unaware of what we feel or why we feel it. We simply know that we feel unsure of continuing with our art.

There may be self-defeating feelings or discouragement in our souls that say we are undeserving of what the completion of our art might bring to our lives. We may be unaware of these old, subtle messages unless we examine our feelings honestly and work through them toward acceptance and balance.

With patience and courage we can uncover the old, discouraging messages we may have previously accepted as true about our self-worth, or our art, or the goodness we may receive from completing our art. We can examine these messages, feel them, and check them out for their relevance and truth in our lives today.

Then, when we're ready, we can turn them over to God. We can pray for guidance and ask for direction with our artistic efforts, looking inside our souls for the courage we need to move on, and take the next right step. We can "let go and let

God" until we get through the discouraging feelings to the peaceful space of balance and healthful self-acceptance.

Many artists find this spiritual work to be as necessary as learning and practicing the skills and talents of our individual artistic gifts in completing a project. The presence of a Higher Power can help each of us to work through the discouragement and connect to the courage we need to be the creative person each of us honestly is.

❖ ❖ ❖

God, please grant me the courage to honestly face and work through my feelings when I feel discouraged in my artistic expression. Guide me to the healthful caring and supportive feelings inside myself that encourage my expressing my art as a gift back to you for entrusting me with it. Thanks for caring.

Recovery Is a
Continual Process

Recovery is not something we do and complete and never have to deal with again. It is a lifelong practice that can produce results in proportion to our willingness to use the healthful skills and strategies recovery has to offer each of us.

Most of us find that our recovery issues remain in our lives to some degree—our addictions and compulsions, as well as our creative gifts. It is in our learning to manage our shortcomings and our gifts that we grow toward feeling peaceful and balanced.

We learn to more wisely invest our time, energy, and resources—our lives—in ways that express our most healthful choices and selves. We continually make decisions that value our expression of our gifts, rather than give the same energy to the shortcomings that divert us from using our creative gifts productively. We express our gratitude to our Higher Power for our gifts by making the best use of them.

❖ ❖ ❖

Today, I will remind myself that my recovery of myself as a creative connection to my Higher Power is a continual process that will last my whole life.

Expressing Who We Are

Many artists arrive in artistic recovery not knowing who we truly are. Through painful experiences, we may have learned to be who everyone around us expects us to be. We lose ourselves by not paying attention to our own feelings and our self-care. We may feel empty, abused, depressed, and unloved.

We can open ourselves to lessons that guide us to being who we honestly are. We learn to make choices based on what we feel, want, and need. We learn to encourage others who are capable to be responsible for their own feelings, wants, and needs. We learn to stop controlling others and invest our energies in being who we are.

The skills and strategies available to learn and develop in recovery can guide us to choices that support our personal expression of who we are in any situation. In creative undertakings and relationships alike, we learn to value our own choices. We state or express them honestly and follow where they lead us. Patiently and with healthful effort, we learn that it is acceptable to be exactly who we are.

❖ ❖ ❖

Today, I will consider whether I am expressing who I am by my honest choices. I will value my feelings, wants, and needs by expressing them in my relationships and my art.

Self-Care in Recovery

There are any number of interpretations for the idea of self-care. Does it mean we think exclusively of ourselves and our art, and neglect connections with anyone else? No. Does it mean that we thrust our needs, wants, and expectations on others and demand that they meet them? No. Does it mean we continually deny our creative gifts and artistic expressions in favor of being available to take care of others' needs at the expense of our own? No.

Learning healthful self-care is a lifelong lesson. Different stages of our development as people and as artists may require unique lessons of self-care. We begin by getting in touch with our feelings. We may ask ourselves, "What do I want and need . . . honestly . . . in this moment? Who do I truly want to be tomorrow . . . next year . . . in the future? What would feel good and healthful to me?" We can strive to meet these wants and needs in ways that respect both ourselves and others with whom we choose to communicate.

Self-care may mean that we define our needs, wants, and expectations; claim the responsibility for getting them met; and healthfully express who we are. We listen for God's will to guide us in ways that may prove better than our own limited or controlling ways.

There are, of course, trade-offs. If, for instance, we want to feel physically healthy, we need to make responsible choices of healthful eating, exercising, and seeking appropriate medical care. We may need to seek balance spiritually by learning and using healthful communication skills and strategies, maintaining personal contact with our Higher

Power, and expressing ourselves and our art in unique ways that bring pleasure and satisfaction to our lives.

❖ ❖ ❖

I can define what personal self-care means to my life and my art. I can become willing to make healthful trade-offs that guide me to be the best creative self I can be.

The Joy That Our Art Brings

Some artists may need to remind ourselves of the joy that is inherent in the expression of our art. When we love what we are doing and focus our energies toward our expression of our art as we feel it, our joy is both expressed externally and felt inside.

Some of us may get caught up in the process or development of our talents and gifts. We may neglect the spiritual aspects that can enhance every other dimension. Our connection to our Higher Power can serve as a channel for our joy through our art.

When we feel complacent or perhaps discouraged with our artistic process, we may need to reconnect with the joy that attracted us to it originally. We can nurture our sense of joy and perhaps seek new angles or varied facets of our expression, rather than working toward limited outcomes.

❖ ❖ ❖

I can remember the joy that my art brings to my life when I slip into feelings of discouragement. My Higher Power can guide me to feeling the joy of expressing my art.

Art Is Not Frivolous

Some of us may have learned to give our energy and power to choose to people who believe that art is a purposeless waste of time. They may have convinced us to use our time and energy in purposeful pursuit of what they value as important. In the process we may have learned to become dishonest about what we honestly do value—our own expression of our art, for example.

We may have been taught by others that the things that nourish our spirits—our art, for instance, are less valuable than other things. In so doing, we may have learned to devalue our creative gifts and talents.

It is possible for us to learn to examine and choose what we value, even if it is different from the things others may value. By using the skills and strategies available in artistic recovery, we can examine our feelings about our art and the value we choose to give to it in our lives. Some artists discover that we disagree with those who say that art is a purposeless waste of our time, or is frivolous, or other discouraging statements about art. We find that our art is a unique investment in our own self-expression.

❖ ❖ ❖

Today, I will examine my own ideas of what art honestly means to me and my life. I will listen to others' ideas about art with respect to my own and others' boundaries.

Exploring Our Creativity

Our art may or may not involve producing a product or visible result. For some artists, creativity may have other meanings that are no less valuable than those that are goal oriented. We needn't berate ourselves if our concept of art or creativity differs from others'.

For some of us, or many of us at particular times in our lives, our expression of ourselves as creative people may involve examining possibilities, seeking and exploring choices, investigating ideas, playing with feasibility, brainstorming inventions, weighing possible risks and benefits, or other concepts of creative expression. To be an artist is not limited in scope to doing something with predictable results in mind.

We can explore our healthful creativity in our relationships, in our jobs, in our surroundings, in our spirituality, and in our world. By becoming open to creative attitudes, listening receptively to inspirations, and following where we feel guided, we can define our artistic expression in our own unique terms.

❖ ❖ ❖

Today, I'll consider whether my ideas of art or creativity are limiting my attitudes. I will meditate on whether I need to explore any of my creative gifts.

Giving Gifts to Ourselves

Many of us were taught to give to others, especially during the holiday season. Some of us were not taught to care for and respect ourselves as much as we do others. We may have learned to invest our time, energy, and interest in always giving to others, and to think of ourselves only after everyone else, if at all.

Meanwhile, our creative, God-given skills and ideas may lie dormant in our souls waiting for us to find the time to invest in them. Some of us deny their existence altogether. Others may feel we lack the courage to claim the time, energy, and attention for ourselves that we lavishly give to others.

In artistic recovery, we can learn to give gifts to ourselves. We encourage ourselves to claim the time to pursue our creative ideas. We put ourselves first on our gift list, seeing that our creative needs are not neglected. We schedule quiet time for ourselves in an otherwise stressful agenda. We trust that if we take care of ourselves first, we will have more honest love to offer those around us.

Some of us find that learning to give gifts to ourselves is the hardest emotional work we have ever done. We come to believe that God wants us to be well cared for and to feel nurtured and loved.

❖ ❖ ❖

I am grateful to learn that it is acceptable to give gifts to myself as an act of creative self-nourishment.

Broadening Our Visions

Some artists may become discouraged because we cling to limited visions of what is possible in our lives or our art. Many of us have learned to deny ourselves and invest our faith in others' agendas of who we should be and how our art should be expressed. Often this is the easier path emotionally if we fear the pain that accompanies our personal and creative growth.

Rather than invest our energy in risk taking and learning new skills for growth, some of us choose to maintain our limited ideas. Other artists courageously face our fears and work through them to more expansive perceptions and creative realities. We broaden our visions and ideas by learning to think more openly. We clarify our options and make healthful choices that lead us toward our creative visions. Eventually, many of us feel the joy that is our spiritual gift for the willingness we have invested in ourselves and our art.

❖ ❖ ❖

Today, I will examine my willingness to broaden my vision to include investing energy in my healthful, creative gifts. I might begin by journaling or talking about my feelings concerning my creative ideas, if that feels right to me.

Letting Go of Distractions

There are any number of distractions that can divert our energy and resources from our art. Our addictions and compulsions may be among them. In fact, it seems to some of us, it is much easier to become distracted from our art than it is to do the work required to keep the focus on our art.

Many artists need to constantly monitor our boundaries for distractions. Other people or systems may want to claim our time, money, resources, or ideas for themselves. We need to maintain an honest watch to remain centered and available for our art.

Some artists may find journaling or support groups to be helpful in letting go of distractions. Others may meditate, pray, or develop our own system of letting go. Each artist may find a method for letting go of distractions and keeping a healthful focus on expressing our art that works effectively for us as individuals.

❖ ❖ ❖

I can learn to let go of the distractions that divert my time, energy, and attention from focusing on my art in ways that feel peaceful to me.

God's Better Plan

As we work on establishing and maintaining a personal connection to God, we learn to let go of our controlling and addictive behaviors and attitudes. We learn by experience that these behaviors only limit our best and most creative interests. We replace these limiting practices with trust that our Higher Power is guiding our lives and our art.

We learn that it is in letting go of confining expectations and outcomes, rigid rules and limiting ideas, and fears about what is possible, that greater choices than we might have imagined appear in our lives and our art. We learn to open our hearts, minds, and souls to plans greater than our own limiting ones. We become receptive channels for God's will and God's plan for our lives and our art.

We go about living our lives and expressing our art secure in the knowledge that we are lovingly interconnected with our Higher Power. We trust our lives and our art to unfold exactly as they need to, and we earnestly believe that everything we need is and will be provided. We peacefully come to accept God's better plan for our lives and our art.

❖ ❖ ❖

If I haven't learned to accept God's better plan for my life and my art, I will trust, just for today, that it is already in place. I will let go of controlling and addictive behaviors just for this one day and open my soul to seeing creative possibilities in all situations in which I am involved.

Honoring Our Inspirations

Some of us have been given creative gifts and have not learned to manage or use them effectively. We hear ideas or inspirations in our souls and deny that we heard them, or we discourage ourselves by believing that they are of no worth. Perhaps we cover them up or dishonor them with our addictive behaviors and attitudes.

In artistic recovery, we can grow to acceptance of our gifts. We learn to redirect our energy to our art in healthful ways that let go of the self-sabotaging behaviors that work against the best use of our gifts and our creative expression of them.

We learn healthful self-care skills and strategies that encourage us to listen to the creative messages we are given. We trust that they are gifts from God, created uniquely for us. We trust that we deserve to receive them. We courageously follow where they lead us, believing that the outcome is in God's care. We honor them by giving expression to the ideas and inspirations we hear as an act of gratitude to God for giving them to us.

❖ ❖ ❖

I can learn to honor my inspirations. I can trust that they are gifts from God given uniquely to me.

Harvesting Our Gifts

The work we do in recovering ourselves as creative beings can have an encouraging effect on the quality of our lives. We stop berating ourselves, belittling our artistic efforts, and sabotaging our potential for receiving the goodness our Higher Power wants us to have. We become willing and grateful recipients of God's gifts to us.

We learn to "be there" for our creative selves. We stand up for our God-given rights, rather than denying them or permitting others to abuse us or them. We learn and practice healthful self-care. We listen to the inspirations we hear in our quiet moments. We trust them and follow where they lead.

When we follow willingly and honestly, artists discover, our inspirations lead us to being exactly who we are—creative and loving connections to our Higher Power who deserve respectful and abundant lives.

As we learn to respect and accept ourselves, others around us learn to treat us with respect and acceptance, too. They may learn from seeing us respect and take care of ourselves and our art that it is possible to learn to respect themselves and their art. Seeing us live our lives honestly and creatively can be a gift to someone else who questions whether self-expression is possible or acceptable.

❖ ❖ ❖

I am grateful, God, to be harvesting the creative gifts of my recovery. I am willing to serve you as an example to others of what is possible in recovery if that is your will for my life and my art. Thanks for caring.

Remaining Open to Creative Growth

There may be those among us who believe that when we attain a certain milestone—perhaps a degree, or position, age, or award—that we no longer need to grow spiritually. This attitude of closure may lead to stagnation, frustration, and depression.

Because there are an infinite number of ways we can express ourselves and our art, remaining open to creative growth can serve to enhance our capacity to expand our concept of who we are. The emotional work we do in making and maintaining a personal connection to a loving and generous Higher Power can provide a foundation for continual expansion of ourselves as channels for the creative process.

We can employ avenues for our continuing creative growth as artists. Some may use recovery or daily meditation books like this one for many years. We discover that as we grow and change, new meanings and implications or awareness to inspirations are revealed. Each year, the same reading may inspire new possibilities because of the significant areas of personal growth or issues with which we are currently dealing.

Others may use journaling as a method of examining feelings, relating issues to our spirituality, and exploring options for our lives and artistic endeavors. There is no one way that all artists do the work of remaining open to creative growth. We each discover our own way.

DECEMBER

❖ ❖ ❖

Today, I will meditate on whether I am remaining open to creative growth. I will ask God for guidance in areas where I may feel discouraged about recognizing my creative gifts.

Turning It Over—A Visualization

By Linda Coons

One of God's great gifts to each of us is our imagination. We can learn to use this gift that has been entrusted to us as part of a skill for turning things over to our Higher Power. Our imagination can serve as a bridge to our souls.

We can also nurture and enrich our connectedness to our Higher Power in creative ways by using meditations. They may help to guide us to our feelings and to giving attention to the importance of our feelings in our lives and our artistic expression.

The following is an example for experimenting creatively with the gift of imagination:

Assume a comfortable position. Allow your breathing to relax you. Take three deep breaths, exhaling gently through your mouth until you feel the need to inhale again. When you breathe out, pretend that you can expel any fatigue or draining energies from your body as the air leaves you. Breathing in through your nose, imagine that the air is filled with soothing, comforting, healing power that can nourish every cell of your body by the simple act of breathing.

Let's begin our experiment by imagining that you are outside in an undisturbed, natural, and safe setting. Envision your surroundings, making a mental note of the pleasant and beautiful things you see around you. Allow your creative self permission to express your inventiveness in your environment. Take a moment to express your gratitude to your Higher Power for each gift you see around you.

Observe, now, that a hot-air balloon with a woven basket

attached under it has mysteriously and quietly landed near you. It is settled peacefully within an easy distance from where you are. Acknowledge your feelings of curiosity. Following your instincts, patiently approach the balloon.

Isn't it wondrous that the balloon is designed in your favorite colors and in a style you find both appealing and tranquil? Allow yourself some time to focus on the design, the colors, and the textures of the picture that has unfolded just for you. Let yourself enjoy the sense of awe, beauty, and serenity that has entered your awareness.

You may want to circle around the balloon to take in the splendor that has been revealed to you. Visualize each fold of the fabric of the balloon. Trace with your vision each detail of the design. Follow the intricate lines of the weave of the basket. Allow yourself to indulge in the magnificence of the display that has developed, and of which you are an integral part.

After a few moments of attention, turn your back to the balloon. See that a large white screen has appeared, similar to a movie theater screen. Imagine that you allow any thoughts, cares, feelings, or opportunities that drift into your mind to express themselves on this screen. Let them have their say. Give yourself permission to feel any emotions that become apparent.

When they are clearly defined on the screen, pretend that they can shrink in size. Imagine that you are able to pick them up in your hand or hands and manage them easily.

Turning around slowly, return your attention to the balloon and basket. Visualize them once more in colorful detail. Envision yourself willingly moving toward the beautiful balloon. Place what you have gathered in your hand or hands into the waiting basket.

Now see that the ropes that anchor the balloon to earth are accessible to you. Being naturally investigative, you wonder how it might feel to set the balloon free. You hesitate, but only for a moment. You remember instantly that your Higher Power hears you when you pray openly seeking guidance. A short prayer spontaneously advanced from your soul: Please show me what is the highest good in this situation.

Shortly you find that your hands are easily detaching the tie-down ropes, and the balloon is gently lifting. An automatic prayer of gratitude slips from your mouth: Thank you for the guidance.

Watch in anticipation as the balloon and basket carrying the thoughts, cares, feelings, and opportunities you have entrusted to them begins to ascend. Slowly they move away from you, lifting ever upward. Study once more the details of the creative design and colors of the balloon, and the exquisite weave of the basket as all of it gently departs from you.

Courageously, wave good-bye as the basket gains distance from you. Acknowledge your feelings as they arrive in your awareness. Again remember that prayer serves as your connection to your Higher Power. Calling your Higher Power quietly, you ask again for guidance. The answer you hear, or perhaps feel or sense, is that the highest good will be done with the things you have entrusted to the basket.

Imagine, now, that the balloon carrying the basket has gotten so small that it is barely visible. It is a speck on the horizon of the sky. In the same instant you become aware of a presence approaching the balloon and its basket. On clearer inspection you recognize the image as your Higher Power. Visualize that sacred presence openly receiving the balloon and the basket with its contents.

A prayer issues again from your soul. It begins: I trust

that you will use these thoughts, cares, feelings, and opportunities I turn over to you for the highest possible good. . . . A few moments are now included for you to create your own personal prayer . . . (pause)

To close the prayer, perhaps you say, "Thank you for caring about me."

When you are ready, you notice that your Higher Power has left a precious gift just for you. A blanket of joy has surrounded your being. You feel the warmth of the sacred trust that has been expressed between yourself and your Higher Power. Cherish, now, the connection that has developed by your faith in the mystery of the power greater than yourself.

You may sense a need to keep the joy within yourself. You have, after all, personally extended yourself by your willing efforts of opening yourself to trusting, asking, and receiving. Your Higher Power perceives this need and offers you another gift from your imagination. At your feet, now, envision a large zipper pull. Attached to it is a tag that says, "Joy containment kit." The directions read simply, "Pull the zipper slowly and gently from feet to head to contain the joy that is a personal gift from your Higher Power to you."

Eagerly, you choose to follow this spiritual advice. Imagine that as you pull the zipper, you enclose your joy first at your feet, then gently around your legs, waist, chest, arms, neck, head, and finally enveloping all of you, body, mind, and soul, when the zipper pull passes over the top of your head.

Now the joy is yours. You can choose to share it as you feel guided by your Higher Power. It will not leak away from you indiscriminately, nor will others be able to take it from you without your permission.

As an act of gratitude to your Higher Power for your connection, you might consciously choose to express yourself

and your joy throughout the day by using all your gifts, creative talents, inspirations, resources, healthful choices, and bountiful abundance to the highest good. To return to the current reality, rub your hands together a few times, wipe your fingers soothingly over your eyes, and when you are ready, slowly open your eyes, bringing with you the joy that has been entrusted to you.

Notes

Notes

Notes

Notes

An Additional Resource

I am happy to suggest to my readers who may be struggling with issues connected to their creativity that there is a relatively new 12-Step Recovery Program called A.R.T.S. Anonymous (Artists Recovering through the Twelve Steps). Here you may find and/or creatively develop a small but international community of artists working together in a "grass roots" effort to solve their common problems and help each other achieve artistic freedom. If you have a desire to fulfill your creative potential but are having trouble, you might wish to contact A.R.T.S. Anonymous, P.O. Box 175, Ansonia Station, New York, NY 10023, or (212) 873-7075, or www.pagehost.com/ARTS.

In the A.R.T.S. literature, members have defined their common problems to be:

1. We grew up in an atmosphere of invalidation that resulted in ambivalence about our artistic expression.

2. In any given twenty-four-hour period we find ways, consciously or unconsciously, to avoid doing that which gives us the most joy—expressing our creativity.

3. We have withdrawn from our art by investing ourselves in lifestyles, relationships, and work activities incompatible with our artistic purpose. Our creative energy has often been diverted into destructive compulsions toward alcohol, food, sex, money, drugs, gambling, and preoccupation with the past.

4. We have made needless sacrifices for our art and yet are afraid to make the necessary sacrifices. We are unable to balance significant areas of our lives—Physical, Financial, Social, Love, Family, Spiritual, and Creative.

5. Self-defeating thoughts and societal myths turn in

our heads: It's too late—I'm too old—I'm not ready—I am not good enough—Art is not practical—Artists are neurotic—You'll starve. We have accepted these as true when, in fact, they are not.

6. We have felt intimidated by other artists' success. Jealously, envy, fear, self-pity, perfectionism, resentment, and other character defects block our creative expression.

7. We stand always on the edge of a beginning, afraid of commitment. Fearful of pursuing our creativity as a means of earning a living, we get caught in the amateur syndrome. The concept of supporting ourselves through our art has seemed overwhelming. We are unable to determine the monetary market value of our art.

8. We have thought of our art as divorced from reality, denying ourselves the right to follow our dream. We forget that artists are entitled to their right work and deserve the happiness and success that right work brings.

9. We deny our responsibility to fully develop and realize our talent. We do not feel worthy of the success we achieve or desire. We feel like a fraud.

10. Being multitalented, we have difficulty discerning our true artistic vision, making a commitment to it, and establishing the priorities to fulfill it.

11. We have difficulty following through on projects and frequently sabotage our efforts. We want to work at our art but don't know how. We become impatient with the process, forgetting that the results come in God's time, not ours. Our time is unmanageable.

12. We have been afraid of our creative energy and have mistrusted our artistic instincts. Lacking spiritual awareness, we have not seen ourselves as channels for the infinite creative process. Our art is a gift to be shared.

Linda Coons—A Profile

I am a multitalented artist who dabbles in and experiences a variety of art forms. I have developed and use skills in calligraphy, floral design, gardening, sewing, cooking, writing poems, songs, and music, and many other pursuits.

I have developed a small antique business and enjoy selling merchandise and decorating my home with antiques.

I have previous experience in community mental health, where I used my Associate of Arts degree in Occupational Therapy. My own personal and spiritual growth journey has currently guided me to write daily meditation books on issues related to creativity.

I have also written a novella, which has not yet been published. It contains words to songs to which I have also composed the music. My great dream is to bring it to life as a book and eventually a movie.

My husband of thirty-three years and I are the parents of three adult children and grandparents of two granddaughters. We live on a small farm in York, Pennsylvania, from where we pursue our creative passions.

One of my current passions involves presenting workshops on creativity. I have developed a format called "Let's Talk About Art," which explores some of the prevailing attitudes about what creativity involves. I am available to present this topic to groups.